NAPERVILLE

NAPERVILLE

· A BRIEF HISTORY ·

BRYAN J. OGG

THE
History
PRESS

Published by The History Press

Charleston, SC

www.historypress.com

Copyright © 2018 by Bryan J. Ogg

All rights reserved

Front cover, top: *Overlook Naperville, Illinois*, limited edition print by Naperville artist Marianne
Lisson Kuhn, used by permission. *Courtesy of Robert Brennan*; *bottom*: William Winehold and
Naperville Lounge Factory wagon. *Courtesy of Don and Bari Landorf family*.
Back cover, top: Bronze statue, *Big Joe*, located in Naper Homestead Park, by artists Jeff Adams
and Dick Locher. Tree stump and surveying tools by artist Ryan Hartman. *Photographed
by the author*; *bottom*: Bird's-eye map of Naperville published in 1869 for the Merchant's
Lithography Company, Chicago, by Ruger & Stoner, Madison, Wisconsin. *Author's collection*.

First published 2018

Manufactured in the United States

ISBN 9781467139168

Library of Congress Control Number: 2018948036

CONTENTS

FOREWORD

When I first met Bryan, I recognized his passion for this community that we both call home. My family moved here in 1939 when I was a kid and the population was about 5,000. Bryan arrived here in 2004 as an adult, when the population was approaching 139,000. He calls himself one of Naperville's "transplants." Today, he's as knowledgeable about life and times in Naperville as though he'd been living here most of his life, too.

I've enjoyed getting to know this humble young man from Morton. When I wondered what I should do to preserve my top hat after I retired, people told me Bryan would know. He's quite a resource. His stories have connected me to people I've known through the years and things I've loved doing. When I first opened this book, I was surprised to learn things about this city even I didn't know!

This book about Naperville is a timeline, of sorts. It's brief, with plenty of photos. I love the photos that bring back memories so I can reminisce more about how this city has grown and developed to attract residents and businesses.

As a police officer on patrol, then as Naperville's mayor for twenty years and now in retirement, my passion always has been to put smiles on people's faces and to show them that we care about them in Naperville. We celebrate culture, books, history and philanthropy here as often as we can through our special events.

Bryan's latest history book shares how this city's growth, planning and spirit of generosity took root starting back before Joseph Naper settled here. When I came to the last section, I got to thinking that this book, like no other, also takes us on a journey that follows my time in Naperville from 1940 all the way to the present.

Bryan's account of our city's rich history is from the heart. I hope you enjoy it, too.

—A. George Pradel, *Mayor Emeritus*
May 4, 2018
Fortieth mayor of Naperville (1995–2015)

In Memoriam

A. George Pradel

September 5, 1937–September 4, 2018

ACKNOWLEDGEMENTS

L ike children, books do not appear mysteriously out of the sky. I was asked to assist in the writing of a book of Naperville history by an anonymous author who later gave me this project. I would not have been able to complete this work had it not been for the help and support of so many people. In no particular order and for assistance rendered me in many ways, I acknowledge with gratitude Peggy Curran of the Naperville Public Library, Roberta Fairburn of the Abraham Lincoln Presidential Library, Dana Tieman of the Wheaton Public Library, Marianne Lisson Kuhn, Stephanie Penick, Tim Ory, Andrew Siedelmann of Kramer Photography, Tom Majewski, Paul Hinterlong, Jo Lundeen of Photos by Jo, Don and Bari (Otterpohl) Landorf, Marion Rickert, Robert Shuster, Doris Wood, Don Johnson, Mary Anne Brock, Carolyn Lauing-Finzer, Russ Breitwieser, Caryn Ferraro, Michael Mantucca of Mantucca Photography, Barb Hower, Charlie Wilkins and Robert Brennan.

A book of this scope could not be written without much research and knowing the community. I have been given the good fortune to have developed so many friendships with Naperville families who have graciously and eagerly shared their treasured stories with me. As a historian and educator, I am blessed with the talent and patience for seeking facts among the records, whether catalogued or forgotten. I am indebted to all the historians and authors before me who left a record of our past. Thank you, Naperville, for giving me a home in your heart.

This small volume is humbly dedicated to the memories of Sue Degges and Paul Rickert, Fox Valley Genealogical Society volunteers whose skills, kindness and friendship helped me learn, appreciate and love Naperville history.

INTRODUCTION

W e are all transplants. In Fredenhagen Park, there is a small grove of seven sugar maple trees planted at the east end of the covered bridge behind the vintage Burger King building. The trees were "transplanted in celebration of the good life [seven men and their families] found in Naperville." A commemorative plaque lists the names and dates the men and their families moved to Naperville. These trees, like the many families who have called Naperville "home" over the last 187 years, have deep roots in our community. The seasons bring about growth and change, times of plenty and times of drought. The trees grow up and out and bear fruit. Though the trunks of family trees may die, the fruit they bore flourishes in Naperville and other communities around the world.

Whether your family tree was planted in Naperville in the mid-nineteenth century or just last week, you are part of a community that is both common and comfortable as well as unique and unusual. This short history of the community you live in, or have lived in, or want to live in, is for you. This brief narrative will explain when things happened and the impact those events or people had on Naperville and the world.

This book is long overdue. The last comprehensive Naperville history, called *A View of Historic Naperville from the Skylines*, was published in 1975 by Genevieve Towsley and the *Naperville Sun* newspaper. *Historic Naperville* is a compilation of twenty-seven years of Towsley's newspaper columns and is a wonderful base for anyone wishing to learn more about Naperville. I always consult Towsley first.

Since 1975, a few books have been published about specific Naperville topics or locations but never a complete narrative of the events and people that shaped Naperville history. For the first time in nearly fifty years, a noticeable gap in the Naperville timeline from the 1930s to the present is filled. This book is a free-flowing narrative and not encyclopedic by design. Endnotes and a bibliography provide the reader with opportunities for further exploration of the Naperville community. I refer readers to the volumes written before *Naperville: A Brief History* that contain much lengthier descriptions of the events and people of Naperville's past. In addition, I have selected imagery that I think best illustrates the latter half of the twentieth century to the present. Hopefully, this book will spark conversations that start with "I didn't know that" or "So that is why" or "Did you know…?"

The Naperville of today is the fruit of seeds planted on the prairie many years ago. Those seeds were cultivated and watered by the men and women who made Naperville their home. The Naperville of tomorrow will be the trees we have been trusted to care for and preserve and the grafts and seeds of change and progress we cultivate now. May our community continue to prosper in the garden of Naperville.

Chapter 1

A PRAIRIE IS SHAPED BY MANY FORCES

A prairie…is shaped by many forces: by fire, water and wind; by Indians and buffaloes; most of all, by the ratio between rainfall and evaporation; and by occasional periods of extreme drought. A prairie is vanquished by two forces: domestic grazing animals and the plow.
—*May Theilgaard Watts, 1957*

In 1951, Naperville resident, teacher and botanist May Theilgaard Watts and her family visited the seventy-fifth annual Wheatland Plowing Match on a farm south of Naperville. It was their annual tradition to see the farmers gather to compete, show off their old-time machinery and enjoy the stories, crafts and food with farming families. A new granite monument had been placed by the Wheatland Plowing Match Association to commemorate Wheatland pioneers and the first plowing match held on the farm of Alexander Brown in 1877. Watts was in search of true, original Illinois prairie.[1]

Imagine, however, before the endless expanse of prairie grasses and flowers a land covered in ice—ice that was over a mile thick. Like slow-moving bulldozers, the various sheets of ice that pressed south over the continent of North America scraped, ground and pulverized mineral-rich rocks into fine, fertile soil. As the ice thawed and refroze over many tens of thousands of years, an aggregate of soils, clays and rocks was left behind. In addition, mounds, ridges, freshwater lakes and rivers were formed by the melting ice and runoff. This is the skeleton and base that formed the northern Illinois

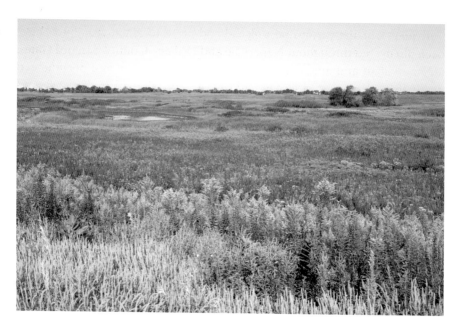

Springbrook Forest Preserve, a slice of northern Illinois prairie. *Courtesy of Positively Naperville.*

prairie. It was these material features that incubated a variety of flora and attracted fauna and, eventually, the human hunters and gatherers.

The first human inhabitants of what we call Naperville have been categorized as the Paleolithic or Stone Age people. During this time, roughly 12000 to 8000 BC, these nomadic hunters followed the herds of large animals and seasons of ripening grains and berries. Crude Stone Age tools such as arrowheads, scrapers and mallet heads have been found around Naperville. These tools can be distinguished from the artifacts of the Archaic (8000 to 5000 BC), Woodland (500 BC to AD 1000) and Mississippian (AD 1000 to 1673) cultures that followed the Paleolithic period. Arrowheads, knives and spear points during the later time periods were made with a higher level of skill and ability. In addition to the hunting and agricultural tools, ceremonial and religious objects such as pipes, animal totems and charms were also crafted by Archaic, Woodland and Mississippian cultures. Around 500 BC at the beginning of the Woodland era, large tribes had formed their own language groups; semi-permanent, seasonal villages; and hunting territories. By the mid-1600s, a loose confederation of tribes, including the Peoria, Kaskaskia, Tamaroa and Michigamia, hunted and lived in an area encompassing all of Illinois and slivers of Arkansas, Missouri, Iowa and Wisconsin.[2]

Evidence of the various post-glacial and prehistoric native cultures have been discovered throughout Naperville and DuPage County. Sanford Gates, a Napervillian and amateur archaeologist, collected data and documented nearly three dozen native sites in DuPage County. His work in the 1950s and 1960s was a direct result of the increase in suburban sprawl and his boyhood interest in Native American culture. Gates published articles in the *Chicago Area Archaeology* journal and lectured. He went arrowhead hunting with local farmers, including Frank Keller Sr., on whose farm Gates found evidence of every native group to have lived and hunted in the Naperville area since the glaciers receded. Gates's maps and notes were among the first attempts to record and preserve the history of the area before white settlement.[3]

The Historic period of native tribes in the area of Naperville (AD 1673 to 1855) starts with the voyage of discovery and writings of the French explorer Louis Jolliet and missionary Père Jacques Marquette and ends with the 1855 DuPage County census, in which one "Indian Boy" was counted in the township of Naperville living in the household of William Strong.

Marquette and Jolliet were the first white men to explore the Illinois country and learned that the natives called themselves *Illini or Illiniwek*, meaning "real or original ones" living in the land where "the Creator placed them anciently." The French called our land—the river bisecting the land and the lake at its northeastern tip—Illinois. The Illini guided Marquette and Jolliet across the Chicago Portage, which connected the Lake of the Illinois (now Lake Michigan and the other Great Lakes, the St. Lawrence Seaway and the Atlantic Ocean) with the Illinois River (and also the Mississippi River and the Gulf of Mexico). A portage is a location between waters where canoes or boats were conveyed from one water source to another over land. The Chicago Portage was located between the south branch of the Chicago River and the Des Plaines River. Father Marquette wrote of the Illinois River and the portage:

> *We have seen nothing like this river that we enter, as regards its fertility of soil, its prairies and woods....In the spring and during part of the summer there is only one portage of half a league* [one and a half miles].... *One of the chiefs of this nation, with his young men, escorted us to the Lake of the Illinois.*[4]

Jolliet lost his maps and notes when his canoe capsized, but in 1674, he dictated his travels to Father Claude Dablon. Jolliet said, "At first, when we were told of these treeless lands, I imagined that it was a country ravaged by

Map showing DuPage County Indian sites. *Redrawn by the author from original map by Mark Ravansei for DuPage County Roots.*

fire, where the soil was so poor that it could produce nothing. But we have certainly observed the country; and no better soil can be found, either for corn, for vines, or for any other fruit whatever." Jolliet added that if a settler did not have oxen to plow the land, he could "use those of this country… possessed by the Western Savages, on which they ride, as we do horses [referring to buffaloes]." In 1683, Father Louis Hennepin wrote about the buffalo hunts in the Kankakee River valley that he observed:

These animals are…in great numbers there, as it is easy to judge by the bones, the horns and skulls that we saw on all sides. The Miamis hunt them at the end of autumn in the following manner: When they see a herd, they gather in great numbers, and set fire to the grass everywhere around these animals, except some passage which they leave on purpose, and where they take post with their bows and arrows.…These Indians, who sometimes kill as many as a hundred and twenty in a day, all which they distribute according to the wants of the families.[5]

The buffalo was very important for both sustenance and spirituality to the northern Illinois tribes, particularly the Sauk and the Fox. Ted Belue writes in his book *The Long Hunt*:

[Buffalo] *herds numbered into the hundreds and were a dependable winter food, making the Sauk and the Fox perhaps the most buffalo-dependent Indians in the East* [of Mississippi].…*Within Caddoan, Creek, Shawnee, Fox, Potawatomi, Winnebago, and other Algonquin and Siouan societies were totemic buffalo clans with buffalo rituals.*[6]

The last recorded buffalo in Illinois was shot around 1808, ending a way of life and livelihood for many native tribes.

During the Historic era, native tribes of Illinois came to depend on the Europeans. Furs were traded for guns, cookware and beads. A French trapper by the name of DuPazhe was located in Will County near the conjunction of the east and west branches of a river and a county that would later bear his name. Native Americans called this land Ausagaunaskee or Tall Grass Valley. Employees and traders with John Jacob Astor's American Fur Company, Jean Baptiste Beaubien (came to Chicago in 1804) and Gurdon Hubbard (came to Chicago in 1818), recalled the "old French trapper" DuPazhe but did not know anything else about the man. Perhaps by a typographical error, the name DuPazhe is now known and written as DuPage. Though most tribes remained traditional and semi-nomadic, some adopted Christianity, developed a written language and dressed in European clothing. The French and the Illini lived peaceably for many years before the advent of the Seven Years' War in Europe (1756–63). This global conflict between colonial powers Great Britain and France was also called the French and Indian War (who were fighting the British in the New World). France lost both its authority and territory in North America at the conclusion of this war by the Treaty of Paris in 1763. Having lost their ally France, the

Left: Arrowheads collected over many generations from one Naperville family farm. *Photographed by the author with permission from the family of Edward C. Otterpohl/Bari Otterpohl Landorf.*

Right: Scratchboard drawing of "the old Frenchman" Du Pazhe, or DuPage. *Image drawn by Catherine O'Brien or Mildred Waltrip for the* DuPage County Guide.

Illini, who could not make peace with British rule, supported the Americans during the Revolutionary War. The loyalties of an emerging new tribe in northern Illinois, the Potawatomi, were split, however. The Potawatomi warriors from Michigan and Indiana "generally supported the British, while those residing in Illinois and Wisconsin favored the Americans." During the American Revolution, Virginian George Rogers Clark led an expeditionary force into the Illinois country to eliminate British and pro-British allies from the lands west of the Appalachian Mountains. The Illinois Campaign of 1778 and 1779 was the only American Revolutionary War struggle fought on Illinois soil. Clark wrote an impassioned letter of support and permission to Virginia governor Patrick Henry:

> *I shall be obliged to give up the country to* [British lieutenant governor Henry] *Hamilton, unless there is a turn of fortune in my favor, I am resolved to take advantage of this present situation and risk the whole in a single battle....I know the case desperate; but sir, we must either quit the*

[Illinois] *country or attack.....No time is to be lost....Great things have been effected by a few men well conducted....We have this consolation, that our cause is just, and that our country will be grateful....If we fail, the Illinois as well as Kentucky, I believe, is lost.*[7]

With a small force, Clark was able to subdue key British forts in the lands northwest of the Ohio River and east of the Mississippi River, thus securing Illinois for the newly independent American confederation. The closest siege to Naperville was the Battle of Sackville, located 260 miles south along the banks of the Wabash River in what is now Vincennes, Indiana. Prior to the development of a port at Fort Dearborn, Vincennes was a major gateway and supplier to travelers to and through Illinois.

Ostensibly free of a French presence, and now, after American victory over Britain, the Treaty of Paris in 1783 guaranteed the newly created America dominion over what is called the Northwest Territory. To govern this vast, sparsely populated land, a series of laws was enacted. The Ordinance of 1787 (a modification of Thomas Jefferson's Land Ordinance of 1784) is considered one of the most important pieces of legislation enacted by the infant Congress of the Confederation of the United States (1781–89). Two years later, after the creation of our current Constitution and congressional system, the ordinance was reaffirmed, strengthened and called the Northwest Ordinance of 1789. This legislation, among other things, allowed settlers the right to form their own civil government and geographic states and the prohibition of slavery. The Land Ordinance stated that all the western territory would be partitioned "into townships of six miles square" and also auctioned off large parcels of land for at least one dollar per acre. Passage of the ordinance sent hundreds of surveyors into the wilderness to scientifically map and grid the land for quick and easy sales. Land offices for Illinois claims were located in major East Coast cities as well as Marietta, Ohio; Vincennes, Indiana; and Kaskaskia, Illinois. From 1787 to the creation of the Indiana Territory in 1800, the settlers in the land of present-day Illinois were organized and governed loosely by a series of territorial governors from as far away as Marietta. The Illinois Territory (present-day Illinois, Wisconsin and parts of Minnesota and Michigan) was separated from the Indiana Territory in 1809. Ninian Edwards was the only territorial governor. The capital was located in Kaskaskia.

With Americans now crossing the Ohio River seeking land and opportunity, a new conflict arose. Though sparsely populated, the Northwest Territory was not devoid of inhabitants. Native Americans who once allied

themselves with the new republic now found themselves and their way of life threatened by land-seeking Americans. Almost immediately after winning independence from Britain, the United States began a campaign against the indigenous peoples living in the Northwest Territory, specifically the land we call Ohio. During Little Turtle's War or the Ohio War (1785–95), Native American tribes throughout the Northwest territories formed a confederation (supplied in part by the British government) for defense against American intrusions and abuses. The war was a massacre of casualties on both sides. There were many hundreds of deaths of American soldiers and native warriors. No battles were fought in Illinois; however, Wayne Township in DuPage County was named after one of the main protagonists, U.S. general "Mad" Anthony Wayne. The war concluded after the bloody Battle of Fallen Timbers (1794) and the resulting Treaty of Greenville (Ohio) in 1795. The future of Naperville was directly impacted by a small portion in the Treaty of Greenville. Per the treaty, six square miles around the mouth of the Chicago River was granted to the United States. Fort Dearborn was established in 1803 at this location.

That same year, the United States bought the Louisiana Purchase from cash-strapped Napoleonic France, which only three years earlier had secured the 828,000-acre territory west of the Mississippi River from Spain by the Third Treaty of San Ildefonso. James E. Davis in his book *Frontier Illinois* writes:

> *The* [Louisiana] *Purchase lifted Illinois from the country's western fringes and placed it nearer the geographic center. Illinois was no longer a marginal region adjacent to European-held territory. Frontier lands now lay westward. Soon Illinois became a staging point, a jumping off place for explorers, trappers, and settlers crossing the Mississippi.*[8]

Trails once traversed by buffalo and Illini were now used ever increasingly by settlers and speculators whose glowing reviews of the tall-grass prairie enticed future landowners. The adventures of Meriwether Lewis and William Clark, the younger brother of George Rogers Clark, were published in 1814 and highlighted their expedition and exploration of the Louisiana Purchase, which launched in 1804 from Wood River, Illinois. Newspapers, books and pamphlets were printed and reprinted in the crowded cities of New England, southern Atlantic states and Europe extolling the wonders of Illinois. Perhaps the most famous guides were written by Englishman Morris Birkbeck. His *Notes on a Journey in America from the Coast of Virginia to the Territory*

of Illinois (1817) and *Letters from Illinois* (1818) were printed in several editions and translated into German, Swedish and French. "After viewing several beautiful prairies," Birkbeck wrote upon first entering Illinois, "so beautiful with their surrounding woods as to seem like the creation of fancy, gardens of delight in a dreary wilderness." Not all reviews were glowing. R. Carlyle Buley in his well-researched volumes *The Old Northwest* surmises:

> *Upon entering Illinois the traveler left behind all the refinements of civilization. It was beautiful country, but the inhabitants, with some exceptions, were semi-Indian in character, ruder and less civilized. They look with disfavor upon the land hunter, forgetting that many of their own class were intruding on Indian lands or squatting on government domain.... Cabins were of rough bark logs, frequently without floors or chimneys, with only holes in the roofs for smoke....A few pots and pans, some old rifles, perhaps a fiddle, constituted the furnishings and utensils.*[9]

However, an anonymous author only identified as "A Friend of Humanity" writes prophetically in *The Evening Post* (New York) on January 27, 1820, "The state of Illinois is undoubtedly destined to rank among the greatest agricultural states in the Union....The soil is so rich, that it is only necessary to break up the ground, fence it and put in the seed, and you will have a crop at your hand."

The agricultural potential and the abundance of animal pelts were too dear a prize to be lost forever. The British, with the help of their Native American allies, made one last attempt to wrest their former New World colonies and the Northwest Territory from the United States during the War of 1812. Shortly after the war with Britain was approved by Congress, U.S. Fort Mackinac, 333 miles north of Fort Dearborn, was taken by the British in July 1812. This fort, located in the narrows between Lake Huron and Lake Michigan, was a strategic defense and important supply trading post. With the fall of Mackinac, Fort Dearborn would lose valuable supplies and might be vulnerable to attack. U.S. commander William Hull ordered Captain Nathan Heald to burn Fort Dearborn and withdraw to Fort Wayne in Indiana Territory. Heald was to destroy the guns and ammunition and provide any surplus food and supplies to the Miami tribe, who would escort the troops, women and children to safety.

The Battle of Fort Dearborn on August 15, 1812, that followed the evacuation of the fort took place just a mile and a half south of the mouth of the Chicago River near the present intersection of Eighteenth Street

and Prairie Avenue in Chicago. One-time American allies, Potawatomi descended on the refugees, killing fifty-two women, children and soldiers. The forty-one survivors were carried off and later ransomed. Black Partridge, a sympathetic Potawatomi chief from Peoria, and his brother Waubonsie warned Heald of the raid and assisted with the rescue of victims during and after the massacre. Fort Dearborn was burned to the ground. The horrors of this battle, often called the Fort Dearborn Massacre, did much to stay the tide of American migration to northern Illinois. The War of 1812 ended with the Treaty of Ghent in 1815, and Fort Dearborn was rebuilt in 1816.[10]

Through a series of treaties, tribal lands were predominantly located in northern Illinois when Illinois became the twenty-first state in 1818. The treaties of 1829 and 1830 with both the Sauk and Fox tribes gave settlers a false sense of security as they made their way to Illinois by land, lake and canal. The Erie Canal across the state of New York was completed in 1825, creating a navigable waterway between the American East Coast and the Great Lakes. "Canal fever" in the 1820s was not unlike the high-speed railroad debates of today. The State of Illinois approved a canal commission in 1825 to connect Lake Michigan and the Illinois River, but it took an act of Congress in 1827 for permission (and land) from the government to begin the projected canal. Although Missouri senator David Barton gave a winded speech against the federal government funding state projects, especially internal improvements, he did highlight the importance of the canals. This excerpt is taken from one of his speeches reprinted in the *Vermont Courier* (Woodstock), on October 2, 1830: "[The "Erie Canal] united the bay of New York with the chain of northern lakes; and the Michigan and Illinois Canal [will complete] the circle of navigation almost around the whole Union. These works are but segments of the circle, still national in their benefits."

The benefits were real to settlers and speculators who purchased lands along the canal, often sight unseen. Chicago lots in 1830 sold at exorbitant prices ranging from $24 to $135. Sailors from ports throughout the Great Lakes must have noted the incredible potential of Chicago and the region as they delivered such large numbers of supplies and settlers to Fort Dearborn. A curious thirty-two-year-old sailor from Ohio looked beyond the growing port of Chicago where a vast prairie beckoned.

Chapter 2

BEHOLD THE
AMERICAN PIONEER

Behold [the American pioneer], *as he turns his face to the West, his gun on his shoulder, his dog by his side, his horses harnessed to the wagon that contains his household goods, his wife and babies, behind which follow at a slow pace his cattle, driven by his young sons.... This is the true pioneer. His step is firm; his glance is keen; his whole appearance commands respect, though his garments may be of the coarsest stuff. To him belongs a singular fame, for he is the first to lay the dimension stone of a social fabric which is to grow up where he plants the seed, and become a lasting monument to perpetuate his memory.*
—Rufus Blanchard, 1882

Before men, women and children arrived in the area we call Naperville, brave, forward-thinking men wandered about the timbers and prairies of northern Illinois seeking their slice of the American pie. Maryland native Stephen Scott and his family are credited as the first of many New England settlers to take root along the DuPage River. Scott was a sailor along the East Coast of the young United States. He married Hadassah Trask in Connecticut but removed to New York, where his son Willard was born in 1808. The Scotts were en route to Fort Dearborn in 1826 when they became the unexpected first settlers of Gross Point, now Evanston, Illinois. The captain of the schooner *Sheldon* accused Scott of paying for the passage in counterfeit coin and put the family to shore. We may never know if the money was counterfeit. Undaunted, Scott built a house and raised his family, earning him the title as first homesteader of Evanston. In 1829, during a

hunting trip in what would become Kendall County, Scott's son, Willard, met and married Caroline Hawley, the daughter of Holderman's Grove pioneer Pierce Hawley. Willard described his wedding night: "We had the sky for our ceiling—the stars for our lights—the trees for our shelter and the ground for our bed."[11]

In August 1830, Stephen Scott and his family, including the newlyweds Willard and Caroline, left Gross Point for a claim at the place where the east and west branches of the DuPage River meet, called "The Forks." The Scotts were joined by Isaac Blodgett, Pierce Hawley, Robert Strong, Reverend Isaac Scarrett, Captain Harry Boardman and Isaac Stockwell and their families. Cumulatively, these families were known as the Scott Settlement in what would become Will County.

By all accounts, the Scott Settlement had the promise of becoming permanent, what with its own blacksmith (Blodgett), minister (Scarrett) and a hardy stock of families. Early Cook County voting records indicate that the settlement was known as "Scott's Precinct," which served as the earliest form of local government. Scottsville, Scottston or Scottsburg were not destined to be part of the map of Illinois. In 1838, the Scotts would move to Naper's settlement, where they would remain.

The honor of being the first pioneer in what would become DuPage County goes to Bailey Hobson. Hobson's parents were Quakers and millwrights from North Carolina. They migrated a great deal across the states of North Carolina, Georgia and Tennessee before settling in Indiana. Bailey Hobson was born in Tennessee. While in Orange County, Indiana, he met the woman who would become his wife, Georgia native Clarissa Stewart. When Hobson was in his twenties, he and his bride decided to leave the Quakers and the heavy timbered regions of Indiana to till the prairie of Illinois.

Before settling along the DuPage River in Lisle Township, the Hobsons were in Newark, Illinois. It was near Newark in the early part of March, while establishing their claim on the DuPage River, that more "than 100 Indians had just encamped hard by [the Hobson] house for the purpose of making maple sugar in an adjacent grove, and [Clarissa Hobson] dare not stay with her five children alone in their midst." Clarissa did what pioneer women had to do—she gathered up the five children, two horses and fourteen head of cattle and braved the crossing of rivers and swamps to seek safety in a distant grove of trees.[12]

By the end of March 1831, the Hobson family had moved into the log cabin that Bailey and his brother-in-law, Lewis Stewart, built. The Hobson

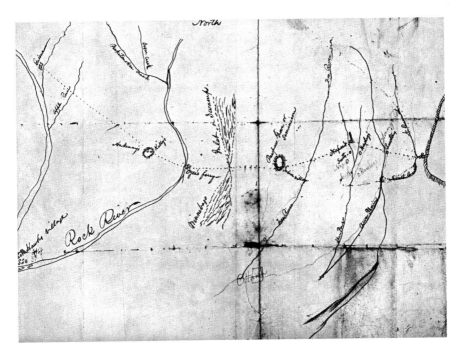

Copy of map showing Naper's settlement and northern Illinois in 1832. Original map in the National Archives, Black Hawk War Collection. *Author's collection.*

log cabin was a crude structure with a split-log floor and no windows, which, according to one source, "was the smallest of their grievances, for the unchinked crevices between the logs let light in enough."[13] This cabin was located on a rise just east of the DuPage River behind the current Hobson House, today marked with a memorial boulder on Hobson Road. It was in the middle of nearly five hundred acres of the land Bailey claimed. The following month, Christopher Paine and his family struck a claim near Hobson, which was fortunate for both Hobson and later Naper because Paine was a skilled carpenter and millwright.

Before Vermont native Joseph Naper took root in northern Illinois, he sailed the northern fringes of the Northwest Territory on the lakes of Erie, Huron and Michigan. He brought goods and passengers to help populate the lands west of the Appalachian Mountains. He was just one of many who offered civilization in a wild land. Born in 1798, his life exemplified the westward motion so typical of American settlement. While in New York, he met and married his wife, Almeda Landon, a native of Connecticut.

It is believed that Joseph's father, Robert Naper, left Vermont to pursue shipbuilding and trade on Lake Erie or the newly chartered Erie Canal.

Joseph's older half brother, Benjamin, served on the Great Lakes under Commodore Perry during the War of 1812. It is possible that the fourteen- or fifteen-year-old Joseph learned to build boats and sail with his brother(s) and father during this time. The earliest record of Joseph Naper sailing the Great Lakes is found in a manifest for the schooner *Traveller.* The manifest records the cargo and owners leaving Mackinac Island for Buffalo on August 1, 1827. Naper is listed as the master or captain of the *Traveller,* which was built in Ashtabula, Ohio, in 1817. There are numerous newspaper entries and port records called enrollments that map Naper's routes on the Great Lakes between 1823 and 1831.[14]

Sailing schooners and piloting steamboats with many tons of cargo and passengers on the often-hazardous waters of the Great Lakes was a hard

A cabinet card of Joseph Naper. Image by Magnus Carlson from a daguerreotype owned by Charles Austin Naper. *Courtesy of the Abraham Lincoln Presidential Library and Museum (ALPLM).*

way to make a living. It is no wonder that Naper and others like him left the lakes for affordable land and a lasting legacy. Men followed Naper to Illinois because they trusted him. In 1829, Joseph and his brother John, perhaps also with their father and half brother Benjamin, built their last ship together at Ashtabula, Ohio. They named the two-mast, twenty-two-ton schooner *Telegraph,* Greek for "distant word." In the July 1, 1829 issue of the *Cleveland* (Ohio) *Weekly Herald,* John Naper introduces the *Telegraph* to travelers and merchants:

> *The new and very fast sailing schooner TELEGRAPH, will leave this place for St. Joseph's, wind and weather permitting, the first week in next month; and will receive freight and passengers at the principal ports on her way, at the most reasonable and reduced rate. Her accommodations need only be examined, to give general and complete satisfaction. John Naper, Master.*[15]

In February 1831, perhaps between sailing ventures, Joseph Naper made a survey of the land along the west branch of the DuPage River for Cook

County. Three miles south of current Naperville was the Scott Settlement. Willard Scott's wife, Caroline, and Joseph Naper's mother, Sarah, were both from the Hawley family. The genealogical connection between the two women is not known, but it is presumed that Naper had a close relationship with the Scott family. Naper must have been educated in geology enough to recognize the natural, raw resources that the west branch of the DuPage River had to offer. The river was not navigable for trade, but it could be dammed to power gristmills and sawmills. The large woods to the north and west would provide plenty of lumber to build fences, homes and businesses. There were large deposits of limestone and clay to build sturdy foundations, and the vast prairies to the south would soon prove fertile for agriculture. On March 3, 1831, Joseph Naper was given a license to sell merchandise to the Potawatomi and settlers in Cook County by the Cook County commissioners. This license indicates that Naper was prepared to return to the region and establish a permanent settlement. Naper hired men from Chicago to build a log cabin and drew up a contract with Stephen or Willard Scott to prepare ten acres of cleared land for the future arrival of Naper's colonists.[16]

One record of the Naper settlers was preserved by the son of Dexter Graves, a Chicago pioneer from Ashtabula, Ohio, who was among the passengers on the last Naper-captained voyage of the *Telegraph*. Henry Graves commissioned a monument for the Graves family in Graceland Cemetery, Chicago. The plaque on the back of the monument reads:

Erected by Henry Graves
Son of Dexter Graves, one of the pioneers of Chicago
Dexter Graves brought the first colony to Chicago
Consisting of thirteen families arriving here July 15, 1831
From Ashtabula, Ohio on the schooner Telegraph
And father and son remained citizens of Chicago till their death[17]

Not all of the thirteen families who sailed with the Napers on the *Telegraph* followed Naper to his log cabin and ten acres of cleared land. Some, like the Graveses and Phillip F.W. Peck, stayed in Chicago. Peck, a young merchant and business partner with Naper from New York, was so unsettled by news of Indian troubles in the West that he traded his interest in the Naper trading post for Naper's three Chicago lots. Some of the passengers went north of Naper's settlement, while some went south to the Scott Settlement.[18]

The Naper colony had arrived at the DuPage River area in the summer of 1831, too late to plant staple grains. Fast-growing buckwheat and

rutabagas were sown in July and provided some sustenance by autumn. Christopher Paine used logs, stones and straw to build the Naper milldam near the present location at the foot of Mill Street. Supplies ran low as brutal winter temperatures and heavy snows killed wild game such as deer, wild boar, prairie chickens and turkeys. The closest gristmill for grinding the small stores of grain was a tortuous fifty-mile oxen ride south to Ottawa. The snow was reported to be four feet deep, and the "cold was intense from November till April, with but little cessation." Clarissa Hobson called the winter of 1831 a famine. The DuPage County history written in 1857 said John Naper, John Murray and R.M. Sweet went to the "Wabash," or Vincennes, for supplies. Vincennes, Indiana, on the Wabash River, is 280 miles south of Naper's settlement. In 1831, Fort Dearborn was in its infancy, and supplies would have been more plentiful in the older and well-established trading post at Vincennes. In addition, Hubbard's Trace, the first official Illinois road, had trading posts every 50 miles between Fort Dearborn and Vincennes.[19]

In September 1831, well before the snows, John Murray, the brother-in-law of John and Joseph Naper, drew up a contract for a school to commence in November. A windowless, floorless log cabin was built at the southeast corner of Ewing Street and Jefferson Avenue for the twenty-two "scholars," who only had planks attached to the walls for desks. Lester Peet was contracted to teach English, spelling, writing, arithmetic and "English grammar, if required," for the princely sum of twelve dollars per month. The superintendents were Joseph Naper, Christopher Paine and Bailey Hobson.

By the spring of 1832, Naper's settlement had grown to 180 people living in what must be imagined as primitive huts or log structures nestled in groves of oak and walnut trees. According to various histories of DuPage County, there were said to be five log cabins "on the high ground" of Naperville (roughly Jefferson Avenue from Ewing Street to Court Place), plus three on the south and east banks of the river and at least a dozen more within a two-mile radius of downtown Naperville.[20] These log cabins were generally sixteen feet square, having one or no windows, a loft and a dirt or split-log floor. It was not uncommon for an extended family of eight or more members to share this space. In extreme cases, two or three families might share a cabin while other shelters were built. The loft was used to store grain, and the children slept there. The elders usually occupied the bed across from the hearth, and a trapdoor might lead to a shallow dugout to store food or hide from hostile tribes.

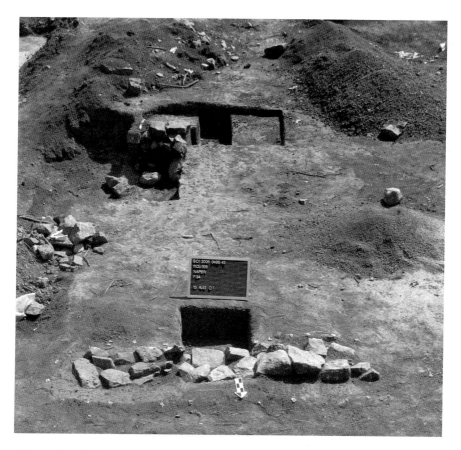

Chimney foundation and cellar excavation of Joseph and Almeda Naper's log cabin.
Photographed by the author.

Evidence from archaeological digs conducted in 2006 and 2007 indicates that the Naper cabin was a double. The east side, used by the family, was separated from the west side, used as the trading post, by a dogtrot, or breezeway. Trade at Naper's post must have been brisk. Articles that fell through the floor and were found 175 years later include large copper cents, ceramics and stoneware vessels, iron and copper hardware, unused sparking flints of both French and English origin used for firing guns and starting fires, straight pins, lead shot in various sizes and glass bottles/fragments. The most significant artifacts found were the glass trade beads in different sizes, shapes and colors, used to trade furs and provisions with friendly Potawatomi.[21]

The log cabins of Naper's settlement were built as temporary structures since the Naper brothers brought the materials to build and operate a sawmill

that would eventually provide the planks and boards for more permanent structures. The large, old-growth forests of oak, locust and elm would provide an excellent lumber source to the growing community. Although skilled shipbuilders, the Napers needed additional craftsmen to help build their town. Joseph sent word to Captain John Stevens, a fellow Vermont native whom the Napers might have also sailed with on the Great Lakes. Stevens, an experienced carpenter, was also a sailor, farmer, hotelkeeper and millwright.

Stevens and his sons-in-law, Josiah Giddings and William Barber, agreed to come to Naper's settlement in May 1832 before word of the impeding Black Hawk War had reached Vermont. After a six-week journey on steamboats, canalboats and ships on the Great Lakes, the Stevens party arrived in Chicago in July in the middle of the Black Hawk War. Undaunted, John Stevens, Paine and the Napers completed the dam and the sawmill, the first on the DuPage River. Paine also helped to fashion grist stones for grinding grain at the Naper site. It was ox driven and relied on the ox or the team that brought the grain to power the wheel to grind it to flour.

Panic hit the settlements along the DuPage River with the news of four hundred to five hundred Sauk warriors and their families crossing the Mississippi River on April 6, 1832, to "make corn" on their ancestral land in northern Illinois.[22] The raids on the homes of Kendall County pioneers Cunningham and Hollenbeck on the Fox River were particularly chilling to the settlers on the DuPage River. By April 14, Illinois governor John Reynolds had called the state militia to order. After receiving news of Major Isaiah Stillman's confrontation and defeat by the Sauk warriors on the Rock River above Dixon, Illinois, and a warning from Shabbona, a chief of the Potawatomi, the women and children of Naper's settlement fled to Fort Dearborn while the men organized a local militia. On May 24, a letter was sent to Colonel James Stewart, the Indian agent in St. Joseph, Michigan, on behalf of the "Chicago Residents" at Fort Dearborn asking for assistance. Joseph Naper's name is among the nine prominent men representing the "Residents and refugees." The same day, Captain Harry Boardman of the Scott Settlement was given command of fifty-five men, including the Napers, from the settlements along the DuPage River. This company was disbanded after fourteen days. Joseph Naper later took command of his own company of thirty-six settlers and served from July 19 to August 15, 1832.[23]

Between April 7 and July 19, many of the Naper pioneers of the DuPage River risked returning to their claims. Their fears were somewhat resolved

by the arrival of General Winfield Scott and the United States Army at Fort Dearborn. Part of Scott's strategy was to build or strengthen a series of forts between Chicago and Galena, Illinois. To that end, he ordered Brigadier General Henry Atkinson to build a fort at Naper's settlement. The order was sent on June 7, 1832, from Ottawa, Illinois, to the newly detached company of Danville, Illinois troops, commanded by Captain Morgan L. Payne. Payne's company of men and Naper's settlers built a two-block palisade fort on the high ground just east of current downtown Naperville where Ellsworth Street and Chicago Avenue meet. The fort was called Fort

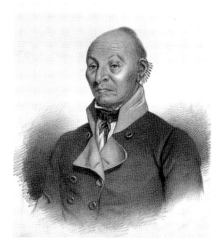

Mac-cut-i-mish-e-ca-cu-cac, or Black Hawk, a celebrated Sauk chief. Lehman & Duval, lithographers, after a painting by James O. Lewis. *Library of Congress.*

Payne, and though sturdily built, it was never used to defend against attacks from the Sauk or Fox. The single local casualty of the Black Hawk War in or around Naperville was one of Captain Payne's men, William Brown. He and another soldier had gone to a grove to collect wood for shingles for the blockhouses when they were ambushed on June 16, 1832.[24]

The death of Brown near Naper's settlement created alarm in the ports of the Great Lakes. By the time the news had arrived in Chicago and dispatches sent by ships, it had morphed into heroic propaganda with unfounded speculation of Joseph Naper's murder. The *Cleveland Advertiser* on June 20, 1832, reads:

DREADFUL INDIAN MASSACRE!!! The Steam-boat Niagara, *arrived here this morning, (Thursday) brings intelligence that expresses had arrived at Detroit, and stating that Captain Joseph Naper, well known in this section of country, had been massacred with all his family, consisting of his wife, wife's sister and four children, near Fort Chicago. Naper, who was a bold, daring man, had been in the Fort sometime; when believing that the people were more scared than hurt, and betaken himself to his log cabin again. NINE of the Indians were found dead near his house, who unquestionably fell before his intrepid arm.*[25]

Similar false reports about Naper's death were published in newspapers across Illinois, Ohio and Pennsylvania. One notice was translated into German. The *Sangamo Journal* of Springfield, Illinois, printed the following on August 11, 1832: "We have often been amused with the fictions relating to the Indian war, which have been published in the eastern papers....We have no doubt that the captain would have despatched any reasonable number in such a contest: but the story is pure romance."[26]

The Great Council or Treaty of Chicago on September 26, 1833, removed the remaining Sauk, Fox and Potawatomi tribes from Illinois altogether. Word of the end of Native American hostilities undoubtedly encouraged George Martin, a grain merchant from Edinburgh, Scotland, to immigrate to Naperville in 1833. In November 1833, George wrote to relatives in Scotland:

A treaty [with the Native Americans] *which has long been spoken of, has taken place at Chicago—about three weeks ago.... We will be well quit of them* [Sauk and Fox tribes]....[The Potawatomi were] *very useful in the last war, informing how the Sacs* [Sauks] *were going to be on* [?] *and saved many a family.*[27]

George Martin married Elizabeth "Betsy" Christie, whose relatives had settled in Wheaton, Illinois. They had one son, also named George Martin. Their log cabin was located on the south bank of the DuPage River near current-day Rotary Hill. This same location is marked with a gray granite monument commemorating the first frame house built in DuPage County. A handwritten receipt shows George Martin the elder paid for walnut, oak and elm tree lumber from Naper's mill in November 1833, which is corroborated in the above-mentioned letter that states George had to haul another tree to the Naper mill for more lumber.[28]

While the Naper mill was churning out lumber, the influx of settlers and craftsmen was building homes and businesses in the growing settlement. George Laird, son-in-law of John Stevens, built the first hotel in 1834 on the northeast corner of Main Street and Chicago Avenue. He called the hotel the Pre-Emption House after the laws that governed land claims. The legal concept of "pre-emption" is claiming or purchasing before deeded title based on occupancy and improvement of property. The acts were Congress's attempt to solve the land grab problem. Pioneers like Scott, Hobson and Naper forged a path through the prairies and timbers, valleys and plains on an invisible grid of sections and townships.

First frame house built in DuPage County/Naperville in 1833. Home of Scottish immigrants George and Betsey (Christie) Martin. *Courtesy of Paul Hinterlong.*

Surveyors and government land offices could not keep pace with the flood of settlers into Illinois. "Squatters" and "claim jumpers" often got into bitter and sometimes fatal disagreements over land. Land offices in Chicago and the military stationed at Fort Dearborn were the earliest form of government, law and order. More locally, claim-protecting societies were formed to resolve land disputes between the "squatters" and the bona fide settlers. In fact, the Pre-Emption House served not only to shelter the new immigrants but also as the land office, public hall, church and possibly school.

The first frame schoolhouse was built in 1835 next to the cemetery on the northeast corner of Washington Street and Benton Avenue. Naper platted the first streets in 1835 with patriotic names like Washington and Eagle, as well as names such as Douglas, Van Buren, Benton and Ewing that reflected his personal Jacksonian Democrat political views. Naperville was physically taking shape.

As the town was growing physically, it also grew spiritually and culturally. Naper and others formed a debating and educational society called a lyceum for the "mutual improvement in Science, Learning and Public Speaking… [and] the purpose of intellectual improvement…to facilitate our progress." This group of men met once a week from October through April. They divided into affirmative and negative debate teams and researched a topic to provide an oration for judgment by the elected president. Appeals could be made. The results of the debates were kept in a ledger, which is dated from 1836 to 1842. The lyceum initially met in the home of the elected treasurer, but as public buildings were built, the meetings moved to the schoolhouse and the DuPage County Courthouse. Many of the topics discussed were government, literature, art, law, culture, morality and spirituality.[29]

Spirituality was brought with the settlers in the form of their beliefs and religious books but also by way of circuit preachers, ministers and priests. Many of the New Englanders who came with or followed Naper were Presbyterian and Congregationalist. Jeremiah Porter is considered the first minister to Chicago and Naperville. He founded many congregations throughout northern Illinois. The First Congregational Church of Naperville was one of the first Presbyterian (later Congregational) congregations in the state of Illinois. The original members first met in a grove of trees in 1833.[30] Stephen Beggs, a circuit preacher of the Methodist faith, also preached in Naperville but was a permanent resident of Will County. A Roman Catholic parish was not established in Naperville until 1846, but it is presumed that Catholics might have had visiting priests in Naperville during the 1830s.

U.S. president Andrew Jackson appointed Alexander Howard, a carpenter and merchant, the first Naperville postmaster in 1836. His store was located on Jackson Street, and his home, then on the northeast corner of Jefferson Avenue and Webster Street, was a stage stop and the location of the first post office. News of the world outside the hamlet along the DuPage River came from relatives' letters, passengers and newspapers that arrived at the Howard home as often as the stages ran.

As more settlers arrived, more rooms were needed. Stephen Scott built a hotel on Jefferson Street to shelter the many visitors passing through or staying in Naperville. Scott managed the hotel for eight years before turning his attention to mercantile and banking interests in the rapidly growing village.[31]

The land about Naper's settlement was becoming more populated, and by the laws of the Northwest Ordinance, citizens could petition to become their own self-governing county. Naper was elected by his peers first in 1832

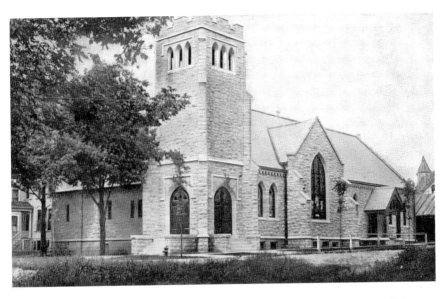

First Congregational Church. This postcard shows the current building of Naperville's oldest congregation, established in 1833. *Courtesy of Paul Hinterlong.*

to serve as Cook County road commissioner and in 1836 to serve in the Illinois General Assembly to represent Cook County, where he would meet Stephen Douglas and Abraham Lincoln. In 1837, Naper voted with Lincoln in favor of the Whig Party's proposal to move the Illinois state capital from Vandalia to Springfield. Naper was reelected to the General Assembly in 1838 and a year later proposed a bill to carve a new county out of Cook County. Lincoln would vote with the Jacksonian Democrats and Naper for the new county. In a very narrow vote, two townships in Will County refused to join DuPage County, which was a bit ironic since most farmers in those townships shopped, worshiped and identified with Naperville. Today, both townships are well within the corporate limits of Naperville.[32]

The Panic of 1837, a national financial crisis that triggered a significant recession until the mid-1840s, was not immediately felt in Naperville, though some of the discussion during lyceum debates did indicate that Napervillians were aware of the impending crisis. Many New England families were encouraged to come to Illinois based on propaganda downplaying "The Panic, which the Bank of England and its Branch, the Bank of the United States, has created in this country, [but] has not…reached the Western States."[33] The town of Naperville seemed to experience exceptional growth during this time, perhaps insulated from the national economic crisis because

of its self-sustaining town-building industry. The town lots and blocks Naper originally surveyed in 1835 were officially registered with DuPage County a year after the passage of President John Tyler's Pre-Emption Act of 1841. These acts were the final say on land sales and claims in DuPage County and paved the way for fast and efficient land sales.[34]

Settlers flocked to the town now being called "Naperville" on maps and in newspapers. The pioneer period was waning as Naper and his sons tore down the sawmill and replaced it with a large, much-needed gristmill in 1842. This was the second water-powered mill on the DuPage, the first being built by Harry Boardman and Bailey Hobson two miles south of Naperville. Naper's own trading post merged with a variety of Chicago-based mercantile operations that also set up their own independent stores to meet the demand of locals and those traveling farther west in pursuit of the American dream.

Chapter 3

ITS VAST RESOURCES ARE IN A STATE OF RAPID DEVELOPMENT

The great region of the North and West…is daily becoming more and more important and interesting. Its vast resources are in a state of rapid development; industry and enterprise, aided by enlightened legislation, are calling forth its energies.… [This land] *was regarded as the outskirts of civilization, it is now…the residence of an active, enterprising and intelligent population. Cities have sprung up as if by magic; agriculture, manufactures and commerce flourish; literature, science and the arts are extending their healthful and invigorating influence throughout the country. Blessed with soil unsurpassed in fertility and a salubrious* [healthy] *climate, and possessing, by means of great rivers and lakes, advantage for trade and commerce, it must, ere the lapse of many years, enjoy all the advantages that can render a country prosperous and a people happy.*
—*J.H. Colton, 1846*

According to the federal census of 1840, there were 476,183 people living in the state of Illinois, a sharp contrast from the 1830 census that tabulated a mere 157,445 people. The majority of this increase is due to shifting populations as opposed to increased birthrates. Of the increase, the majority of people settled specifically in northern Illinois. Emigrant guides like the *Western Tourist* quoted above promoted and guided travelers to "Go West!" and build the nation. Letters from friends and relatives also encouraged settlement. In the mid-1840s, primitive settlements were beginning to resemble the eastern towns and cities that the first pioneers had left only a few years before.[35]

The number of travelers passing through or settling in Naperville in the 1840s and 1850s can only be estimated by the number of stage routes, hotels and businesses established during this time. The oldest and most traveled route through northern Illinois is that of the Chicago Portage, which was likely first traveled by French explorers in 1673. The Chicago Portage is the land connecting Lake Michigan, principally the harbor at Chicago, and Ottawa, the most northern point on the Illinois River that a steamboat could navigate. Louis Jolliet and Father Jacques Marquette were guided through the portage by Native Americans on a trail they called the "high prairie trail" and what others later called "a deep-cut horse path." In the summer of 1831, it was no surprise to Joseph Naper that the newly created Cook County was to commission two properly surveyed and constructed roads through the Chicago Portage, including a portion of the county that would become DuPage County. By 1834, the year the Pre-Emption House hotel was built in Naperville, Dr. John Temple, owner of Chicago's first stagecoach line, was given the first government contract to carry the mails from Chicago to St. Louis. Naperville was at the crossroads of two major roads, one of which went south to Ottawa and the other north and west to Galena. It was on these roads that more than fifty prairie schooners, or wagons, would rest at Naperville every night during fair weather. Accommodations were offered at Naperville inns like the Pre-Emption House (1834–1946) and the Naperville Hotel (1838–46), the latter of which was built and managed by Willard Scott Sr. To meet the growing demand for rooms, Robert Murray, the nephew of Joseph Naper, converted a large, all-brick blacksmith and carriage shop into the New York House (1845–69). Temple's mail contracts and stage routes were eventually bought by the famous Frink and Walker stage company in 1837, which improved the mail and passenger routes that led out of Chicago like spokes of a wheel.[36]

The opening of the Illinois and Michigan Canal in 1848 was a revolution in transportation in Illinois and had a direct impact on the development of Naperville. Wheat, corn, oats and other agricultural products moved north on the canal toward Chicago. Transversely, finished goods from the east and precious building lumber from the north via the Great Lakes were shipped south on the canal. In addition, a "steadily increasing proportion of the passenger traffic between the East and the West selected the all-water route from Buffalo to St. Louis by way of Chicago and the Illinois River." It is no accident that the "tail" of Downers Grove Township connected 1839 DuPage County with the future I&M Canal. Established roads crossing the canal became important arteries of commerce connecting farmers to

the Chicago markets, and Naperville had the advantage of being at the crossroads of two important east–west and north–south routes. The Frink and Walker stage line from Chicago to Peoria ran daily and the route from Chicago to Galena ran tri-weekly, both with stops in Naperville.[37]

The plank road system, first observed in Russia in the 1820s and introduced to Canada in 1839, was introduced in to the United States in 1846 and Illinois in 1847. The particular geography of the Illinois prairies made road improvements a necessity for the increase in stage routes, passenger travel, cargo and mail transport. Muddy roads were sticky and deep, and ruts in dry dirt roads became wheel hazards. In both instances, coaches and wagons could easily be overturned and damaged. By an act of the Illinois General Assembly, the Southwest Plank Road Corporation was created. In January 1850, the road had reached as far as Naperville, and local businessmen solicited 500,000 planks of white or burr oak to be "eight feet long, three inches thick, and no more than thirteen inches wide" to complete the road from Naperville to Oswego. At twenty feet wide, the road was just wide enough for two wagons to pass carefully. The planks were laid on stringers or rails and then on the ground. The stringers were to keep the planks off the mud and level for a smooth ride. Various tolls for travelers on horseback, in a wagon and driving livestock ranged anywhere from half a cent to fifty cents per wagon, rider or animal, depending on which direction you were traveling. The tolls for going east toward Chicago were twice as much as the tolls going west on the plank road.[38]

Naperville was situated at that quintessential spot where villages become great metropolitan centers—a crossroad of transportation. Wherever there is a break or a meeting of two methods of transportation, a center of commerce will develop. The number of businesses, service providers and homes grew, as did the need to supply the travelers and those who bought the newly surveyed lots. Craftsmen were in demand to build the town, its homes and businesses. Teamsters, blacksmiths, tinsmiths, masons and carpenters could easily find work in Naperville.

In the 1840s, log homes were quickly being replaced with frame structures built primarily in the hall-and-parlor style. These homes were slightly larger than the log house, though with two rooms separated by a wall. The "hall" was used for sleeping and the "parlor" for kitchen, dining and company. The ladder that led to a loft in the log house was replaced with a steep and narrow staircase leading to the half-story above. A lean-to or addition was added as the family and its needs grew. The primary method of construction for these homes and commercial structures was

the sturdy post and girt, or mortise and tenon, a form well known to the shipbuilders and captains Naper, Boardman, Sleight and Stevens. Heavy timbers were fitted together with bored holes and hewn pegs forming a large box frame in which the floor and wall joists were also inserted. This solid frame was time consuming to build. It was replaced by balloon frame construction, which revolutionized and epitomized boom construction in Naperville and the Midwest.[39]

Balloon framing originated in Chicago and is today the standard method of wood-frame construction. Instead of hand-hewn timbers and joints, the supports, frame and studs were nailed together. This lighter framing technique also allowed first and second floors to be built as separate sections. Window and door frames could easily be added to the structure without complicated holes, pegs and joints. Vermont native Lorin G. Butler, a carpenter and capitalist, was Naper's business partner. Together, they built many of the first homes and businesses in Naperville, which was growing and keeping builders very busy.[40]

The population of Naperville more than doubled between the 1840 census (estimated at 745) and 1850 census (1,628). The boom in Naperville is directly linked to the improvements in transportation and the increased number of acres cleared for agricultural production. Immigrants from the American East and Europe seeking both land and an escape from political turmoil came to Naperville for a new beginning. "Up to this time settlers had come from sister states and, like all Americans, were of many parentages— English, Irish, Scotch, and Scotch-Irish, with some Pennsylvania Dutch; but all had been in the new country long enough to have become essentially American." During the 1840s, the pioneer stock of New Englanders were beginning to become a minority as an increase in German-speaking folk took root in Naperville. Germans came from loosely organized territories like Bavaria, Saxe-Coburg, Prussia and Alsace-Lorraine and from the state of Pennsylvania, where many of the German immigrants knew extended family members.

One of the reasons for this increase in German migration can be traced to an 1820s book written by Gottfired Duden titled *Bericht über eine Reise nach den westlichen Staaten Nordamerika's* (*Report on a Trip to the Western States of North America*), in which Duden describes his Missouri farm and America in glowing terms, leaving out the crude details of pioneer life. Oppressed, land-starved and desperate people in the German states read this book as a means of escape and took it as a guide to the New World. Missouri was a slave state, however, and so Illinois, a free state, "particularly into

that region opened up by the Blackhawk War," was more suitable to the new immigrants. Together, Europeans and German Americans traveled by ship, canal and Conestoga wagon to Naperville. This new population brought important skills to the young Naperville. "From Germany there came such numbers that the admixture of Teutonic blood in the people of Illinois was to furnish much of the bone and sinew of the state."[41] German craftsmen like cobblers, butchers, bakers, brewers, cabinet and furniture makers, tinsmiths and stonecutters lived and worked with their New England neighbors. A few of the German families whose businesses started in the 1840s and 1850s include the Bapsts, who were carpenters and bakers; the Stengers and Egermanns, brewers and makers of hand-cheese; the Joneses, Vaughns and Strausses, blacksmith and plow works; the Germann and Knoch tailor shops; Ehrhardt's boots and shoes; Long's cabinet and furniture store; and the Schulz and Knoch cigar factories.

Many of the new German immigrants were farmers and were able to purchase land that, thanks in part to the Pre-Emption Acts, was now available with clear title. Improved equipment and large families to help plow, plant and harvest really helped families like the Schwartzes, Hinterlongs, Erbs, Drendels and Wehrlis take root. These German families also brought their faith. The Pennsylvania Dutch were Evangelical, but the majority of the Europeans were Roman Catholic. Prior to 1846, Naperville Catholic families met in the "log cabin of Joseph Wehrli, then located about half a mile southeast of the present site of Naperville," and later in taverns and homes of the faithful.[42] A church was built at Naperville in 1846 and called Saint Raphael's Church after the first pastor, Reverend Raphael Rainaldi. His first official act in Naperville was the marriage of Robert LeBeau to Emily Beaubien on September 8, 1846. Saint Raphael's wood-framed church would serve as the Catholic house of worship until 1866. It was located at the current location of Wenker Hall of the Saints Peter and Paul elementary school on the west side of Ellsworth Street between Franklin and Benton Avenues.

The predominantly German-speaking Evangelical Association was introduced in Naperville with the arrival of two Pennsylvania families by the name of Gross and Schnaebele. The following year, more families arrived, and the association's first minister, Reverend J. Boaz, was sent from Ohio to the Naperville church that met in the homes of various families. In 1843, a church was built, but it was quickly found to be too small. It was enlarged in 1844 by carpenter and general contractor Jonathon Ditzler. Ditzler built many of the homes and businesses in Naperville, including his own home.

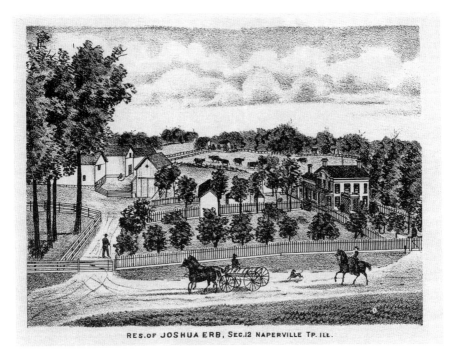

RES.OF JOSHUA ERB, SEC.12 NAPERVILLE TP. ILL.

Joshua Erb farm, portions of which are now Century Farm subdivision. From the 1874 *DuPage County Atlas* published by Thompson Brothers and Burr. *Author's collection.*

In 1858–59, he built a large brick structure known throughout Naperville as the Brick Church.

The Ditzler family and their many Pennsylvania Dutch cousins made significant contributions to Naperville as builders, merchants, clergy, farmers, teachers, librarians and historians. The last three professions could be found in one person, Jonathon's daughter Hannah Ditzler. Hannah was born in Naperville in 1848, and for all but a few years when she lived with relatives elsewhere, she lived in Naperville. Her meticulous and thoughtfully composed and constructed diaries and scrapbooks contain the records of life in Naperville through the newspapers, letters, transcribed ledgers and even fabric scraps she collected. She grew up in the shadow of the Naperville Academy, built in part by her father, located just west of her home on the northeast corner of Van Buren Avenue and Eagle Street.

Hannah and her siblings were students of the academy, a private school organized by businessmen of Naperville, principally Joseph Naper, James G. Wright, C.H.P. Lyman, H.L. Peaselee, George Martin and Adiel S. Jones. The idea to build a new schoolhouse was entertained in 1849 in response

to the fact that the first frame schoolhouse constructed in 1835 had been sold and Naperville was without a proper schoolhouse or regular classes. Naperville was "destitute of a school building, and the public schools of Naperville were of little benefit to the community. They were usually held for only a small portion of the year, at places the most inconvenient and uncomfortable."[43] According to Hannah Ditzler, Joseph Naper, who was among the first to contact a teacher in 1831, offered to donate the land and raise the school by subscriptions. Building a town of permanence and importance required education. Throughout the 1850s, money was raised in five-dollar monthly installments, and building began. The masons were John Hall and Samuel Baliman, and the carpenters were John Collins, lumber dealer, as well as Jonathon Ditzler, E.R. Loomis and W. Patrick. By the end of 1850, only the basement was finished, and the building sat idle for lack of lumber. The second floor was completed in 1852 but still did not have a third floor or roof. Finally, in 1853, the Masonic Euclid Lodge of Naperville paid the last $700 in return for exclusive use of a room on the third floor to be used as its meeting hall.[44]

Classes were taught at the Naper Academy in four terms the first year, with 171 students in attendance from Naperville and DuPage County, along with those from Will and Kane Counties, Wisconsin, Ohio and as far away as New York City. Students were instructed in English, grammar, modern geography, bookkeeping, history of the United States, natural philosophy, algebra, instrumental music, German, physiology, natural history, astronomy, penmanship, composition and declamation (a form of oration). The Ditzler children paid partial tuition, which was augmented by chores like sweeping the floor and hauling wood for the many stoves. The collection of nearly six hundred books from the first public/subscription library founded in Naperville in 1845 was donated to the academy in 1851. In 1860, the Naperville School District Number 7 was created, and the academy was sold to the school district. Thereafter, it was called the Naper Graded School.[45]

The plank road system that brought the students to Naperville was enthusiastically heralded but quickly grew obsolete. The road was used extensively, but the maintenance on the road ate up the profits made from the tolls. The planks would float during heavy rains and warp during a drought, making repairs costly. As railroad technology improved, so did interest in a more profitable enterprise. The 1836 charter for the Galena, Chicago and Union Railroad (GC&U) was dusted off in 1846 by the Illinois General Assembly for review. By 1847, the same year Morris Sleight was granted a charter for a plank road through Naperville, William Ogden was

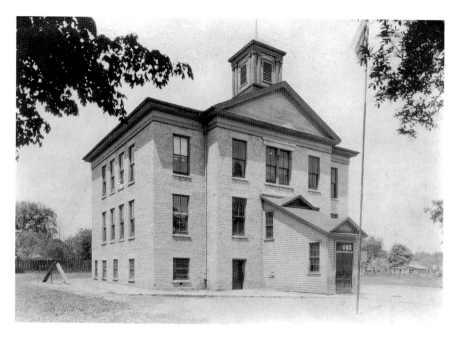

Postcard of the Naper Academy (1850–60), later Naper Grade School (1860–1926). *Courtesy of Paul Hinterlong.*

traveling the proposed route for the new railroad between Chicago and Galena drumming up support. Ogden bought a large tract of land on the west side of Naperville, presumably in anticipation of the future rail route through his land. The railroad would have liked to go through the county seat at Naperville, but Napervillians were opposed to the scheme, as they had already invested in the plank road. Desperate to make their investment pay, the directors of the plank road solicited Naperville for half a million feet of good oak plank in payment for outstanding debts at local businesses. In addition, and possibly to cover his investments, Naper decided to reenter the political field. He was elected in 1852 to serve DuPage County in the General Assembly, now located in the new capital of Springfield, to craft legislation to favor Naperville and its businesses. Although too ill to attend the first legislative session, Naper introduced an Act to Amend the Southwest Plank Road charter in February 1854, essentially turning the plank road into a railroad. That same month, a Whiteside County representative proposed the incorporation of the Chicago, Sterling and Mississippi Railroad (CS&M), which would pass through Naperville. It is not surprising that of the thirteen directors for the new CS&M Railroad, nine were businessmen

from Naperville, and the majority of them were investors in the plank road.[46] Naperville businessman Lewis Ellsworth was elected president, Aylmer Keith secretary and Dr. David Hess treasurer of the CS&M Railroad, but in name only. Despite the best intentions of Naper and others for the improvement of Naperville, neither the GC&U nor the CS&M Railroad would lay tracks through Naperville due to the reluctance of farmers who did not want to sell land to the railway.

Aylmer Keith, one of the directors on the CS&M Railroad, came to Naperville around 1839 and was involved in nearly every business and cultural institution in Naperville until his death in 1855. Keith was an investor in the plank road and the CS&M Railroad, as well as the Joliet and Elgin Railroad. In February 1841, he was appointed secretary and served on the executive committee of the DuPage County Bible Society and also helped form the Methodist Society. He served as the first clerk and secretary of the newly organized Naperville Cemetery Association, which moved the original cemetery from the northeast corner of Washington Street and Benton Avenue to its current location on South Washington Street in 1842. He served as a delegate to the Chicago River and Harbor Convention in July 1847. He was appointed a director of the Merchants and Mechanics Bank of Chicago in 1851 and Naperville postmaster in 1852.

Perhaps Aylmer Keith's most important service to Naperville was to petition the Grand Lodge of Illinois for a charter or dispensation establishing a Masonic lodge in Naperville. "A meeting of the petitioners and other Master Masons was then called at the office of Calvin Barnes.…Joseph Naper was appointed chairman and Aylmer Keith secretary.…It was also resolved at this meeting that Ezra Gilbert (he being the oldest member) select a name from the proposed. He selected 'Euclid' which was unanimously adopted as the name of the lodge."[47] The third floor of the limestone building built by C.H.P. Lyman as the DuPage County Cash Store (48 West Chicago) served as the first meeting place for the Euclid Lodge No. 65 of the Ancient Free and Accepted Masons. The first Mason raised, or accepted, into the lodge was Eli Rich. John Collins and George Martin were the second and third members and the first of many Napervillian leaders, businessmen and clergy to become master Masons.

Joseph Naper, Aylmer Keith and the other petitioners were all members of the Masons before their arrival in Naperville. It is unclear why they waited so long to charter their own lodge. Town building is physically and culturally hard work. When the work of town building is interrupted by conflict, there are bound to be delays in progress. One distraction in early Naperville history

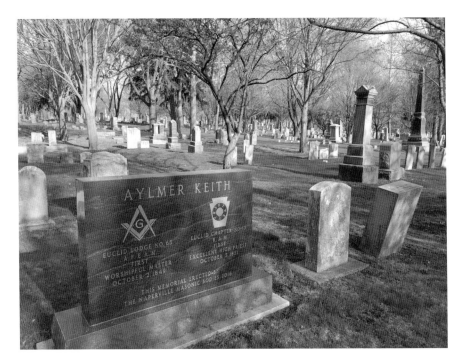

The Naperville Cemetery. The first cemetery was at Benton and Washington and moved to the current location in 1842. *Photographed by the author.*

was the U.S. declaration of war against Mexico. On May 25, 1846, Illinois governor Thomas Ford issued a notice to Illinoisans to raise three brigades of volunteers to avenge the Mexican assault on the newly annexed state the former Republic of Texas (1836–45). Four thousand Illinoisans answered the call within ten days, and many more were turned away. "A favorite employment of the young men of the state had been the organization of rifle companies which drilled and marched and displayed themselves in full regalia in Fourth of July parades and at patriotic meetings. Now these companies saw a chance for real service and at once offered themselves."[48] Naperville "boys" were no different. On June 4, 1846, the owner-operator of the Pre-Emption House, Edmund B. Bill, along with Nelson Thomas, Amos Vaughn, Myron Whipple and forty-eight-year-old Joseph Naper, formed a company to join the Mexican War. Naper's nephew and DuPage County sheriff Robert Murray had to tell the group on June 6 that Governor Ford's quota had been filled. Undaunted, Naper found a commission in the regular army as an assistant in the quartermaster's department, serving from June 26, 1846, through September 25, 1847. Naper participated in the Battle of

Buena Vista, "the most stubborn battle of the war, and its turning point."[49] He wrote the *Chicago Democrat* newspaper from the battlefield: "I open this to let you know the result of one of the greatest battles ever fought. Santa Anna and his army of 20,000 strong met our force of 4,500 all told....[Santa Anna's] loss was very great—some thousand killed....It was a splendid victory. It beats all the other battles fought in Mexico."[50]

Naper's health was impaired, as was the case for many of the United States troops who were ill fitted for the exotic climate of Mexico, but he was one of the lucky ones to make it home. When General Edmund Bill organized another company of men from Cook and adjoining counties on April 9, 1847, he was appointed a captain of Company G, Sixteenth U.S. Infantry. Though he served admirably in Mexico, General Bill would die of yellow fever onboard the *Tahmaroo* on his way back to Naperville. Bill's manservant, Bartholomew Murphy, pleaded with the captain of the *Tahmaroo* not to have a burial at sea and thus returned to Naperville with the body of General Bill in a lead coffin. General Edmund Bill is buried next to his wife in the Naperville Cemetery.[51]

The Mexican War was fought by a large number of Illinois troops who made significant contributions to the relatively quick and successful conclusion to the war in 1848. Illinois politicians, clergy and abolitionists were watching the developments in the American South and Southwest. If Texas were admitted as a slave state, the whole of the American Southwest might follow. Antislavery sentiment in northern Illinois spread quickly after the death of Elijah Lovejoy, the abolitionist printer in Alton, Illinois. In 1837, an antislavery society was formed in a part of Will County that even to this day identifies with Naperville. The abolitionist newspaper *Genius of Liberty*, founded in Lowell, Illinois, in 1840, was renamed the *Western Citizen* and moved to Chicago in 1842. The *Western Citizen* was the leading abolitionist newspaper in northern Illinois, with many Naperville and DuPage County subscribers. The northern Illinois Presbyterians and the Methodists drafted declarations and principles of "no fellowship with slavery" during their synods, and in 1844, a Baptist convention held in Warrenville, one of Naperville's closest neighbors, turned into an antislavery mass meeting. In the July 13, 1844 issue of the *Western Citizen*, a cartoon of the Underground Railroad appeared. It was most certainly read and shared by Naperville subscribers. One Kane County antislavery convention declared that "Kane County was as safe for runaways as Canada." Evidence of the Underground Railroad, a secret network of people and locations that would guide slaves from the South through anti-slave states to safety in the North and Canada,

can be found in DuPage County and surrounding counties but remains hidden in Naperville. Naperville's position so close to strongly abolitionist Wheaton and Downers Grove, coupled with known Naperville subscribers to the *Western Citizen*, would suggest that the Underground Railroad was in operation in Naperville.[52]

According to the census data in 1840 and 1850, there were just a handful of free black men and women living in DuPage County but none in Naperville. The first known African American living in Naperville was Sybil Dunbar. Her name appears on the 1860 tally sheet between two prominent merchant families, father and son Henry and Luther Peaslee families, who lived on Water Street in downtown Naperville. Her nativity is listed as Vermont, where she and her father and grandfather were born *free*. In the 1850 census, she is living in Chicago with the Horatio Loomis family, cousins and business partners with the Peaslees. Sybil's occupation in 1860 is listed as "Independent" with an estimated $2,000 wealth. She might have been a retired storekeeper or a domestic for the family. Sybil died in 1868 and is buried in the Peaslee family plot in the Naperville Cemetery next to the Butlers, who were also merchant families in Naperville and Vermont. The connections between these merchant families and their network of stores and supply houses in New England, Chicago and Naperville is an example of frontier capitalism and migration but with many unanswered questions.[53]

This was the time in Naperville when congregations of the faithful began to build houses of worship. Circuit-riding missionaries of every faith traveled and preached in Naperville. The congregations had grown out of the homes, barns, taverns and courthouses where the faithful met. The philanthropic landowners like Naper, Sleight and Ellsworth donated land for congregations to build larger buildings of worship. The Baptists built a church on land donated by nurseryman Lewis Ellsworth. The Congregationalists met there on every other Sunday until Morris Sleight donated a lot for their church house. Captain Sleight placed restrictions on the sale, however. The Congregationalists were not to add a cemetery to the churchyard (the original cemetery had been moved just a few years before), and the church was to have a bell. Captain Naper donated land to the German Evangelical church on Van Buren, which was later used by the German Lutheran church. Both the Methodist and Catholic congregations bought land from Sleight and built churches. In a few years, the area north of Courthouse Square would be called Piety Hill for the number of churches built in proximity to one another.

Piety Hill taken from the top of North Central College's Old Main. View from a stereocard. *Courtesy of Tom Majewski.*

As the number of churches increased, so, too, did the saloons and taverns/hotels. To supply these saloons, or "sample rooms," Naperville had its own breweries. Although Jacob Englefriedt is considered the first brewer in Naperville (circa 1842), it was the Egermanns and the Stengers who provided the suds for Naperville. Xavier Egermann came to Naperville in 1844 and established a brewery on the northeast corner of Eagle Street and Jackson Avenue. The impressive Naperville-limestone building was connected by tunnels running east–west to the northwest corner of Webster Street and Jackson Avenue, where the Peter Stenger brewery was located. These tunnels were used to lager or cure the hundreds of barrels of beer in a consistently cool environment. Peter and his son Nicholas Stenger successfully ran the brewery until Nicholas caught "gold fever" and joined nearly one hundred Napervillians in the gold rush to California. Nicholas's brother John Stenger, a cabinetmaker or joiner, left New York to help his father run the brewery in Nicholas's absence.

The removal of anywhere from 100 to 200 men from the hamlet of about 1,600 people could have spelled disaster for Naperville, as a large part of the working population was gone. Lured by dreams of incredible wealth, old and young alike headed to the California gold fields seeking fortune. Young men like Robert Naper, Joseph Naper's son, went, as did older men like Willard Scott Sr., still with a spark of adventure in them. They went by overland trail through the unknown West and the all-water route around the tip of South America. Most did not find their golden fortune. Some, like Morris Sleight, made a fortune selling goods and supplies. After a few years, Sleight returned to Naperville and amassed a large real estate holding that he and his family developed on the east side of Naperville. Others like Michael and Nicholas Stenger found gold and returned home with their strongboxes of gold and/or cash. Michael bought property in Aurora and ran a saloon, while Nicholas invested in the family brewery and built two large three-story malt and brew houses on the north side of Naperville. Ferdinand Schwartz returned from California with enough cash to buy large farms for his family and generations thereafter. The hardship of the "diggings" and the climate was not for everyone, and some came home empty-handed or broken.

News of the California gold rush came by way of letters and newspapers printed in Chicago and elsewhere and delivered to Naperville as frequently as the stage made stops. The first newspaper printed in Naperville/DuPage County was nearly its last. Naperville had five newspapers fail before 1862. Naperville was growing fast and demanded its own newspaper. Businessmen offered to buy a secondhand press and set up an editor in 1849. Charles Sellon obliged, took money for subscriptions and rolled out the *DuPage County Recorder*. "The paper, in its commencement, was a decided success. It started off with a circulation of about 500."[54] As the political climate was changing and readers thought his paper too Whiggish for Democratic Naperville, Sellon changed the name to the *Democratic Plaindealer*. A Chicago newspaper, the *Daily Journal*, reported in its March 14, 1850 issue that "arrangements for a telegraph station on the O'Reilly lines were being made at Naperville" that would keep the presses full of news. Sellon took subscriptions up front and offered all types of printing jobs, especially legal forms and deeds for the thriving attorneys and lawyers clustered around the county seat in Naperville. A businessman on top of the trends, Sellon took subscriptions for a new paper called the *Daughter of Temperance* to appeal to the rise in non-drinkers. Napervillians, however, woke up one day to discover Sellon, his newspaper and their money were gone.[55]

Sellon left his press, his family and his journeyman H.S. Humphrey, whom businessmen C.C. Barnes and Charles Keith partnered with to get another paper printed in Naperville. This paper, the *DuPage County Observer*, lost Humphrey halfway through 1851, at which time Gershom Martin joined the paper as publisher and editor. This paper failed in 1854 and was replaced with the *DuPage County Journal*, managed by the Keiths, J.M. Edson and E.M. Day. The presses churned out the local news, stage routes, political news and advertisements for just about everything. The number and variety of businesses in Naperville reflects the growth of the town. All looked good until that fateful February thaw in 1857 that swelled the DuPage River and sent massive ice chunks slamming into the newly constructed four-arch stone bridge across the river at Main Street. The bridge, acting as a dam, pushed the ice and torrents of water down North Water Street (now Chicago Avenue). All of the frame buildings on the south side of the street were swept into the DuPage River. Hannah Ditzler reported in her diary that years later, some of her students found lead type in the riverbank east of Naperville. A new press and paper were started by E.H. Eyer, which authors Richmond and Vallette called a very "respectable sheet and bids fair to rival its predecessors in permanence and usefulness." The *Naperville Newsletter* did not last, and what fragments are extant do not contain news. The newspaper that would herald the arrival of the Civil War and Joseph Naper's death would be the *Naperville Sentinel*, printed by D.B. Birdsall.[56]

The news and advertisements found in the papers of the 1850s show a Naperville bursting at the seams. Several new additions to Naper's original town were made specifically around Courthouse Square on the east side of downtown. The trees cut down twenty to thirty years before were in need of replacement. The nursery of fruit and ornamental trees started by Lewis Ellsworth in 1849 saw competition from the Hunt brothers Eclectic Nursery begun in 1853.[57] The DuPage County Agricultural and Mechanical Society, the forerunner of the DuPage County Fair, also started in 1853. When Wheaton grabbed the Galena and Chicago Union Railroad, Naper gave up politics for the moment and founded the Producers Bank with Dr. David Hess, merchant Henry L. Peaslee and Peaslee's cousin Chicago businessman Horatio Loomis. The bank was able to raise an impressive $200,000 in capital stock. Not to be outdone, pioneer Willard Scott Sr. capitalized on the cash flow and success of his general store and charted his own Bank of Naperville in 1854. The Scott bank would become one of the oldest incorporated banks in the state of Illinois.

Banks with capital financed industry and commerce. The Naperville Plow Works, founded by Adeil Jones in 1840, was, by 1856, hammering out 2,500 plows a year and employed several smiths. George Martin opened his quarries in the 1840s and later found clay beds on his estate. He began to manufacture bricks in the 1850s that employed many men seasonally. Philip Beckman was one of many harness, hide and leather craftsmen whose businesses started in the 1840s. The number of harness makers and blacksmiths reflects how heavily agrarian Naperville was. Although tobacco was not grown here, Naperville had a cigar factory in the late 1850s. Tailors and barbers opened shops to keep gentlemen looking like gentlemen. Ladies were still buying bolts of cloth to have dresses made either by themselves or dressmakers. Lawyers formed partnerships to help with deeds, wills and matters of domestic and criminal law.

All land transactions and circuit, criminal and chancery courts were held in the courthouse at Naperville. Circuit riders—lawyers who tried cases in established district court systems—brought news and excitement to town. The courtroom galleries would often be filled with the curious. One of the most infamous trials in the Naperville courthouse took place in 1853. Patrick Doyle and coworkers, two brothers named Tole, were returning from an evening of celebrating payday. When the first brother, Patrick Tole, passed out on the road, Doyle took the opportunity to fatally beat and rob him of what was left of his pay. The other Tole brother fled the scene in fear for his life. The case was open and shut, and Patrick Doyle was the first (and only) person tried and hanged for murder in Naperville. But the story does not end there. In the 1850s, medical students were desperate to practice on cadavers. After the body of Doyle was taken down, it was taken to a potter's field (or pauper's grave) in the Naperville Cemetery. Medical students noted the location of the grave and, in the middle of the night, dug up the body of Doyle and hid it in some bushes for future recovery. Unknown to the first set of medical students was another set of medical students who, in turn, stole the cadaver and hid it for their study. Officials found out, and the body was turned over to Naperville's doctor, Hamilton Daniels, a graduate of Rush Medical School in Chicago. Whether Dr. Daniels performed an autopsy or used the body of Doyle for study is unclear. It is reported that Daniels kept the skeleton on display in his drugstore on Washington Street for years before he donated it to North-Western College.[58]

Less grisly, but horrifying nonetheless, was the verified rumor that Illinois representative Erastus Hills from Bloomingdale proposed a bill in the Illinois General Assembly during the first session of 1855 to remove the county seat

from Naperville. Captain Naper, too ill to make the journey, sent George Martin as a "citizen envoy...carrying a remonstrance against the [county seat] move signed by alarmed citizens, and personal letters of introduction from Joe Naper to the right people." After intense lobbying, the bill was removed from committee, but the beginning of a heated debate over the location of the county seat ensued.[59] Perhaps the Naperville visit of Senator Stephen A. Douglas in the fall of 1856 was intended to impress and/or frighten anyone who wanted to move the county seat. Twenty years before, Douglas and Naper, both Democrats, had sat across the aisle from Whig politician Abraham Lincoln in the Illinois General Assembly. Douglas, a Vermonter by birth, had close ties with the strongly Democratic Naperville. Naper's nephew Robert Murray hosted the "Little Giant" at his home in downtown Naperville. Douglas was in town for a Democratic meeting three months after he'd lost his party's nomination for president. Douglas might also have been feeling the waters for his senatorial reelection in 1858. Unfortunately, neither the *DuPage Journal* nor any other regional newspapers captured the content of Douglas's September 27 Naperville speech.[60]

Mormons were thought to have passed through Naperville on their way to Utah Territory. A letter written by then newly elected president James Buchanan on March 14, 1857, was in the possession of Robert Murray. The contents of the short, three-line note indicate that a Mr. Delana Eckles was a Naperville favorite for the territorial governor of Utah. The underlines are President Buchanan's:

> *Gentlemen—The decision in regard to the appointment of a Governor for Utah was delayed mainly <u>because there is no existing vacancy</u>.* [Brigham] *Young still continues Governor under the terms of the law creating his office. It was postponed <u>for the present</u> for public considerations; and not at all because of the opposition of any person to the appointment of Mr. Eccles* [sic]. *Your friend very respectfully James Buchanan.*[61]

The importance of placing the "right" governor in a territory that was a critical transportation route to the West Coast must have weighed on the gentlemen of Naperville. The Utah Territory, though mostly desert, was heavily populated and armed with a trained militia of exiled Mormons from Nauvoo, Illinois. Indeed, six months after the note was written, Buchanan declared war on the Mormons and sent troops to squash the upheaval. The Utah War is also known as the Mormon War or Buchanan's Blunder. The Mormon question must have been discussed in Naperville. Thomas Betts

served in the Sixth U.S. Regular Infantry during the Utah War (May 1857–July 1858) and might have discussed his experiences with his family and other Napervilians. The "war" was a series of guerrilla skirmishes between Mormon settlers and the U.S. Army. Eckles, a friend of Illinois senator Stephen Douglas, did not get the governorship, but he was appointed the chief justice of the Utah Territory Supreme Court.[62]

Naperville was a divided community. The land west of Washington Street was in Naperville Township, and the land east of Washington Street was in DuPage, now Lisle Township. The 1849 Illinois act to create a township form of government enforced the "towns" jurisdiction over the prescribed thirty-six sections of a township. Essentially, Naperville and Lisle would have two separate road commissioners, clerks, assessors and so on. School districts were divided, and each town had its own constable. In 1852, Captain Naper easily won the township supervisor election, which was the beginning of his reentry into local politics. Naper knew his unincorporated village would not withstand a contest for the county seat if not incorporated as a self-governing and taxing municipality. An Act to Incorporate the Village of Naperville passed the General Assembly on February 7, 1857. Also at this time, the name "Naperville" was officially established. Prior to the act to incorporate Naperville as a village, the cluster of people and buildings around Naper was labeled on maps as "Naper's Settlement," "Napers Settlement," "Napiersville" and "Napersville." In the May 1857 election held at the Pre-Emption House, Joseph Naper won the office of the first village president of Naperville. Of the six elected officials of the first village board, five were Masonic brothers who would forever help shape, strengthen and build the character of Naperville. In October, Naperville doubled in size after Joseph Naper surveyed and added forty more acres of town lots to the village plat. Naper sold his interest in the Producer's Bank to George Martin and James G. Wright in 1857. Prosperity was looming, and the county seat question was deferred.[63]

In 1860, the DuPage County seat, specifically the courthouse, took center stage, and the new village of Naperville was suddenly known across the United States. The reason for this notoriety was the much anticipated and celebrated Burch Divorce case. Mr. Burch was a wealthy Chicago banker and community leader who accused his wife of adultery. Mary Burch was a Chicago and New York socialite and the niece of railroad magnate Erastus Corning. The trial concerning adultery and deception among the upper crust of Chicago elite was too sensationally and emotionally charged for a fair trial in Cook County, so the venue was moved west to the DuPage

Chicago Avenue from Washington Street around 1875. The building on the left is now the Lantern Restaurant. View from a stereocard. *Courtesy of Tom Majewski.*

County Circuit Court. Reporters from all over the United States flocked to Naperville to view the spectacle. Dispatches went out daily describing Naperville and the progress of the trial. The team of defense attorneys took over both hotels in town. The plaintiff's army of lawyers boarded wherever they could find beds in private homes. Mrs. Burch stayed with the Skinner family, and Mr. Burch stayed at the home of Aylmer Keith's widow. The women of Naperville attended court nearly every day. John Haight and his law partner, Merritt Hobson, were employed on the team representing Mr. Burch. John wrote to his wife:

> *The Burch case is causing some excitement in our little town. It will take three weeks to try the case. Hobson and Haight were employed by*

*Mr. Burch in June last. I am fearful we are on the wrong side. Burch
I think to be a narrow minded, jealous, fated man whose God is money.
He evidently wants to get rid of his wife so that he can marry one Mary
Spalding who has about $200,000. Mrs. Burch is a delicate, sensitive
and refined woman. She has the sympathy of the whole community here
and in Chicago. The trial shows one thing most clearly, to wit, that there
can be misery in a palace. Mrs. Burch looks to be the most miserable being
on earth. The trial of the cause will cost $100,000. There are nineteen
lawyers employed in the case.*[64]

The case concluded on December 10 in favor of Mrs. Burch. Naperville
rejoiced at the verdict, as well as the business and exposure the trial created.

The cries of jubilation and excitement would soon wane. With the news of
the surrender of Fort Sumter on April 12, 1861, Naperville and the country
were thrust into a bloody conflict that pitted American against American.
Throughout the Civil War, DuPage County, and Naperville especially,
responded immediately to President Lincoln's call for volunteers. "Pursuant
to a call circulated on Friday [April 19, 1861] and signed in less than half
an hour by over one hundred of our citizens, regardless of party, the Court
House was filled last Saturday evening by the most enthusiastic crowd we ever
saw assembled in DuPage County."[65] The first recruits formed a company
called the DuPage Plow Boy Rifles, a nod to the number of farmers in the
community.

John Naper, town co-founder and Joseph's brother, had passed away
in 1850 and did not see his sons march off to war. Joseph Naper died on
August 23, 1862, at the age of sixty-four. Hannah Ditzler and Warrenville
diarist Hiram Leonard both wrote of the long funeral procession and
solemn ceremonies for Captain Joseph Naper. Naper's obituary, though
full of typos, is peppered with phrases like "spirit of benevolence," "strict
integrity" and "public confidence and trust," which speak to the character
of the founder of Naperville. Though spending thirty-three years building,
improving, representing and leading Naperville, he would not see his country
heal from its Civil War nor hear a railroad roll through town. Naper left the
community that he and early pioneers had carved from the wilderness. He
left a community more than double in size due to the efforts of the early
pioneers who followed him into the wilderness and the immigrants who
established a solid foundation of infrastructure, business and culture. Naper
left a community that future generations would continue to seek, build upon
and call Naperville.

Chapter 4

THE PROSPECTS OF NAPERVILLE ARE OF AN ENCOURAGING CHARACTER

Handsome brick, stone and frame stores, line the business thoroughfares
[of Naperville], while the principal residence portion contains many
substantial, ornate and comfortable dwellings....There are the usual church
organizations, each with a very credible (several very fine) edifice...a college,
public schools, a fire department, band, masonic, odd fellows and other
lodges, and many additional advantages pertaining to modern civilization and
the pleasures and benefit of life....With the enterprises already in active and
successful operation, and those in contemplation, the prospects of Naperville
are of an encouraging character.
—John Holland, 1886

A week after Joseph Naper was buried, Union forces were defeated for a second time at the Second Battle of Bull Run on August 28–30, 1862. This would leave the North vulnerable and paved the way for General Robert E. Lee's Maryland Campaign. The number of Napervillians who participated in this disastrous defeat is unknown, and the news must have affected Naperville families who had soldiers in the war. A rush of support caused sixty-one Napervillians to join the Union army that August. The previous year, 1861, saw the largest number of local and national recruits, especially in the months immediately following the surrender of Fort Sumter on April 12, 1861.[66]

Twelve-year-old Napervillian Hannah Ditzler wrote, "When the news came that Fort Sumter had been fired upon, great fear took possession

of our town people. People were out on the street all night and wagons were moving and men talking." On April 13, 1861, a day after Fort Sumter surrendered, President Abraham Lincoln called for volunteers. The only Naperville newspaper at the time, the *Naperville Sentinel*, published Illinois governor Richard Yates's "proclamation calling for six regiments…issued on Wednesday [April 17, 1861] of last week; on Monday [April 22, 1861] of this week, one hundred and twenty-five companies had been offered, or more than twice than the number called for, and still they keep pouring in."[67]

Men and boys of Naperville did not waste any time in answering President Lincoln's call for volunteers. The rolls were filled within a few days, and those left out went to nearby towns and states to join any available regiment. Illinois sent nearly 260,000 troops, or about 15 percent of its total population, to battle. The *Sentinel* reported, "In less than half an hour…over one hundred of our citizens, regardless of party, [filled] the Court House….Last Saturday evening [it was] the most enthusiastic crowd we ever saw assembled in DuPage County." Red, white and blue bunting decorated the interior of the courthouse, patriotic speeches were given one after another and songs like "Yankee Doodle" and "The Star-Spangled Banner" were sung with gusto.[68]

On May 9, 1861, before their departure, Captain Morris Sleight invited the DuPage Plow Boy Rifles to dinner at the Pre-Emption House.

> *The company were then dismissed for two hours to give time for dinner, and to enable members to complete their hasty arrangements for departure, take final leave of their friends, etc. At two o'clock P.M. they again mustered in the Square, which was crowded with our citizens, their wives and children, an opportunity was given for a final goodbye, hands were shaken, the last "God bless you" spoken, and while tears flowed freely from eyes unused to weeping, the company were marched to the wagons prepared for their conveyance to Aurora, and with three cheers for the Union, and more for its gallant defenders, the "DuPage Plow Boy Rifles" were on their way to defend their country, and support her flag wherever duty may call them.[69]*

These were the first of nearly three hundred Naperville recruits who were represented in nearly fifty-five infantry, cavalry and artillery regiments and who participated in several major battles during the war.[70]

News of the troop movements and battles reached Naperville by way of mail, local newspapers and now the telegraph, which, when interrupted, caused local panic.

"Bad For The News"
Owing to the severe thunderstorm of this week the telegraph fails to work,
and we are therefore without certain news of much importance since last
Saturday. The substance of information is that troops are pouring into the
Capital by thousands, and that a bloody conflict at Baltimore is imminent.[71]

The absence of news was not unique to Naperville. Rumors hung in the air like a heavy blanket. David Givler wrote in his memoirs that just before he enlisted, "rumors were afloat that the rebels had captured Cairo [Illinois] and were moving northward, and everybody arriving in town would crane his neck, gaze southward and ask, 'Where are the rebels?'" Hannah Ditzler said, "We felt as if the enemy was right here upon us. [When drawing water out at the pump,] we were afraid when we heard wagon wheels. It was the dreaded signal for war."[72]

Napervillians rallied to help with the war effort in many ways, including forming relief agencies and sending care packages of homemade food and clothes. "Associations for Army relief sprang up everywhere. Not to engage in them resulted in forfeiting social position." The U.S. Sanitary Commission was created to help soldiers with food, medical supplies, nurses and doctors. Local chapters would organize "fairs" to raise money and supplies for the troops. These fairs inspired even the smallest community to hold bake sales, auctions, dinners and other entertainment in order to raise money for the Union cause. Most fairs resembled carnivals with thematic displays, dinners and dances. One of the first large-scale Sanitary Fairs was held in Chicago from October 27 to November 7, 1863. Nearly $100,000 was raised, and a large quantity of supplies was gathered in warehouses and shipped to the troops. The report of the Chicago fair mentions the amount of produce and provisions sent "from the hinterland," which presumably included Naperville, to Chicago. According to the report, the Chicago area collected "one hundred wagons laden to overflowing with the produce of the garden and the farm. Potatoes, blue, pink, and brown, in heaps onions, with the silver skin; squashes, which must have known of their destiny in the early spring, so big with fat were they; cabbages, beets and turnips, and the whole anti-scorbutic fraternity; barrels of cider, kegs of beer."[73]

The women of Naperville were the primary suppliers of the produce and handiwork mentioned above. Throughout the war, Naperville women and girls were encouraged to sew socks, uniforms and blankets, as well as to provide sewing supplies. In his diary, Adam L. Dirr of Naperville mentions doing odd sewing for his fellow company members and especially

the occasion of making his first pair of pants. He undoubtedly was kept in supply of fresh needles and thread by the generosity of women from back home. In his memoirs, Private Robert H. Strong, a recruit from a farm between Naperville and Plainfield, recalls receiving a "housewife" from the Christian Commission. "The Christian Commission used to furnish us men with Testaments and tracts and a sort of thread-and-needle case with pockets, called a 'housewife.' These were made by Northern women and girls, and not infrequently contained letters."[74]

Wherever the troops marched or rode through on trains, they were "constantly interrupted by well-meaning women from nearby towns who delayed the troops with flags, Bibles, cakes, and thread." The ladies of Naperville were no different and on one occasion made a flag for the members of the DuPage Plow Boy Rifles. It was made of silk, measured five feet by seven and a half and was reported to have cost forty dollars. The delegation traveled to Camp Dement in Dixon, Illinois, to present the flag. While in camp, the ladies heard rumors that the company might dissolve due to a number of deserters. Patriotic zeal took hold of the women, who talked "of forming a Company to go in place of the homesick ones." A thank-you letter from the Plow Boys was published in the *Sentinel*, but no mention of an all-female company ever materialized. The women of Naperville, particularly the farming families, managed the farm or business while the men and boys were at war. Managing farmhands, family and worrying about their husbands, brothers or sons must have been similar to the hardships faced by the first women of Naper's settlement.[75]

There is evidence from the diaries and memoirs of Strong, Givler, Dirr and Ditzler that Naperville was predominantly pro-Union. Augustine A. Smith, then president of North-Western College (now North Central College, or NCC), repeatedly mentions going to Union meetings at various times before and during the Civil War. The *Naperville Sentinel* was clearly pro-Union, as evidenced by the American flag banner used liberally throughout the paper in advertisement and editorial sections. The editorial section of the *Sentinel's* April 18 issue urges, "No more Democrats! No more Whigs! No more Republicans, Know-Nothings, or anything else, but everyman a patriot, with a heart to pray, with a tongue to shout, and a strong arm to strike, for 'The Union Forever!'" The motto "The Union Forever" was emblazoned across this flag and anywhere appropriate.[76]

Copperhead politics, or antiwar Democrats, were also represented in Naperville. Private Strong mentions, "I remember the excitement when news first came that the South had seceded. Indignation was felt by all except

Copperheads and dough-faced Democrats." Four years later, upon his return to northern Illinois, Strong describes anti-Union altercations in Chicago and then, closer to home, somewhere between Lemont and Naperville. In Chicago, though the commander had sent word of the returning troops, no fanfare was given, nor any form of hospitality. When rations did arrive, they were spoiled. "There was lots of talk among the boys of raiding the Copperhead City [Chicago], but better counsel prevailed." On his walk from the Lemont train station home, Strong approached a farmer in a wagon. When he asked for a ride, the farmer swore at him and called him a "thieving Bluecoat," refusing to give Strong a ride.[77]

There is no evidence that Naperville experienced any form of depression or hardship during the war. The fact that the railroad was built and completed during the war indicates both the financial stability of the village and the need for a railroad. Private Strong wrote that some families "stayed at home and raised wheat and corn and pork for a big price, for the government to buy for the boys who did rally." A couple of other noticeable local effects of the Civil War were Naperville's Masonic lodge suspending meetings for a few years and the *Naperville Sentinel* newspaper ceasing to publish.[78]

The local reaction to the end of the Civil War, which culminated in the surrender of General Robert E. Lee to General Ulysses S. Grant at Appomattox Courthouse and the assassination of President Abraham Lincoln at Ford's Theatre, must have been one of celebration and great mourning. However, issues of the *DuPage County Press*, which would have reported on Naperville sentiment, are missing from the historical record. Hannah Ditzler wrote, "News came [of General Lee's] surrender, so there was a great time in town. No school, and the school girls marched around town with red, white, and blue badges. Boys made a man of straw and rags, calling it Jeff Davis [the president of the Confederate States from 1861 to 1865]. It was hauled around the streets. Stores were closed and decorated with tri-colors....In the evening the streets were alive with people. Fireworks shot off and the effigy burned." On the assassination of Lincoln, Hannah wrote, "Eli [Hannah's brother] brought the painful news that President Lincoln is dead....I hope the murderers will be caught. Everybody is in sorrow. All public places are draped in crepe, also some private homes."[79]

Naperville soldiers returned home with many scars from the battlefields. Some were disabled either physically or mentally. Veterans, disabled soldiers and especially widows had trouble collecting pensions. Luther Peaslee of Naperville, for example, solicited the law firm of Hughes, Denver and Peck in Washington, D.C., to secure his pension. Attorney, Civil War veteran and

Naperville native Merritt Hobson put an advertisement in the *DuPage County Press* offering assistance for collecting on "war claims" at his office on Main Street. "War claims" were specifically intended for veterans and their widows who were trying to collect pensions or disability payments for their family. Most Napervillians returned to their old professions; the majority were farmers. The soldiers with business talents and skills returned to Naperville perhaps with stronger resolve, energy and manpower than before the war began. Postwar Naperville saw a surge in population and professions.

No battles were ever fought in Illinois, which allowed agriculture and industry to continue and, in most instances, thrive. Illinois infrastructure grew with the addition of many miles of roads and railroads being built for the war effort. Agricultural production increased due to improvements in technology that also aided in the war effort. As soldiers returned to Naperville, they found a thriving village taking full advantage of the natural resources and the technological advances of the Second Industrial or Technological Revolution. Steel, the telegraph, improved rail service and machinery systems were propelling Naperville and America into a new era of commercial strength.

In May 1864, a year before General Lee's surrender and Lincoln's assassination, the Chicago, Burlington and Quincy (CB&Q) Railroad was completed to Naperville. Rather than displace numerous businesses and residential homes, the CB&Q laid tracks on the smooth, unencumbered prairie to the north of the business district. The station and freight house stood on the north side of the track across from the current location of the Metra and Amtrak station, which was built in 1912. A number of livery services and teamsters that initially hauled freight and passengers from Wheaton and Warrenville train stations to Naperville (and the reverse) were now shuttling between the Naperville station and downtown Naperville. Hannah Ditzler wrote, "The railroad is in operation now. Last evening we were surprised to see Aunt Hannah and Emma come on the first train. Have seen several freight trains of 80 cars and 6 passenger trains go through." On July 29, Hannah wrote, "I rode on train to Chicago—first time from Naperville."[80]

A spur line was constructed by the railroad in the middle of Ewing Street around 1886 to connect the stone quarries with the main trunk line. An additional spur was created connecting the Ewing Street line with factories along Jackson Avenue and to bring coal to Enck & Drendel Coal Company and, later still, to the city power plant that was located near the northeast corner of Jackson Avenue and Webster Street. Industry had taken root in

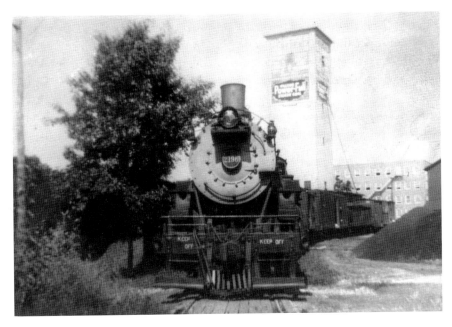

Train on the Chicago, Burlington & Quincy Railroad at Naperville. Boecker Grain & Coal and the Kroehler factory are in the background. *Courtesy of Kramer Photography.*

downtown Naperville and also began the shift northward along the railroad tracks. Bernard Boecker Coal & Grain and H.&E. Musselman Coal & Grain located near the CB&Q, as did the Michael & Anthony Schwartz Lumber Company during this time.

Since the 1860s, new businesses like Boecker Coal & Grain, Frederick Long Furniture, Philip Beckman Harness, Ernst Von Oven Nursery, George Crabbe Carriage Works, Martin & King Brick Works and Jacob Salfisburg's stone quarry employed hundreds of Napervillians. Successful and well-trusted merchant-tailor George Reuss built a substantial mercantile block on the northeast corner of Jefferson Avenue and Washington Street. He conducted his tailoring business and opened Naperville's third bank, the Reuss Bank. Post–Civil War Naperville was growing rapidly. The 1860 census reported 1,333 people living in Naperville. By 1870, the number had increased to 1,713, the largest increase in Naperville population before 1900. Illinois historian Theodore Pease summarized, "The rural prairie commonwealth between 1870 and 1893 underwent changes that dwarf those of the preceding twenty years. Population and industry developed… at an accelerated rate….[The] first feeble beginnings of manufactures

developed by the demands of the Civil War were turning into mightier and mightier industries."[81] In 1875, the Naperville Plow Works, under the management of Simon Straus and Frank Goetsch, began turning out the "Old Naperville Plow" or "Jones Plow" that was first built by Adiel Jones in Naperville in the 1840s. In a year, the company was re-incorporated as the Naperville Agricultural Works and began producing hayforks in addition to plows. The factory was located on Washington Street just south of the bridge and was "well equipped with steam engine, lathe, polishing and grinding machines, and everything necessary for the production and repairs of plows and general machinery." This company was later absorbed into the Oliver Plow Company.[82]

During the 1870s and 1880s, established businesses grew, and Naperville attracted many new industries like Charles Kaylor and Henry Miller's Marble & Granite Works, W.W. Wickel's Drugstore, David Frost Broom Works, Joseph Egermann and Joseph Bauer's Cheese & Butter Works and William & George Knoch's Cigar Factory. Though started in the 1840s, the Stenger Brewery was at the height of its production in the 1870s and 1880s before it was absorbed into a Chicago consortium in the 1890s. In 1869, Stenger hired a young German immigrant, Adolph Coors. Within a couple of years, Coors was the highest-paid worker on the payroll, which indicates he was most likely a brewmaster. Extensive records in the Probate Court of DuPage County indicate that the trust agreement set up by Nicholas Stenger, deceased business partner and brother of John Stenger, created a financial crisis in the business that could have resulted in the sale of the brewery. Young Coors was unable to buy out Stenger family members, nor was he willing to marry into a family that might divide or dissolve the business, so he took his skill westward to Golden, Colorado.[83]

Coors left Naperville during a time of explosive growth. In the 1870s, owners of downtown Naperville properties were replacing frame residences and storefronts with brick and stone structures. Commercial Italianate and Queen Anne styles of architecture with ornate building details, including cast-iron fronts, ornately carved window and door treatments, plate glass and /or bay windows, were beginning to define the streetscape along Jefferson Avenue and Washington and Main Streets. Village ordinances were passed to improve board sidewalks and roads. The conversion of many commercial structures to brick and the use of pressed tin ceilings was done in part for fire safety, perhaps a result of the Chicago Fire of 1871. It has been said that the glow of the Great Fire was observed from the cupola of Willard Scott Sr.'s house on the corner of Washington Street and Franklin Avenue. Curious

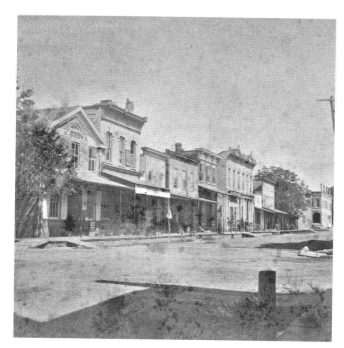

Jefferson Avenue around 1875. The second building is the former Daniels & Morse, Cassem & Strayer, W.W. Wickel and Oswald's drugstore. View from a stereocard. *Courtesy of Tom Majewski.*

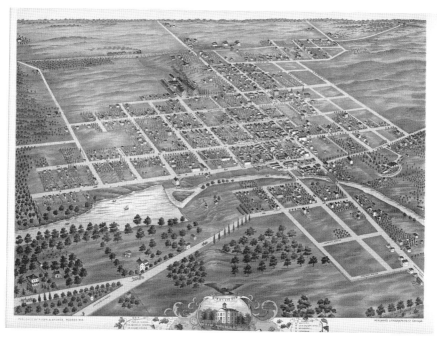

Bird's-eye map of Naperville. Published in 1869 for the Merchant's Lithography Company, Chicago, by Ruger & Stoner, Madison, Wisconsin. *Author's collection.*

Naperville tourists traveled to Chicago to see the ruins and would also send aid to Chicagoans. One effect of the Great Chicago Fire on Naperville was the flourishing of the Martin, Von Oven and Salfiburg quarries and brickyards, which supplied building material to Chicago contractors.

Interestingly, Naperville did not have a fire department in 1871. At its incorporation as a village in 1857, Willard Scott Jr. was appointed fire marshal over a bucket brigade of volunteers. There appears to be no discussion of a structured fire department until 1874, when the New York House hotel caught fire the night of July 6. Napervillians were unable to control the fire and sent word to Aurora for assistance. Aurora sent by railcar its steam pumper, and downtown Naperville was saved from a fate similar to Chicago's. By September 1874, the village board had approved the purchase of firefighting equipment, and the No. 3 Button Hand Engine and a hose cart were purchased. The new pumper was named the "Joe Naper" and was in use from 1874 to 1907. The Joe Naper pumper is still functional and is used for demonstration by the Naperville Hose Co. No. 1. The Hose Co. is an organization of retired and active members of the fire service. The group was founded to preserve the history of the Naperville Fire Department.[84]

As businesses and the labor force grew, so did the need for new housing stock. Many new subdivisions or additions to the map of Naperville were built during the 1870s and 1880s. Park Addition and Ellsworth & Sons Second Addition were added to the north, and Stevens Addition and the re-subdivision of the Woodlawn Addition were made to the west of downtown. Delcar Sleight carved more town lots and blocks from the family estate in the form of Delcar Sleight's Addition, Sleight's College Addition and East Addition on the east side of town. George Martin added his Second Addition to the south of town. In fact, a real estate rivalry took place between Naperville businessmen George Martin and Delcar Sleight in 1868. Both gentlemen were trying to woo North-Western College to relocate from Plainfield, Illinois, to their particular real estate in Naperville.[85]

Plainfield College was established in 1861 to provide a liberal arts education for those of the Evangelical faith. The first president was Augustine A. Smith, who was elected by the board of trustees. The name of the college was changed by the board of trustees to North-Western College in 1864. Plainfield, however, did not have a railroad, and the school was looking for a town that had a railroad to convey and attract its students and faculty. Naperville was one among many railroad towns courting the college. On old maps, Hillside Avenue was once called College Avenue, a street named by George Martin in his Second Addition to the plat of Naperville in hopes the

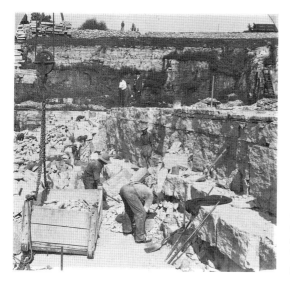

Quarry workers. The quarries were drained in April and were worked through November. View from a stereocard. *Courtesy of Tom Majewski.*

college would build on his land. Other towns hoping to attract North-Western College included Hinsdale, Illinois, and South Bend, Indiana. Naperville's candidacy was questioned by a "reviewer for the *Aurora Herald* [newspaper, who] saw nothing but breweries, distilleries and saloons in Naperville."[86]

Ultimately, Sleight's donation of two town blocks and its proximity to the railroad station persuaded the college to relocate to Naperville in 1870. John Van Osdel, Chicago's first significant architect, was commissioned to design Old Main. Givler told his readers:

> *The present strength of our population makes it impossible for any particular sect, society or class of men to carry out any undertaking of any importance; hence it is indispensably necessary that if we desire to place our town in a growing and prosperous condition, there must be a union of action, a working together, and a friendly feeling fostered.*[87]

The area around the college, nicknamed Quality Hill for its prestigious homes, lived up to its moniker. Between 1870 and 1890, large, architecturally significant Victorian homes were built by business owners, by church congregants for use as parsonages and by professors of the college. The elite of Naperville lived on Quality Hill, which in 1986 was designated Naperville's only historic district. The variety of styles in the district reflects an era of leisure and prosperity in Naperville.[88]

What could have been a setback to Naperville's prosperity was the loss of the DuPage County seat in 1868. In 1857, four years after Wheaton allowed

the railroad to pass through its town, county officials proposed moving the county courthouse to Wheaton because the town was more centrally located in the county. DuPage County voted, and Naperville narrowly won the vote to retain the county seat. The vote to move the county seat returned to the ballot in 1867, at which time Naperville lost the vote. Claiming fraud, Naperville refused to give up the records even though a new courthouse was built in Wheaton. On a cold December night, a group of Wheaton citizens, primarily Civil War veterans, descended on the courthouse in Naperville and stole the records. Immediately, Hiram Cody, who lived across the street from the courthouse, ran to the Congregational church and rang the bell to alarm Naperville of the commotion at the courthouse. Napervillians formed a posse to confront and take back the records. Wiser heads prevailed. Former DuPage County sheriff and Napervillian Philip Strubler encouraged the group of men from Naperville to pause at the tavern of the Pre-Emption House, where they proceeded to debate and drink the night away without incident. The case was settled in the Illinois Supreme Court in favor of Wheaton, and by 1871, the DuPage County seat was officially operating in Wheaton. The county square in Naperville was given to the village of Naperville and renamed Central Park. The old frame courthouse was sold and removed from the site. The old brick jail and records vault was used briefly as a fire station for the Joe Naper pumper and hose cart.[89]

In 1874, Lieutenant Willard Scott Jr. facilitated the purchase of a captured Confederate cannon. The 954-pound rifle-barreled cannon was made by the Noble Brothers in Rome, Georgia, around 1861. The cannon has been in Central Park for more than 140 years and, at one time, was fired regularly for patriotic events. It was plugged for safety reasons and mounted in a concrete base around 1910. Gale Pewitt and Roy Grundy led a restoration effort to restore the cannon and create a new carriage. The Noble Brothers cannon was rededicated in Central Park in November 2009.

The same year that the county seat was legally moved to Wheaton, David Givler bought the *DuPage County Press* from Robert Potter and renamed the paper the *Naperville Clarion*. The rivalry between Henry Childs, editor of the Wheaton newspaper *Northern Illinoian*, and Givler provided exciting reading as the county seat drama unfolded. The *Clarion* would become Naperville's main newspaper from 1868 to 1934. The Givler family owned and edited the paper, giving it a strong local perspective. The paper was produced weekly with a mix of local news and stories from other sources. Leisure time was taking root in Naperville during this era of prosperity. The paper reported on Napervillians and their travels to exotic places like

DuPage County clerk's ledger showing the vote of 1,721 to 1,604 to move the county seat to Wheaton. Photograph by Bob Schuster. *Courtesy of the DuPage County clerk's office.*

Florida and California. Organized baseball was introduced in Naperville in 1867. In the 1880s, a roller-skating fad was introduced in Naperville. A large roller-skating rink was built on Jefferson Avenue east of Washington Street near the current parking deck. The beginnings of the Municipal Band were taking root in the form of the Light Guard Band, which was

called to play at various parades and civic events. Around 1876, during America's Centennial of Independence celebrations, Willard Scott Jr. added a public hall above his commercial block called Scott's Hall. The three-hundred-person auditorium was the largest in town and held many traveling performances, lectures, music recitals, school graduations and even poultry shows. The performance hall was later enlarged with a balcony to accommodate four hundred people.

In 1884, a local chapter of the Grand Army of the Republic (GAR) was formed in Scott's Hall. The GAR, a national patriotic and social club, was founded in Decatur, Illinois, in 1866 by veterans of the Civil War. The organization spread nationally among veterans and communities, and eventually its national headquarters was established at Springfield, Illinois. Membership was restricted to veterans of the Civil War, though there were auxiliary branches for Women's Relief Corps, Ladies of the GAR and Sons and Daughters of Union Veterans. The Naperville Post No. 386 was named in honor of Captain Walter Blanchard.[90] Members of the Blanchard GAR post bought a small piece of land to commemorate the first shot fired at the Battle of Gettysburg. Marcellus Jones, Levi Shafer and Alexander McS. S. Riddler hauled a four-sided, inscribed Naperville-limestone monument to Gettysburg in July 1886. The south side reads, "First shot Gettysburg July 1st 1863 7:30am." The east side reads, "Fired by Cap. Jones with Sergt. Shafer's carbine. Co. E 8th Ills. Cavalry." The north side reads, "Erected 1886." The west side reads, "By Capt. Jones Lieut Riddler, Sergt. Shafer."

In addition to veterans' groups, Naperville had a large number of Christian faith-based organizations. The Young Men's and Young Women's Christian Associations (YMCA and YWCA) met at North-Western College. The Naperville chapter of the Woman's Christian Temperance Union (WCTU) was organized in 1883 at the Congregational church. Lovisa Steck was one of the most vocal leaders of the WCTU in Naperville and the Chicago area. She wrote many articles and speeches promoting the prohibition of and abstinence from alcohol. The Naperville Gun Club was also founded at this time to "develop a love for outdoor sport, and general healthfulness."[91]

Constantly in motion, Naperville was culturally and physically changing. In 1864, the Roman Catholic parish St. Raphael built a large stone church and renamed the parish Saints Peter and Paul. The first public telephone was installed in Thomas Saylor's confectionary store on Jefferson Avenue in 1885. The wires and telephone poles would multiply quickly across town as many families would take advantage of the new technology. The Baptist congregation, which built a church in the 1840s on Chicago Avenue

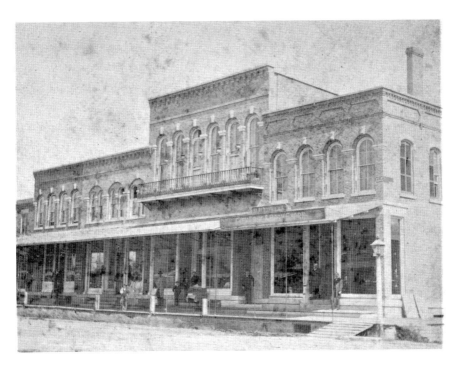

Scott's Block/Hall around 1875. This hall was used as a community gathering space for many events. View from a stereocard. *Courtesy of Tom Majewski.*

Postcard of the interior of Saints Peter and Paul Church before the 1922 fire that completely consumed the church. *Courtesy of Paul Hinterlong.*

across from the current parking deck, disbanded in the early 1880s. The building was abandoned for over a year before it was moved to the east side of Washington Street just north of Chicago Avenue and used as a carriage and wagon showroom. The church bell was secured by the village of Naperville and used as a curfew and fire bell. It was installed first on the Reuss State Bank on the northwest corner of Jefferson Avenue and Washington Street. Roads were graveled and graded, making it easier for transportation through town. An iron bridge across the DuPage River at Washington Street replaced a wooden bridge. The Naper milldam at the foot of Mill Street was removed and the riverbed rechanneled to better work the quarries. The large blocks seen today on the Naperville Riverwalk near the Naperville Park District office are the remains of the CB&Q Railroad spur bridges and the channeled riverbank to keep the DuPage River from flooding the quarries. The first Saturday of the month was established as a time for farmers to trade their horses with businesses from Chicago and other farmers in the area. Horse Market Days (1883–1905) was held in front of the Pre-Emption House, now Sullivan's restaurant, on Chicago and Main.

The growth of Naperville and its civic pride can be seen in its first business directory, published by the Holland Publishing Company in June 1886. Written in three parts, this book contains a history of Naperville, a list of advertisers and short biographies of businessmen and women. The directory "shows in a concentrated form, that, Naperville has a valuable location, shipping facilities, social, religious and scholastic advantages of high merit, and a full complement of liberal business men [and women] possessing the innumerable inducements purchasers are seeking." More than one hundred businesses are listed in Holland's directory from agricultural implements to watches, clocks and jewelry.[92]

At the same time as the *Holland's Business Directory* was published, the first Sanborn & Company fire insurance map of Naperville was drafted. These maps were used for fire prevention to show what type of building material a structure was made of and where all the water sources, like wells and cisterns, were located. The Sanborn maps were a tremendous resource for local fire departments like the Naperville Fire Department (NFD). In 1887, the NFD purchased up-to-date firefighting equipment, including a steam pumper. To accommodate the growing fleet of vehicles, the NFD moved out of the old DuPage County building in Central Park and built the first dedicated firehouse in 1888. This building was located on the south side of Jefferson Avenue between Main and Webster Streets. The old Baptist church's curfew

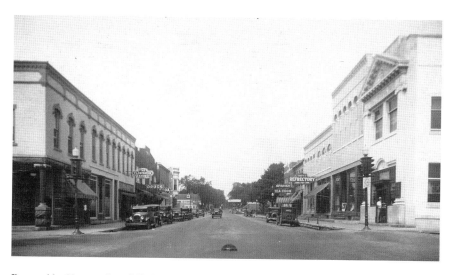

Postcard looking north on Washington Street from Jefferson Avenue. *Courtesy of Paul Hinterlong.*

and alarm bell was removed from the top of the Reuss building and installed on the top of the new firehouse, where it would remain until 1956.[93]

During this time of growth, Napervillian James L. Nichols I would publish *The Businessman's Guide.* The guide was originally written in 1886 as a textbook for his business class at North-Western College. The book outlined proper forms of business, calculation tables, business etiquette and other practical business methods. It would sell more than four million copies and was translated into several languages. The book was originally published outside Illinois. The *Guide*'s success allowed Nichols to build a press here in Naperville on Washington Street. Nichols was a German immigrant who suffered extreme hardship after being orphaned at an early age. He overcame many obstacles as a boy working on farms in harsh conditions. Before Nichols was able to afford school, he taught himself. He rose through the educational system to become a grade school principal, a college professor and a department chair. Nichols's anglicized name, "James Lawrence," was after "that old American naval hero James Lawrence," whose motto "Don't give up the ship" embodies Nichols's own work ethic.[94]

This spirit of determination and hard work, already a hallmark of the first settlers, continued to grow in the Naperville community, which was increasing in size, culture and importance in the region. The turning of the century from the 1800s to the 1900s was an exciting time for America and Naperville.

Chapter 5

ALL THE RESOURCES AND CONVENIENCES

The city of Naperville is situated thirty miles west of Chicago.....Naperville is in direct communication with Europe, Asia and Africa and the Islands of the Sea, by way of the justly celebrated "Burlington Route." Its location is unsurpassable, lying high and dry, and thoroughly drained by the placid DuPage River. Surrounding it are well tilled farms....Its educational facilities are first class.... Churches dot the town....The purest water on earth gushes spontaneously from the earth in copious quantities; the finest building stone in the state are taken from its quarries, and the best drain tile and brick are made here. Its fire apparatus and water supply is equal to meet any probable emergency, taxes are not burdensome... merchants wide awake, progressive, liberal and accommodating...In short Naperville possesses all the resources and conveniences necessary to develop a city of ten thousand before the New Year's issue of the Clarion *in the year 1900.*
—*David B. Givler, 1890*

The village of Naperville looked optimistically forward during the last decade of the nineteenth century. The world was just a train ride in either direction east or west. Naperville was poised between the Chicago metropolis and the ever-growing city of Aurora, where department stores, theaters, museums and hospitals were visited (by choice or necessity) by the people of Naperville. The wonders of these cities must have impressed Naperville. Nine years after Aurora installed electric streetlights and took the moniker the "City of Lights," Naperville threw the switch on its own electricity. When the first eighty-six electric street lamps were lit on the night

of February 17, 1890, a great cheer went up, the Light Guard Band played rousing tunes and fireworks burst over town. Initially, just a few businesses and streets were provided power by the privately owned Naperville Electric Company built by local contractor John Collins. Daniels and Sons' drugstore, Valentine Dieter's grocery and Collins & Durran's jewelry store were among the first to have electric lights. A casualty of progress, however, was the loss of the town lamplighter's position. Men like Peter Steward, Ernest Ode and the very last lamplighter, John Schrank, lost the fifteen- to eighteen-dollars-a-month job to climb the ladder, clean and fill the lamps, trim the wicks and bring light to the nighttime streets of the small village.

At the same February 7, 1890 village board of trustees meeting at which the ordinance passed that allowed John Collins to provide electricity to Naperville, the trustees also discussed a petition for Naperville city incorporation signed and presented to the council earlier in November 1889. The petitioners "comprising one eighth [52] of the legal voters [650] of the Village of Naperville, State of Illinois do respectfully petition that you submit the petition as to whether such village shall become incorporated as a City under the act of the Illinois General Assembly." The board, abiding by the petition, called for a special election to be held on Monday, March 17, 1890. The pressure was on Naperville to be the first incorporated city in DuPage County. Crossing the finishing line before Wheaton would really be something to crow about. Increased taxes (an ever-present worry) was the major concern of residents who were opposed to the village-to-city transition. Progressives like *Clarion* editor David Givler wrote:

Naperville has been wearing infantile apparel long enough. It has outgrown the restrictions imposed by the charter granted 33 years ago. It served us admirably up to the year 1870, when the new State Constitution went into effect, but since then so many general laws have been passed that annulled our charter privileges that neither our council nor magistrates know whether we are afoot or on horseback—don't know what is good law or worthless.... Let us wheel into line on the 17th day of March, by casting a unanimous vote for reorganization and thereby inaugurate a new era of prosperity in the history of Naperville. The change is not only entirely safe, but is also desirable and absolutely necessary to meet the present and future demands of our city.[95]

Before the monumental vote, the village was divided into three wards. Election judges were appointed, and Scott's Hall was chosen as the one and

only polling location. Because personal data from the 1890 census was lost, we will never know how many Irishmen (women could not vote yet) may have attended the special vote held that Monday night on St. Patrick's Day. When the votes were counted, Naperville voted 338 to 61 in favor of city incorporation. The first city election was held on April 15, 1890. The first council elected under city incorporation included:

Mayor **James J. Hunt** (284), V.A Dieter (196)
First Ward Alderman **Levi Shafer** (147), John W. Baumgartner (12)
First Ward Alderman **John Collins** (149), Michael Schwartz (1)
Second Ward Alderman **Joseph Bapst** (133) Frederick Kailer (39)
Second Ward Alderman **Dr. John A. Bell** (124), Isaac N. Murray (41)
Third Ward Alderman **Frank S. Goetsch** (109), Samuel Mather (77)
Third Ward Alderman **Holt Sieber** (89)
Clerk **Thomas W. Saylor** (288), Jasper L. Dille
Treasurer **Alvin Scott Jr.** (477)
Attorney **H.H. Goodrich** (444), John Haight (13), Hally Haight (6)

The 2,216 residents of the new city of Naperville glowed with pride and looked to its newly elected leaders for a bright and prosperous future. And prosperity came to Naperville. In 1891, a new bank was chartered and built with the help of the Euclid Lodge No. 65. The First National Bank of Naperville erected a large, Richardsonian Romanesque–style building on the south side of Jefferson Avenue in the heart of downtown Naperville. Chicago architect and former supervising architect of the U.S. Treasury Department Mifflin E. Bell designed the ornate and stately building that was built with locally quarried limestone. Bell studied with and helped noted architect Alfred H. Piquenard with the designs for both the current Illinois State Capitol and the Iowa State Capitol. Many of Bell's designs for post offices and customhouses across the United States have been landmarked for their style and historical significance. The bank was Bell's first DuPage County commission. The second floor of the bank was used as the meeting rooms for the Masons. The bank building was their sixth lodge since their charter in 1849. At the same time, a south wing was added to the North-Western College building that housed classrooms, the laboratories, a commercial department, a museum, the Union Bible Institute and female student boarders. The much-needed, large three-story addition was also constructed with Naperville stone from the original 1869 designs of John Van Osdel. Steam heat replaced the individual stoves located in nearly every

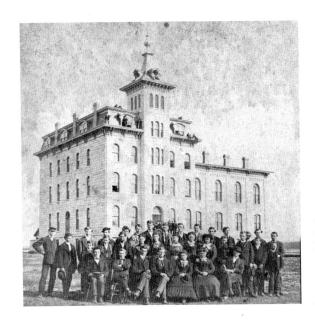

Old Main of North-Western College around 1875. In 1926, the college was renamed North Central College. View from a stereocard. *Courtesy of Tom Majewski.*

room, and electric lighting replaced kerosene lamps in 1892. At the time of publication, both Old Main and the First National Bank of Naperville are still standing. The buildings have a warm, aged, yellow-glow color to them. Naperville limestone, however, when first quarried and cut, has a brilliant white shine. In 1891 and for years after, the new buildings must have impressed students, Napervillians and visitors alike.

A student-turned-professor who must surely have been impressed with the progress of the college and Naperville was German immigrant and orphan James L. Nichols. Nichols's book published in 1886, *Safe Methods of Business (The Business Guide)*, was a tremendous success, and Nichols, taking his own business advice, looked to invest in Naperville. Stenger Brewery, though a popular and profitable business, probably did not appeal to Nichols's religious convictions. In addition, Nichols must have looked at or been aware of the bottom line of the once prosperous Stenger Brewery. Whether because of the financial Panic of 1893 or because the taste for lager beer had changed, a decrease in production was experienced by the brewery. In 1893, John Stenger, the last of the original Stenger brewers, sold the operation to a Chicago brewery trust, which mothballed the Naperville malt and brew houses. Prior to the sale, one of Stenger's daughters, Mary, married brewer Joseph Schamberger, who tried unsuccessfully to make a go of the Naperville operation. Schamberger later moved some of the Stenger equipment to Astoria, Oregon, where he managed a highly successful brewery. Rare

Schamberger beer bottles marked "Naperville" are evidence of the Stenger family's last years of brewery operations in Naperville. In 1917, nationally known mushroom grower A.V. Jackson bought the old Stenger buildings. He boarded up the windows and made "cellars" for growing mushrooms commercially. An excerpt from a full-page advertisement in the October 1914 *Popular Mechanics* explains:

> *Growing mushrooms by the Jackson method is practically an assurance of success. He is universally admitted to be the most successful mushroom grower in the country....State Agricultural schools use his books of instructions....Mr. Jackson has been growing and studying mushrooms for twenty years* [1894]. *He built and owned the largest mushroom plant in the world, and is now at the head of the most modern and scientific plant in the world today—the Falmouth Mushroom Cellars.*[96]

The mushroom plant in Naperville employed about three dozen temporary workers from September to May. Most of the workers were from Puerto Rico and Mexico. The plant closed around 1955 and was torn down.

Nichols instead set his sights on a number of independent Naperville furniture makers who had booming businesses. Using the talents and skills of craftsmen like Fred Long and John Kraushar and the capital of businessmen like Willard Scott Jr., Nichols formed the Naperville Lounge Factory in 1893. Perhaps no other piece of furniture best exemplifies the era of prosperity and leisure in the late nineteenth century than the lounge, chaise or fainting couch. One had to have leisure time to use such a piece of furniture and a room large enough to accommodate it. Nichols must have recognized the trend or fashion to own such a piece of furniture. Long and Kraushar were turning out lounges by hand at a speedy rate but not enough to keep up with demand. A factory, Nichols surmised, could meet the supply and demand, employ more people and make a profit for the investors. Nichols wrote one of his former students, then twenty-one-year-old Peter Kroehler (pronounced *kray ler*), to join the new venture as a secretary and salesman. Despite the nationwide depression following the Panic (1893–97), demand grew, and the "factory" was relocated to an abandoned roller-skating rink on the south side of East Jefferson Street.

James Nichols died in 1895, leaving large bequests to his alma mater and former employer North-Western College and to the City of Naperville. To honor the school that gave him advanced education, a teaching position and the launching pad for his highly successful *Business Guide*, Nichols bequeathed

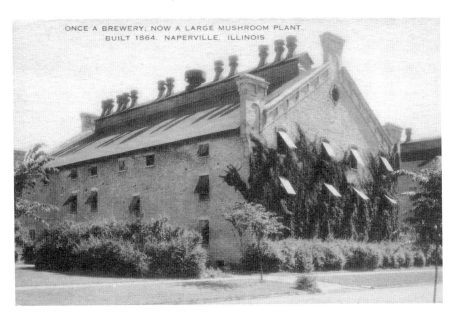

Postcard of A.V. Jackson's mushroom "factory" in the former Stenger Brewery buildings. The building shown was built in 1854, not 1864. *Courtesy of Paul Hinterlong.*

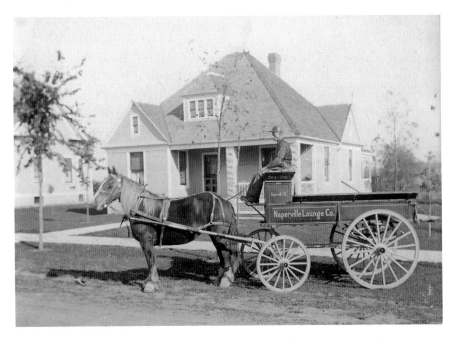

William Winehold and Naperville Lounge Factory wagon. Furniture and supplies were delivered in wagons like this before automobiles. *Courtesy of Don and Bari Landorf family.*

a princely sum of $10,000 for a building dedicated to the physical health and well-being of the students. The gymnasium was a necessity, according to college historian Clarence Roberts in his book *A Century of Liberal Education*, to eliminate "emotional stress, sickness and epidemics" among the student body. Unlike Nichols's bequest to the City of Naperville, the money Nichols gave to the college was to be held in interest-bearing accounts or trust for five years, after which time the money would be used to build and equip a gymnasium. The terms were met, and in 1901, Nichols Hall was dedicated. Roberts added, "It might be noted that the gymnasium was built at North-Western before many colleges or even state universities were favored with such structures."[97]

James L. Nichols also left $10,000 to the City of Naperville to establish a free public library. A location in Naperville was selected on the west side of Central Park. The former house of Dr. David Hess was moved off the property to the corner of Main Street and Benton Avenue, where it still stands. Mifflin E. Bell was hired to design the Nichols Library. This was Bell's third and last DuPage County commission. Bell's Richardsonian Romanesque design for the building, made of yellow brick and Naperville limestone, was a popular style for civic buildings. The First National Bank of Naperville (1891) and the DuPage County Courthouse (1896) are variations of the Richardsonian Romanesque style. The community donated two hundred books and the Women's Literary Club (later the Naperville Woman's Club), which had just formed the previous year and was committed to education, contributed five hundred books more. More than six hundred books were checked out in its inaugural year of operation. The Nichols Library was a source of pride in the small community. No town as small as Naperville had such an impressive library. The structure and purpose of the building so impressed the U.S. Geological Survey that it marked the corner of the Nichols Library with a benchmark plaque. The medallion is inscribed, "Elevation above sea level 693 feet datum 1905. 250 dollars fine for disturbing this marker." The first permanent head librarian for the Nichols Library was former schoolteacher Hannah Ditzler. Ditzler helped catalogue and organize the collection for six years (1898–1905) before her marriage to John Alspaugh.

Naperville's iconic librarian was Miss Mary Barbara "Matie" (pronounced *may tee*) Egermann. Miss Egermann was appointed head librarian in 1908, and over the next forty years, she shaped the reading habits and community for many Naperville families. In 1915, she asked the Library Board and the City of Naperville for space on the upper level of the library for use as the first city museum. Egermann displayed mostly military memorabilia and

Postcard of Nichols Library around 1898. James Nichols helped create one of the largest and most-awarded libraries in the United States. *Courtesy of Paul Hinterlong.*

early settlement documents. The "museum" grew to include pictures, books, letters and diaries of old Naperville families. Egermann loved children and was instrumental in furnishing and supplying a 1939 remodel of the library to accommodate a children's room. Her doll collection, which grew to more than five hundred dolls, was a highlight and delight for students and visitors During both World War I and II, Egermann organized book drives and letter campaigns for the soldiers, many of whom brought her dolls and souvenirs from their travels. The Nichols Library was a special place for Napervillians thanks to the generosity of a German immigrant who found opportunity and purpose in Naperville.

In 1896, one year after the death of James L. Nichols, his son James L. Nichols II incorporated the J.L. Nichols Publishing Company. In addition to his father's monumental 1886 *Business Guide* that was reprinted in many editions and languages, the press also published health, home and farming guides, as well as "Books of General Interest, Religious Books, Books by Negro Authors, Bibles and Testaments." Nichols employed hundreds of young college students who sold his books by subscription to help pay for their tuition. Besides Naperville, the company also had presses in Toronto, Canada, and Atlanta, Georgia.

Table of Contents page from a 1934 J.L Nichols Publishing Company catalog. *Courtesy of Barb Hower.*

The world came to Chicago in 1893 for the 400th anniversary of Columbus's discovery of the New World. The World's Columbian Exposition, or World's Fair, was held on 690 acres around Jackson Park. More than forty-five countries participated in the fair showing off their cultural, industrial and agricultural wonders. "Modern" machinery, curiosities, exotic food and amusements were eagerly enjoyed by nearly twenty-seven million visitors. Napervillians took the CB&Q trains to a special station built on the fairgrounds. During open season, Naperville native Hannah Ditzler attended the fair thirty-six times. She even returned to the fairgrounds an additional eight times after it closed. With each visit, she recorded her path, what she saw and who went with her. Her Columbian Exposition scrapbook contains a variety of tickets, postcards and memorabilia of what must have seemed to her, and most visitors, as the Eighth Wonder of the World. Architecture and domestic interior design in Naperville were influenced by the exposure to world cultures and the magnificence of the exposition buildings, known as the White City. Compare, for example, the large ornate Corinthian-columned porch added to the Francis Kendall home at 43 East Jefferson sometime after 1893 with the square, plain columns of the 1850s Federal Revival–style home of Dr. David Hess on the corner of Benton and Main. Some homeowners decorated rooms with exotic objects, furniture, wallpapers and textiles imitating things they had seen on display at the fair. A Naperville son and land developer, Delcar Sleight, made an addition of thirty-six lots to the east side of Naperville. He named the addition and a street in honor of the World's Columbian Exposition. Columbia Avenue is the eastern border of Naperville's only historic district.

The 1893 World's Fair succeeded in highlighting the achievements of America, the countries of the world and America's place in the world. America's strength was challenged on February 15, 1898. While anchored in Cuba to help Americans and their economic interests on the island of Cuba, the nearly brand-new USS *Maine* exploded, killing 261 of its 355

sailors. The United States declared war on Spain in April, and a wave of patriotism swept Naperville. Jacob Saylor, the newsstand proprietor, made a Cuban flag from scratch and hung it proudly. But David Givler, editor of the *Clarion* and a Civil War veteran, warned, "Don't enlist unless you want to. Keep your head on your shoulders and don't fly off the handle....Our young men should remain cool and collected." Fewer than a dozen Napervillians voluntarily served in the Spanish-American War, and all returned home safely. At the conclusion of the short conflict (April–August 1898), the Grand Army of the Republic erected a limestone obelisk of local stone in Central Park to commemorate the service of Napervillians who served in the Black Hawk, Civil and Spanish-American Wars. *Our New Possessions*, published by the Nichols Publishing Company, described the history, geography and culture of the Philippine Islands, Cuba and Puerto Rico acquired by the United States at the end of the Spanish-American War.

By the turn of the century, Naperville's infrastructure and amenities had greatly improved. The municipal waterworks was again put to a vote in 1903,

Postcard of Dr. Otto Goetz, dentist, and his horse, Captain. Dr. William J. Truitt was also located in this building. *Courtesy of Paul Hinterlong.*

and this time, citizens passed the measure 431 to 180 in favor of city water. Two one-thousand-foot-plus wells were drilled into the St. Peter Sandstone Aquifer, and a water tower was constructed behind the city electric plant on the corner of Jackson Avenue and Eagle Street. The City of Naperville took over the private electric plant in 1904. By 1912, more equipment was required to supply growing Naperville with power. The LaGrange (Illinois) Gas Company, later incorporated as the Western United Gas and Electric Company, brought gas for residential and commercial use to Naperville in 1905. Naperville began to pave its dirt streets first with a layer of chipped stone, which pulverized with use into a hard surface. These roads, called macadam, were sometimes tarred to control dust. The open creek that flowed south from the Stenger farm through downtown to the DuPage River was tiled and placed below ground. The business district received both brick pavers (Jefferson and Washington in 1910) and concrete surfaces (Main Street in 1914). The CB&Q built a new, spacious train station on the south side of the tracks in response to petitions from Naperville commuters and the Naperville City Council. At the time of publication, this station serves both Chicago Metra commuter traffic as well as Amtrak passenger trains. The old CB&Q station on the north side of the tracks was used exclusively as a freight office before it was torn down.

The Chicago Telephone Company moved its exchange to the home of Louise Skelton around 1891, and by 1909, she managed 318 Naperville telephone customers at her switchboard. Despite all of these civic improvements, the Naperville Grade School on Eagle Street did not have indoor plumbing or electric lights.

A group of 51 west side citizens signed a petition that urged an election of a board of education and proposed spending $4,000 to provide Naper Academy with running water and electricity. Although interest ran high and 300 votes were cast, both propositions were defeated by wide margins....In 1905, the District 78 Board of Education was formed, however, and the following year, water pipes and toilets were installed at the school. [98]

After nearly four decades, David Givler released his beloved *Clarion* to his son Rollo Givler, who purchased the paper and took over as editor in 1905. Columns such as "Eastern Occurrences," "The National Capital," "Across the Ocean" and "Fresh and Newsy" attracted Naperville and DuPage County readers to the news and local advertisements. The paper was still set by hand and limited to eight pages. The paper was delivered once a week, and what

news Napervillians could not find in the *Clarion*, they could with subscriptions to other newspapers at home or available at the Nichols Library.

In 1907, Eudora Hull Gaylord Spalding opened a fourteen-bed treatment facility of the Chicago Tuberculosis Institute called the Edward Sanatorium, named after her husband, Edward Gaylord. Before the antibiotic era, fresh country air, rest and a good diet were used to cure patients with tuberculosis (TB), a bacterial infection predominantly of the lungs. Edward Sanatorium had both permanent, year-round structures and smaller open-air cabins and tents. The grounds were nicely landscaped and provided peace and quiet in the Naperville countryside. Though a medical facility, Edward Sanatorium was not a hospital for the treatment of non–TB related medical conditions. A Naperville hospital was conceived, however, by furniture maker and co-founder of the Naperville Lounge Company Frederick Long. By the terms of his will that went into effect at his death in October 1911, Long left certain moneys to his relatives and the remainder of his estate "for the purpose of establishing and maintaining a public hospital in and for the said City under the Statutes of the State of Illinois, directing that the said sum of money so paid to be used exclusively for the establishment, construction and maintenance of said hospital." After probate was settled, the city accepted the remainder of the Long Estate in December 1923 and passed Ordinance No. 177, An Ordinance Creating a Board of Hospital Commissioners and Prescribing Its Duties. Over the years, the commissioners sporadically reported the financial activity of the Hospital Fund, but a facility was never designed or built. In 1927, the fund had a little over $7,000. By 1935, the Hospital Fund had reached nearly $29,000. The heirs of Frederick Long took the city to court for inactivity and not fulfilling the terms of the bequest. The money, with interest, was disbursed among the heirs, and the City of Naperville had to wait another twenty years before Edward Sanatorium was converted to a public hospital.[99]

Health and well-being were very important to another member of the Naperville Lounge Factory, Peter Kroehler. His sons Delmar and Kenneth, in their tribute book *Our Dad*, write:

> *For one thing,* [Dad] *loved to go swimming with the boys down at Hobson's mill. For another, he enjoyed bicycling—a favorite form of locomotion. Above all, in a sort of gymnasium that he had rigged up near the* [factory], *there was boxing at all hours and open to all comers.… Wrestling was a frequent variant for the gloves—until one of the force, young Art Beidelman, got his leg broken in a match.*[100]

Bird's-eye View of Edward Sanatorium, Naperville, Ill.

Postcard of the Edward Sanatorium. Fresh country air was one of the treatments for patients with respiratory problems, specifically tuberculosis. *Courtesy of Paul Hinterlong.*

Kroehler led the campaign to build a facility for the Young Men's Christian Association in Naperville. The representatives from Naperville were told by the Chicago YMCA office that Naperville was too small to support a Y building. Napervillians, however, were not discouraged. The campaign to create a YMCA started in 1909, and within fifteen days, the small town of 3,400 had raised $26,260. The cornerstone was laid on Memorial Day 1910, and the three-story brick facility opened to the public in March 1911. Over the years, hundreds of boys and girls, men and women have benefited from the athletics, programming and shelter provided by the YMCA.

At the July 19, 1912 city council meeting, the decree of Judge Charles D. Clark was read ordering an election to be held in Naperville on August 28, 1912, "for the purpose of submitting to the voters the question:—Shall the City of Naperville Adopt the Commission Form of Municipal Government?" The commission form of municipal government in the United States was a direct result of the devastating hurricane in Galveston, Texas, in 1900. The abject destruction and recovery effort was so great that decisions had to be made fast. Alderman-turned-commissioners split up duties and were empowered to act swiftly. The efficient form of local government spread throughout Texas and the United States. Naperville voted 260 to 193 for a commission style of local government. The vote was split clearly between the

Photograph of the Young Men's Christian Association building. Image taken by Charles Koretke for the 1917 *Homecoming* book. *Author's collection.*

First and Third Wards (the east side of Washington Street) that favored the new government and the Second and Fourth Wards (the west side), which objected. In the new system, the council was elected at-large, and the loss of representation in one's ward was most likely a concern. The first council elected under commissioner form of municipal government consisted of:

Mayor
Francis A. Kendall (484)
William J. Truitt (304)

Commissioners
Charles Schwartz (478)
William Hiltenbrand (451)
Walter Givler (417)
Charles Bowman (387)
Charles Stoos (374)
Henry Saylor (373)
Henry Meily (351)
Arthur Beidelman (317)

Naperville voted "yes" for a new form of government, but when asked on a special ballot the month before, "Shall the City bond for $7,000 to improve the electric plant?" and "Shall the City be an Anti-saloon territory?" the answer to both was a resounding "no." Perhaps the presence of a church-sponsored school and seminary for training ministers influenced the moral fiber of Naperville, which had had a love-hate relationship with the prohibition of alcohol since its incorporation as a village. The first prohibition of liquor sales on Sunday took effect on July 13, 1857. The council felt compelled to reiterate the ordinance by public notice in 1861 and by 1866 had approved the expense of hiring a Sunday policeman to monitor and uphold the ban of liquor sales on Sunday. In the twentieth century, Naperville voted to eliminate saloons from its corporate limits in 1908 but voted to return them in 1912. In 1915, Naperville voted again to go dry with the help of female voters. This is the earliest recorded instance that Naperville women were allowed to vote for council members and referendums—five years before the Nineteenth Amendment to the U.S. Constitution giving all women the right to vote. There was a large voter turnout in 1915: 961 men voted versus 905 women, and more women than men voted in the Second and Third Wards. In 1919, Naperville created six new voting districts, but voter turnout for both men and women was down. The novelty of women casting ballots must have worn off.

Peter Kroehler, Nichols's star pupil, had since 1893 risen in the Naperville Lounge Factory. By 1896, he was a partner in the firm; in 1903, he was the president of the company; in 1909, he patented new styles of sleeper sofas called a Unifold and a Duofold; in 1910, he built his own furniture plant at Kankakee, Illinois; and in 1915, he merged the Kankakee, Naperville and two other furniture companies, forming the Kroehler Manufacturing Company. In all of this, Kroehler was twice elected mayor of Naperville, in 1907 and 1909. Kroehler resigned as mayor in 1910. He said:

> *I am planning to start another factory, which will still further occupy my time, and I feel that, since I have served the City six years faithfully I have done my whole duty in this respect.....Now that the affairs of the City are in very good shape, and the City's financial condition has never been in better shape, I feel this the opportune and proper time to tender my resignation.*[101]

The letter did not mention his divorce, which was some cause for concern in early twentieth-century politics and Naperville. The city council responded with respectful, sincere gratitude:

Resolved, That the highest appreciation of thanks of the City be and hereby are tendered to Honorable P.E. Kroehler for his able, honorable and just service to the City during his three years incumbency as Alderman and three years incumbency as Mayor, be it further Resolved, That the individuals composing this Council personally tender Honorable P.E. Kroehler their thanks for the compliments to them contained in such letter, and also tender him the expression of the same sense of deep regret that the City lose by his resignation, an official unexcelled in loyalty to the City, honorable service and efficiency in results achieved, and that the members of this Council lose thereby a presiding officer eminently conducive to harmonious and successful administration of the City's affairs.[102]

Kroehler moved to Hinsdale but returned to Naperville every day to conduct business. He never forgot his adopted hometown, his employees or his first factory at Naperville. Kroehler instilled civic responsibility into his children, whose philanthropy benefited the YMCA, North Central College and Naperville.

The growth of the Kroehler Manufacturing Company and the growth of Naperville seem to go hand in hand. Many significant changes took place in Naperville between 1900 and 1917. The town of Naperville was growing. New school buildings were necessary. Saints Peter and Paul Catholic parish built Wenker Hall in 1911 for grades one through eight. Wenker Hall was named after the beloved Reverend August Wenker, who died suddenly before the school building was finished. Seven years later, Naperville School District 78 erected a "modern" three-story high school building on North Washington. The school was built with a cafeteria, gymnasium, science and domestic arts labs and classrooms for the 193 students and 12 teachers. Prior to 1916, the high school classes met in the upper levels of the Naper and Ellsworth graded schools. Both the Masonic orders and the First National Bank of Naperville were growing, too. After renting various rooms around Naperville for sixty-eight years, the Masons decided to build their own temple, and the bank decided to move to larger accommodations. The bank moved into the old Moses B. Powell Drug Store on the northeast corner of Washington and Jefferson that at the time was being used as the Naperville Post Office. The old brick building was resurfaced and made to look like a Greek temple. The Masons moved down the block from the old bank on Jefferson. They built meeting rooms on the second floor and rented retail space on the first floor. To accommodate the growing need for city services and administrative needs, the City of Naperville bought the old bank

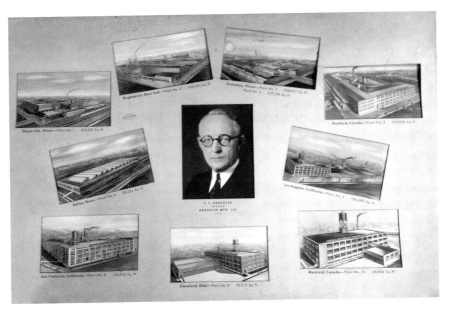

Peter Kroehler and nine furniture factories. The company grew to twenty-two factories in the United States, Canada and Mexico. *Courtesy of the Don and Bari Landorf family.*

building and turned it into city hall. The offices of the city clerk, treasurer and, at one time, the police department were located on the first floor. The city council met upstairs.

In 1915, druggist William W. Wickel sold his pharmacy to his son-in-law, Louis Oswald, who changed the name to Oswald's Pharmacy. Although Wickel and Oswald had many years of experience and recipes for medicinal cures for people, they could not prevent or treat the dreaded and highly contagious viral hoof-and-mouth disease that affected livestock. Nor could Naperville veterinarians like J.E. Stiles and F.D. Hart. Once a herd was infected, the animals had to be put down. Many Naperville farmers lost animals to this terrible disease. In a community where economic livestock outnumbered their human caretakers, the war on hoof-and-mouth was a real threat to Naperville.

World War I or, as it was known at the time the "Great War" or the "War to End All Wars," started in Europe in 1914. Donald F. Tingley, Eastern Illinois University professor and author of *The Structuring of a State*, writes:

> *World War I wrought havoc in the lives of Illinois citizens....The people of Illinois found themselves organized, taxed, regulated, and regimented in*

unprecedented fashion; their eyes, ears, and minds were assaulted constantly with patriotic slogans....World War I, as war always does, set off waves of intolerance and bigotry.[103]

Many German families in Naperville, both recent immigrants and those who had been in Naperville since the 1840s, lived in a state of anxiety over their relatives in Germany and U.S. sentiment toward German Americans. Pressure to eliminate all things German was also felt in the community. As was common across the United States, some Naperville families changed their names to sound more American. At the college, a program with all coursework in German was eliminated. The United States formally entered World War I with a declaration by Congress on April 6, 1917. At the time, Naperville spanned only three-quarters of a square mile with 811 residences, 96 stores and 9 churches. During the war, Naperville and the college collaborated on recruitment, local Red Cross efforts and the sales of war bonds. The Red Cross was headquartered in Scott's Hall. President Woodrow Wilson proclaimed that all German "alien enemies" must register with the United States, and North-Western College's newspaper, the *Chronicle* of January 29, 1918, stated, "In accordance with the Presidents Proclamation dated November 16, 1917, all male German alien enemies of fourteen years of age and upward, residing in this post office district, are required to register under the direction of the Postmaster."[104]

During the war, Naperville women often took up the hammer, plow or keys to the car, truck or tractor to support their families. The cultural shift was noticed acutely in 1927, when Hilda Diehl won top honors at the Wheatland Plowing Match for plowing, not baking. Miss Egermann's letter and care-package campaign helped Naperville soldiers feel connected to their families and community while serving during the war. In turn, the soldiers' letters and postcards brought news of the war and descriptions of other lands and cultures to Naperville. More than three hundred Naperville men served in the armed services during the war. Some returned home wounded; seven died either in the States or overseas. Mayor Francis Kendall's son Oliver Julian "Judd" Kendall was among those who did not come home. While on a reconnaissance mission behind enemy lines, Lieutenant Kendall was captured by the German army. Believing Kendall to have valuable information, the Germans held and tortured Kendall, who would not give up the position of the First Division or of the future Battle of Cantigny. Kendall was killed on May 25, 1918. The Battle of Cantigny would be the turning point for Allied victory in the war. Less than a year after her husband,

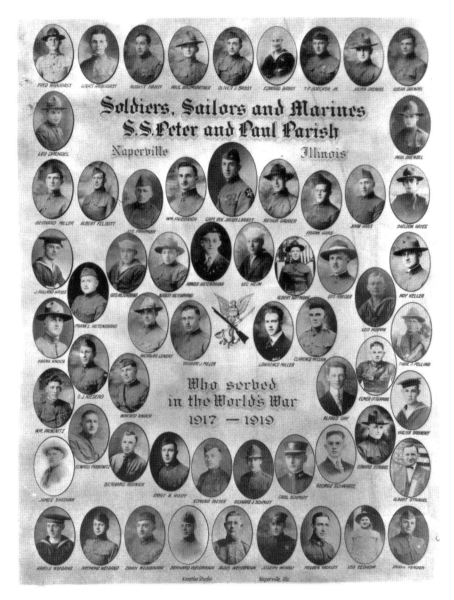

World War I soldiers and sailors from Saints Peter and Paul parish. Photo composite by
Charles Koretke. *Courtesy of Kramer Photography.*

Mayor Kendall, died in office, Linne Kendall learned the news of the death
of her son in Germany. His body was discovered by American forces and
buried in the Somme American Cemetery and Memorial in Bony, France.
Local Veterans of Foreign Wars (VFW) Post 3873 and Jackson Avenue were

honorarily named after Judd Kendall. On Memorial Day 1997, eighty years after his death, the U.S. Army posthumously awarded the Silver Star, Purple Heart and World War I Victory Medal to this hero who was captured by the Germans and never divulged important information to his captors. Kendall has also been awarded the POW medal.[105]

Before America joined the Great War, the Naperville Association of Commerce decided to host a weeklong "Home Coming Celebration" in late May and early June 1917 for the purpose of showcasing Naperville's progressive transformation into a modern city. The planning, started in 1915, would highlight Naperville's modernization, including public utilities (waterworks, electric, sewers, gas mains), ornamental iron boulevard lights, concrete and brick paved streets, the railroad station and more. On the education front, Naperville was eager to spotlight its new high school and contemporary facilities at the college. Other points of pride were Naperville's many houses of worship, its new YMCA building and its active business community, including the furniture making of Kroehler Manufacturing, the butter and ice cream making of Naperville Consumer's Company, First National Bank, Reuss State Bank, five motor garages, the new Masonic temple, several store buildings, stone quarries, nurseries, greenhouses and more. The Edward Sanatorium was also spotlighted. The Home Coming festivities of 1917 were massive for Naperville. Preparatory, agenda and wrap-up details dominated the pages of the *Clarion* for weeks. On June 1, the newspaper published on its front page a lengthy list of all visiting guests and the cities from which they hailed. Many guests came from Chicago and neighboring municipalities like Aurora, Glen Ellyn, Lisle, LaGrange, Oak Park and Elgin. Some traveled from distant states like Louisiana, Pennsylvania, Wyoming and California. The 1917 Home Coming set the bar for future Naperville celebrations.[106]

At the end of World War I, the Eighteenth Amendment to the Constitution was passed. The new constitutional amendment prohibited the manufacture, sale or transportation of intoxicating liquors within the United States for beverage purposes. The Volstead Act, passed in 1919, would enforce the amendment. The members of the temperance clubs and prohibition movement of Naperville rejoiced as the saloons closed. Some reopened as "drinking" clubs serving soft drinks or tea. A drinking club called the Limited Club was founded on Main Street in the old Hobson Law Office in 1921. About this same time, Samuel Rubin moved his family to Naperville across the street from the Limited Club to conduct a dry goods business. The Rubins are considered the first Jewish family to live in

Naperville. Both of Sam's sons, Norman and Alfred Rubin, grew the family business and instilled in their families a deep sense of pride and benevolence for their community. When a new store was necessary, the Rubins moved the historic Hobson Law Office (then known as the Murray Building) from Main Street to Fremont Street as a home for Carl Manes and his family. A tearoom was opened on the second floor of Scott's Block in 1925 by Clarence Croft, a graduate of North-Western College. Before Croft hired Louis Paeth, a Naperville son and Chicago commercial artist, to redecorate, the establishment was simply known as the Tea Room. Paeth used the Spanish Revival style that was popular in the 1920s to create such rooms as Alhambra and Granada. Croft changed the name to the Spanish Tea Room. The restaurant and dance floor were even frequented by Chicagoans because of the big bands that would perform. Naperville had many popular hangouts during this decade, including the soda fountains in local drugstores like Oswald's. A small group of golfers formed the Naperville Country Club and purchased land, previously owned by the Sleight family, in 1921. Nine greens were constructed in 1924, and the full eighteen-hole golf course was completed in 1927.

The brief period of prosperity following World War I called the Roaring Twenties was not all fun and games for Napervillians. On the morning of June 4, 1922, Saints Peter and Paul Church was completely destroyed by fire. In the June 8 issue, the *Naperville Clarion* described the fire and its destruction. Pictures taken by Charles Koretke were also included. Fire investigators believed arson to be the cause, though no one was ever accused or convicted. The June 8 issue of the *Naperville Clarion* included a description of a large Ku Klux Klan (KKK) rally held in Plainfield on the night before the fire. The presence of the KKK in Naperville has never been verified. Images of college students in white robes in the NCC yearbooks may be more parody than participatory. Naperville sentiment in the 1920s would not have been all that different from other American cities but perhaps more tolerant due to its religious institutions. However, KKK information-request postcards with the motto and beliefs of the KKK also list a Chicago post office box as a return address. This address was scratched off and a Naperville post office box, "Box 75," written in its place. Because there is no date on the postcards, the owner of this post office box may never be positively identified. Naperville post office records list a Hans Larson paying quarterly rent for Box 75 in 1921, but there is no proof that he was a member of the KKK. The community of Naperville supported its Catholic neighbors while the church rebuilt. Local congregations shared their sanctuaries with the

Postcard of the Spanish Tea Room. The Spanish Revival theme for Clarence Croft's restaurant was created by Naperville artist Louis Paeth. *Courtesy of Paul Hinterlong.*

parishioners of Saints Peter and Paul while a new church was built. A year later, another church fire of unknown origin was started in the basement of Grace Evangelical Church. In 1927, the gymnasium at the college, Nichols Hall, also burned to the ground. Saints Peter and Paul built the current church building in 1927, Grace Church was restored and enlarged by 1924 and Merner Field House was built in 1931 to replace Nichols Hall.[107]

The restoration of these buildings was part of the many building projects in Naperville in the late 1920s. Bethany Lutheran built a new church. North-Western College changed its name to North Central in 1926 in the midst of a building boom on campus. Beidelman Furniture store and funeral chapel built a large three-story Gothic Revival building on the corner of Jackson and Washington. It was the first Naperville building to have an elevator. New subdivisions were being added, and two modern grade schools were built. Both Naper and Ellsworth Grade Schools were torn down and replaced in 1929. The necessity of new grade schools was precipitated by an increase in Naperville population. In 1920, the population of Naperville was 3,830, and in 1930, it was 5,118.

The Roaring Twenties came to a halt in late 1929 with a significant fall in stock prices that helped trigger the severe economic downturn known as the Great Depression. Naperville was not initially affected with hard

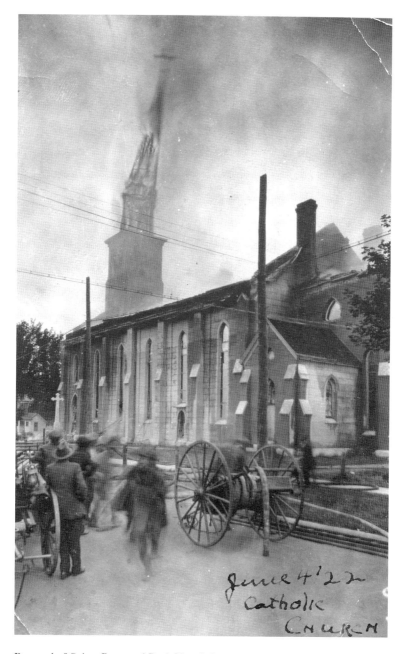

Postcard of Saints Peter and Paul Church fire, June 4, 1922. Note the hand-drawn firehose cart. Photo by Charles Koretke. *Courtesy of Paul Hinterlong.*

times. Planning had already begun for the 100th anniversary, or Centennial Celebration, of the founding of Naperville. In February 1931, as Naperville approached its 100-year birthday, the *Clarion* was addressing the question of why a centennial celebration should be held. The newspaper gave readers three main answers:

> *Sentiment! That's the first reason for our coming celebration. We love to "remember way back when" a log house, a fort, a covered wagon and a plank road represented the acme of civilization and to contrast them with the homes, the public buildings, the motors, and the forty-foot speedways of today.*
>
> *Pride! We like to see how far we have come and to let others see it too. Here then is the second reason. In her public improvements, educational facilities, churches, parks, forest preserves, and business opportunities, Naperville has much of which to be proud.*
>
> *Hope! And as we grow sentimental and somewhat boastful let us not forget the future. A successful centennial celebration will require the whole-hearted cooperation of every loyal citizen. Political, religious, economic and social differences will be forgotten, and the road thus paved for future progress such as we have never dream[ed] of.*[108]

The *Clarion* also explained that one of the primary objectives of the centennial was to establish a permanent memorial—a birthday present from the city to its citizens. By the end of March 1931, the memorial was determined and being reported by the *Clarion* to its readers: "Lake Von Oven, Twin Lakes and forty-five acres of abandoned quarry and DuPage River frontage have just been purchased from the Natural Products Company and this magnificent piece of park and forest preserve is to be dedicated June 6th, 1931, as the permanent memorial of the Centennial Celebration." The $16,500 property purchase, a longtime ambition of Napervillians, was credited to the efforts of the Permanent Memorial Committee, chaired by William R. Friedrich, and was underwritten by thirty-three residents. "It may have taken us a hundred years to do a big job like this, but it was worth doing. It's one of the greatest things that has ever happened in our history," reported the *Clarion*. "A safe swimming hole for young and old, a place for row boats, canoes and speed boats, the cleaning up and beautification of our greatest natural asset the DuPage River."

The agenda for June 5–6, 1931, was packed with a five-mile-long parade, a six-hundred-character historical pageant and a variety of entertainment.

The morning of Saturday, June 6, was reserved for the dedication of Centennial Park. With more than $88,000 of its own money plus assistance from government programs like the Civil Works Administration, the Illinois Emergency Relief Commission and the Works Progress Administration, Naperville was able to complete work along the DuPage River and open Centennial Beach, including the bathhouse, in 1937.[109] The celebrations were not without controversy. The beautiful beach and park with its many amenities is the design of landscape architect Eric Baumgart, who at the time was a German-born Napervillian not yet naturalized as a United States citizen. At the May 31, 1932 Naperville City Council meeting, a petition was presented requesting the council "remove from the payroll of the work done at Centennial Park, Eric Baumgart," and later still on July 15, 1935, another petition was presented to the council to terminate the "employment of Eric Baumgart as grounds keeper for city parks." Baumgart had immigrated to Naperville to live with his relatives, the Ruckerts, when he was twenty-one. Anti-German sentiment was widespread despite the large number of Napervillians whose ancestry was German. He died in 1942 at the age of thirty-seven, leaving a wife and infant son, Erich. A portion of his obituary extolls his skill but mysteriously excludes reference to his work on Centennial Beach:

> *He became a useful member of our community, decided to remain here, made application for citizenship and was duly naturalized as an American citizen. For many years he has been in the employ of the Naperville City council, holding at the time of his demise the position of assistant superintendent of parks....His artistic and creative talent is largely responsible for some of the major improvements in our city. There stands in our midst a fine and useful monument to his skilled workmanship and to his creative imagination. A monument of which any town may justly be proud.*[110]

The delight and enthusiasm shared by so many people during Naperville's centennial celebrations faded to the gritty realities of the Great Depression. Prior to President Franklin D. Roosevelt taking office in 1933 and enacting the New Deal, several churches, clubs and local government worked to provide relief locally. Naperville daughter Doris Wood collected statistics and stories from Naperville residents into an unpublished book called "A Small Town Weathers the Depression." Wood said:

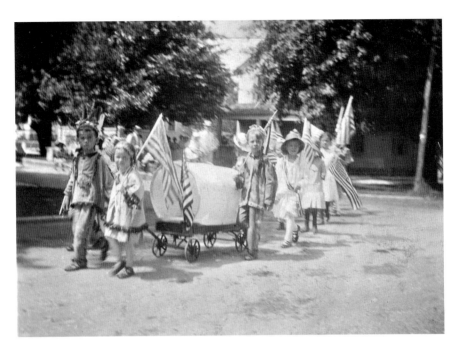

From the 1931 Children's Parade, part of the many centennial celebration events planned in 1931 to commemorate the founding of Naperville. *Courtesy of Paul Hinterlong.*

Postcard of the DuPage River. The island and dam were part of Eric Baumgart's general landscaping plan for Centennial Park. *Courtesy of Paul Hinterlong.*

Postcard view of Centennial Beach. Centennial Beach has been a popular summer destination for Napervillians and visitors since 1931. *Courtesy of Paul Hinterlong.*

Naperville sure had a lot going for it. Surrounding farms were fertile, its people industrious, its merchants conscientious and paternal, its city solvent, and a major industry, Kroehler, which although drastically curtailed in the early part of the depression, did not shut down except for four weeks during the strike of 1934. Less tangible, but of no less importance, was the spirit of its residents. The slogan of the Association of Commerce was "Do it For Naperville" and it fit the attitude of the townspeople. Although they had more time, less money and fewer illusions, they had a strong sense of community and of optimism.[111]

The surrounding farms were fertile most of the time. Drought brought on chinch bugs, which would creep over a field like black water laying fields to waste. The bugs attacked the tender stems near the ground, and the weakened plants would topple. To stop the infestation, trenches were dug around fields and filled with oil. Wally Schmidt told Wood, "As a gimmick, and perhaps out of sympathy, farmers were admitted to the World's Fair in Chicago (1933) with a quart jar of chinch bugs rather than money." In 1932, Naperville resident Ed Ulrich, an army cook in World War I, took a thirty-dollar-per-month job serving food in the local soup kitchen located

on the west side of the City Light Plant. "I went to work at 7 a.m. and often didn't quit before 10 p.m.," Ulrich told *Sun* reporter Genevieve Towsley in 1959. "I know there must have been some kids whose parents didn't know they were there, but I never could turn a hungry youngster away." The Knife and Fork Club solicited funds and food for the Community Kitchen. Mayor Alexander Grush issued a notice assuring that Naperville residents who were in need would find relief. The notice also informed the "floating population," or vagrants, that they would be given assistance once but would be asked to work off fines on civic improvement projects if they lingered. Paul Brock, a mason contractor, talked about his role as a supervisor on the Centennial Beach Bathhouse and Main Street Bridge projects:

> *There was a lot of work hauling stone and pumping water from the caissons. Lots of people had nothing to do but walk the streets and they were real glad to get jobs. The pay was 35 cents an hour....As supervisor, I was told to hire as many local men as possible to create employment.... The hardest part of the job was when men who lived outside the city limits asked for work. I was not allowed to hire anyone who didn't live in Naperville proper and turning them away, destitute, with tears in their eyes, was really hard.*[112]

Initially, local relief efforts started with the family, neighbors, the city, the township and the county. As the Depression spread in intensity, the federal government began to offer assistance programs. One of President Roosevelt's alphabet agencies under the New Deal legislation was the Civilian Conservation Corps (CCC), which established a six-barracks camp at McDowell Grove, now McDowell Forest Preserve. About two hundred relief workers built bridges, picnic areas, a boathouse, bridle paths, a limestone dam and the first paved walkways along the west branch of the DuPage River. The corps was discontinued in 1937, and following the bombing of Pearl Harbor in 1941, the barracks became a secret radar training facility for the U.S. Army Signal Corps.[113]

Perhaps one of the most significant businesses that took its start in Naperville and actually flourished during the Depression was Prince Castle Ice Cream. Boyhood friends Earl S. Prince and Walter S. Fredenhagen joined forces in 1931 to make ice cream. Ice cream is an affordable, easy-to-make-and-sell treat that was welcomed on a hot summer day. Prince was the inventor and Fredenhagen the dairy product producer. Prince designed prefabricated castlelike buildings that could be assembled just

about anywhere. Fredenhagen's creamery collected milk from the Naperville farmers and made ice cream in many different flavors. Fredenhagen called his ice cream Frozen Gold. Prince Castle drive-ins were located across the state of Illinois in two territories, one managed by Prince and the other by Fredenhagen. Earl Prince invented many industry firsts, including the square scoop that reduced the scooping time and presented a novelty portion and the open freezer with a glass front allowing the customer to see the ice cream as it was being scooped. In 1937, after a conversation and field trip to Michigan with paper cup salesman Ray Kroc, Prince and Fredenhagen introduced the One-in-a-Million shake. Ray Kroc told the story of the new shake in his book, *Grinding It Out: The Making of McDonald's*:

> *An engineer from Sterling, Illinois, named Earl Prince had a coal and ice business he was phasing out, and he was building little castles in towns all around Illinois in partnership with a boyhood buddy of his named Walter Fredenhagen. They called them Prince Castle ice cream parlors....They bought paper cups from me. I kept my eye on them, I thought their operation had a lot of promise.* [Kroc asked Prince and Fredenhagen to make frozen milkshakes, and Fredenhagen responded,] *"Ray, you are a nice guy, and I like you. But I do not want to get into the milk shake racket. We do a nice clean ice cream trade here, and the last thing I want is a big clutter of milk bottles to handle. It's too messy."...Both Earl and Walter had their eyes opened on that trip to Battle Creek. They were sold on the frozen milk shake and wanted to start with their own version immediately. The whole trip back to Chicago was spent planning for a new operation with the shake that Earl announced he was going to call the "One-in-a-Million."*[114]

The shake sold so well that Prince had to invent a metal collar for the top of the cup used in mixing the shake and, later, a five-armed mixing machine he called the Multimixer that would mix five shakes at one time. Kroc was hired to sell the Multimixer to other restaurants and drive-ins across the country.

In 1936, Harold Moser, who had founded the *Naperville Sun* a year earlier, sold the newspaper to Harold White Jr. and Gordon Haist. The *Sun* was originally a free paper delivered to about two thousand households. The paper was printed in Downers Grove, but White moved the presses to Naperville in 1939. The office and presses were located on the second floor of Scott's Block in the rooms of the old Spanish Tea Room. Moser started

the newspaper to compete with the sixty-eight-year-old *Clarion* published by David Givler. Both local papers competed for advertising dollars and readers seemingly without animosity.

In October 1936, the *Sun* and the *Clarion* reported the passing of Mrs. Edward (Caroline Martin) Mitchell, the last descendant of her grandfather and Naperville pioneer George Martin. During the Naperville centennial in 1931, Mrs. Mitchell displayed some of her family's treasures in the front window of Broecker's Department Store. She carefully labeled each item as if it were a museum display. In 1933, she opened her home to visitors in commemoration of the centennial of her grandfather's arrival in Naperville from Scotland. Mrs. Mitchell was the last of her immediate family. Her conversations with Naperville son Judge Win Knoch led to a carefully prepared plan for the disposal of her estate that included 200-plus acres of farmland with barns; a large Victorian mansion, Pinecraig, full of family heirlooms; and the 1830s pioneer frame home of her grandfather called Century House. Knoch had experience helping clients organize trusts and estate planning. In 1922, he worked with Joy Morton to establish a foundation to create the Arboretum. Shortly after the death of Mrs. Caroline Mitchell, Napervillians learned the intent of her will. Century House and her home, Pinecraig, were to become museums and showcase her family's and Naperville's history. The acreage around these homes would be a public park. The remaining 200-plus acres of land were to be used for unspecified public good. After Mrs. Mitchell's will had made it through the probate courts in 1939, the *Clarion* explained to its readers that Naperville had just gained a new park that was "49 acres larger than the Chicago loop (156 acres)." In September 1939, during the DuPage County centennial, the Caroline Martin Mitchell Museum opened to visitors. Miss Egermann's history collection from the Nichols Library was moved to the museum. Thousands of visitors toured the exhibits and furnishings during the celebrations. In addition, the grounds were packed for an air show that was held over the park. Century House was rented out but never used as a pioneer museum. The fields were worked for many years before they were carved into parcels for the new high school and athletic fields, more cemetery lots, the Sportsman's Club, Rotary Hill, the public gardens on West Street, half interest in the Von Oven Scout Camp and a small portion of Edward Hospital complex. Pinecraig and the Martin Mitchell Park are known today as Naper Settlement.[115]

In the election of April 1939, Mayor James L. Nichols II won reelection and the "wet faction" of Naperville held the majority, allowing the retail sale of liquor in the city. North Central College reported 587 students from

eighteen states and five nations, and the third annual Naperville Auto Show was held at North Central's Merner fieldhouse, featuring new car models and merchandise vendors. The radio, as a medium of entertainment and news, had been gaining popularity since the late 1920s. For a short time, Kroehler made elaborate radio cabinets. There is no evidence that Orson Welles's broadcast of H.G. Wells's *War of the Worlds*, about a Martian invasion of the planet, caused mass hysteria in Naperville. What did concern Naperville was the news that Germany invaded Poland in September 1939. Though America declared official neutrality, embargoes were enforced and supplies were provided to the Allied forces of Britain, France and Russia. America was preparing for another world conflict while Naperville was building a brand-new stand-alone post office. Since the first postmaster, Alexander Howard, was appointed to process mail in Naperville in 1836, the post office location had moved among postmasters' residences or a variety of rental locations downtown. A brand-new Art Deco–style Naperville Post Office building was built on the corner of Benton and Washington to serve Naperville's growing population and the letters, parcels, newspapers and magazines it would receive and send. By 1940, the Naperville census was 5,273, still 4,727 short of Givler's prediction of 10,000 by the year 1900. It was at this time, also, that the streets were uniformly numbered and given direction. Numbers on the west and north sides of the streets were odd. The numbers on the east and south sides of streets were even. Benton Avenue split Naperville into north and south, while Washington Street split Naperville into east and west. Initially, mail was delivered twice a day. Personal letters and business correspondence were delivered in the morning and magazines in the afternoon.[116]

Two years later, immediately following Japan's surprise attack on Pearl Harbor on December 7, 1941, the United States declared war on Japan and soon also Germany and Italy. World War II had a profound impact on Naperville. During the war, building construction was significantly reduced, and hundreds of young Napervillians, men and women, joined the armed forces. School curriculum was adjusted to meet the growing employment needs of agriculture and industry plus course offerings on electricity, radio and aeronautics. In 1943, North Central College launched a basic engineering course under the Army Specialized Training Program. Like many American factories, Kroehler adjusted its production lines in the majority of its plants to support the war effort. These factories produced more than two hundred war-related items. Furniture upholsters made backpacks, bedrolls, shoulder and gun straps and other cloth

Postal cachet of the November 16, 1940 official dedication of Naperville's first permanent post office, now Naperville Bank & Trust. *Courtesy of Paul Hinterlong.*

materials for army use. The furniture assemblers made propellers and other airplane parts, desks, filing cabinets, chairs and tables for officers, lockers, practice shells and artificial limbs. Naperville women joined the production lines during this time. Rationing affected all residents but was not such a hardship for farm families, many of whom had large stores of food in root cellars and pantries. Naperville farm families, however, were not immune to the effects of the world war. Gertrude Miller, living on the Jonathon Royce farm south of Naperville, lost her husband, John, eleven months before the bombing at Pearl Harbor. Her story is told in *Naperville Area Farm Families History*:

> Gertrude [Miller] *sold the Royce farm and bought the smaller Schrader farm near Barber's Corners during World War II. The reason for this was that son John was in the Army Air Force in Guam, son Paul, a Marine, was island hopping in the South Pacific and son Peter was in the Navy and also in the Pacific, leaving Gertrude with only 15-year-old James to help on the farm, so, therefore, the oldest son, August, quit his mechanical job and came back to operate the farm during World War II.*[117]

Harold Vial, a dairy farmer, had to sell his herd of one hundred cattle because "it was impossible to hire men to help because of the draft." The Wheatland Plowing Match suspended meeting during the course of the war.

On the west edge of Naperville, the top-secret radar installation at McDowell Grove trained as many as four hundred men during the war. It was a source of wonder and intrigue for Napervillians. Miss Egermann and the Nichols Library organized another Victory Book campaign, providing books to servicemen and women. As the war dragged on, Egermann collected the photographs of Napervillians serving in the armed forces. She created a display in the library "where the public can become better acquainted with those from this community who are in the service of our country." In addition, Egermann promoted books from the library on gardening to encourage and assist those growing Victory Gardens. With all the resources and conveniences of a city, Naperville and America were destined for victory.[118]

Chapter 6

A HOMEOWNER COMMUNITY WITH BALANCED COMMERCIAL AND INDUSTRIAL AREAS

What kind of Naperville do you want? A homeowner community with balanced commercial and industrial areas? Or a community existing for the benefit and profit of land developers and foreign financial institutions?…The City Council will decide.
—*advertisement excerpt*, Naperville Sun, *May 30, 1968*

T he news of the first use of an atomic bomb during war must have affected Napervillians with both wonder and horror. Although the Manhattan Project that developed a successful atomic bomb was researched in secret and unbeknownst to residents of Chicago and the suburbs, Napervillians were aware of the secret government activity at Camp McDowell. After the second atomic bomb was dropped on Japan on August 9, 1945, and the eventual Japanese surrender five days later, Napervillians rejoiced that the war was finally over and their loved ones would return. "The lights burned late in many Naperville homes as celebrants went from house to house, visiting people they had never met before," the *Naperville Sun* reported. "Introductions were not necessary on this momentous occasion. Naperville 'let its hair down' as it never has in the past, and as it probably never will again."[119]

The long night of celebrations did not ease the harsh local realities of war. Multiple Naperville families had been notified earlier in the week that their sons were missing in action. The victory celebration coverage in the *Sun* shares the same page with two reports about War Department telegrams

Tri-fold flyer promoting movies screened on February 20 and March 5, 1948, at the Naper Theatre on Jefferson Avenue. *Courtesy of Paul Hinterlong.*

arriving at Naperville homes with sad news. Two Naperville familes were informed that their sons, Larry Nadelhoffer and George Massier, were also missing in action. The news was even more tragic, as both families had missing sons already.[120]

Less than a month later, residents were slowly moving forward into postwar lives, learning of Kroehler Manufacturing Company's plans to hire two thousand employees over the next twelve months and invest $1.2 million in plant expansions. According to the *Clarion*, "The company, whose ten plants are located throughout the United States and Canada, has been producing a limited amount of furniture for civilian consumption during the war years, in addition to extensive government work covering more than 200 different war items."[121]

Kroehler, with more than $20 million in annual sales in the mid-1940s, was anticipating significant increases in furniture demand with soldiers coming home and families expanding. At the Naperville plant on Fifth Avenue, Kroehler planned to hire five hundred new employees, almost doubling its local workforce and helping reinforce Naperville's status as a factory town and furniture manufacturer of the world. The Naperville plant alone made as many as five thousand major pieces of upholstered furniture a week.[122]

Oliver J. Beidelman Furniture and Undertaking, located at the corner of Washington and Jackson, was also foreseeing growth at the war's end and promoted its Kroehler collection to attract shoppers. In October 1945, Beidelman's local newspaper advertisement read:

When he comes home, will your home be everything he's been looking forward to? Or will it be just the same old house, with worn-out, unsightly furniture…the same old "easy" chair with broken springs and soiled, worn covering? Now, you can start to make your home the kind he's always wanted (and you too). And start right away with one of our brand new Kroehler 5-star Comfort Construction living room suites. They're better looking…more comfortable than ever.[123]

As Naperville students went back to school in September 1945, enrollment numbers reached 1,042 total students from kindergarten through high school. Naperville public school enrollment remained relatively unchanged from 1945 to 1948, but District 78 officials were anxious to address several issues that were magnified during the war years, as well as brace for significant enrollment growth expected in the years ahead. However, financial resources had been scarce during the Great Depression, and school construction projects slowed during World War II. Plus, many teachers left their jobs for higher-paying ones. "If teachers' salaries cannot be raised sufficiently to retain quality instructors, vacancies will occur, which cannot in most cases be filled at current salaries unless inferior teachers are considered," said school superintendent Ralph E. Beebe, who persuaded Naperville residents to vote in favor of a tax increase in 1945 to increase teacher salaries and plan for facility growth to support more students.[124]

Kroehler furniture workers. Generations of the same family would accumulate hundreds of years of service for Kroehler. *Courtesy of Kramer Photography.*

In 1946, the City of Naperville sold District 78, a portion of the Caroline Martin Mitchell estate bordered by Aurora and West Street, to be used as the site of a new high school building. Prior to the sale, plans had been drawn for a municipal airport to be built, including three runways and a small terminal, on the land south and west of Pinecraig.[125]

Beyond the public schools, Naperville Catholic and Lutheran schools had attendance of 308 and 34 students, respectively, in 1948. That same year, Naperville was also a bustling college town with nearly 1,000 students enrolled at North Central College. In 1945, Kroehler Manufacturing Company announced gifts of $25,000 to North Central College, $25,000 to the Naperville YMCA and $10,000 to the Evangelical Theological Seminary, as well as varied amounts to Naperville churches. "With the gift to the college, [Delmar] L. Kroehler, president of the company, expressed hearty accord with plans for the future development of the college and a sharing of interest in the establishment of a Kroehler memorial at the college. Including the recent gift, the company has given the college a total of approximately $55,000," reported the *Chicago Tribune*. The memorial was to remember Peter E. Kroehler, founder and chairman of the Kroehler Manufacturing Company, who died in 1950.[126]

Naperville's population slowly grew to 7,013 during the 1940s, but it remained a thriving farm town during the decade, unaffected in large part by postwar urban sprawl until the late 1950s. During the period of 1921 to 1946, the number of tractors on Illinois farms increased from 23,000 to 150,000, and several of those were certainly active on the dozens of Naperville-area farms. In addition to local dairy farms, alfalfa, hay, wheat, corn, oats, barley and soybeans were among the many crops grown by resident farmers.[127]

In 1946, the razing of the Pre-Emption House tavern shocked some residents and aroused local preservation sentiment that influenced the work of artist Les Schrader and newspaper columnist Genevieve Towsley. Schrader, a sign painter and wood finisher at Kroehler, painted a scene of the once regular Horse Market Days in front of the Pre-Emption House to remember and preserve the old building. He even used wood from the structure to make a frame. Over the years, Schrader painted an additional forty-one paintings of historical scenes from Naperville. These colorful paintings now form an important part of Naperville's cultural heritage. Though not a native of Naperville, Towsley embraced her adopted community and inadvertently began to preserve its history in her newspaper columns in the *Clarion* and *Sun*. Her words have helped shape the preservation of

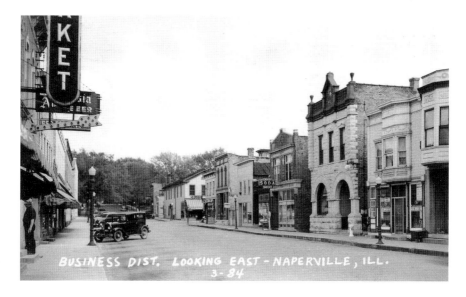

Postcard view of the south side of Jefferson Avenue looking east in 1942. *Courtesy of Paul Hinterlong.*

significant Naperville landmarks and formed a text that is still a valuable resource tool. In 1947, the Association of Commerce changed its name to the Chamber of Commerce, and Naperville created a Planning Commission for making thoughtful growth recommendations and staying informed with urban planning and zoning best practices. As part of its early reporting, the Planning Commission noted the city had 2,649 telephones in service, of which 581 belonged to businesses. This represented a 214 percent increase in phones since 1920. Among the largest Naperville employers in 1947 were Kroehler (1,300 employees), Prince Castle (40), DuPage Boiler Works (30), Naperville Nurseries (25) and National Bag Company (15). During the next several years, Naperville would cement its reputation as a commuter town with about fifty modern trains a day between Naperville and Chicago on the CB&Q Railroad lines, and cars routinely parked fender to fender for blocks around the station.[128]

Naperville and the CB&Q made headlines again, in 1946 when two passenger trains collided near the Loomis Street crossing behind the Kroehler plant. Hundreds of newspapers from Seattle to Boston reported the tragedy, which has remained one of the worst train crashes in Illinois history. But this was not the first tragedy on the CB&Q line in nearly the same location in Naperville. On the first full day of a railroad strike, February 28, 1888, an

improperly trained fireman overloaded coal in the boiler of the Denver express bound for Chicago. Because the flames were not spread evenly throughout the boiler, the engine could not make enough steam to pull the heavy train of cars. The engine was dislocated from the train while speed runs were conducted in order to fan the flames of the coal. Having set the throttle at "Full" on the return run, the engine ran backward into the mail car at full speed, telescoping into the mail car and shattering every window in the train. Passengers on the train were dislocated and injured. Three mail car workers who were crushed, burned and scalded with steam died of their injuries.[129]

The 1946 CB&Q wreck occurred on the clear, pleasant afternoon of April 25. The *Advance Flyer* passenger train had departed from Union Station in Chicago and was destined for Nebraska. It was carrying about 175 people, including many servicemen and women returning home from World War II. Just east of the Naperville station, the *Advance* unexpectedly stopped to inspect a smoking wheel. Passengers confusedly peered out the windows, curious about the cause of the stoppage. One rear-car passenger was twenty-one-year-old marine sergeant Raymond Jaeger, who had served in the South Pacific and suffered a broken leg from multiple gunshots. Following the train's stop, Jaeger stood up and walked to the back of the coach for a drink of water. Within seconds, the sight of another train barreling down the track alarmed Jaeger. "It came fast. I watched horrified. The train came on bigger and bigger," Jaeger recalled. "I turned around and ran yelling warnings toward the front of my coach. The next second it hit." The other train was the *Exposition Flyer*, a passenger train bound for California carrying nearly 200 people. According to the engineer of the *Exposition Flyer*, he was going eighty-five miles per hour when he noticed the first of two warning signals and applied the brakes, but there was too little distance between the trains to stop in time. Less than 180 seconds after its unexpected stop, the *Advance* train's last cars were crushed and derailed by the *Exposition*. The crash killed 45 passengers and injured another 100. Among the first citizen responders to the crash site was twenty-year-old Naperville resident Calista Wehrli, on leave from the U.S. Marine Corps Women's Reserve. Running to the scene from her sister's home on nearby Center Street, Wehrli immediately started helping and removing casualties from the wreckage. For eight hours, Wehrli worked side by side with hundreds of other first responders clearing debris and caring for injured passengers. The gut-wrenching stories were followed by reports of heroism, service and support. From various newspaper reports and organizational newsletters at the time, Naperville appears to have come away from this catastrophe with a stronger sense of community. In 2015,

Century Walk engaged Naperville artist Paul Kuhn to create a memorial to the victims and the first responders. Kuhn used railroad spikes to create a sculpture he titled *From Tragedy to Triumph*.[130]

With millions of soldiers now back in America and the baby boom in full effect, Naperville experienced record-setting growth during the 1950s. Its population skyrocketed 84 percent from 7,013 to 12,933 during that time, setting off increased demand for housing, city services and healthcare. In 1950, Naperville was considered a typical Midwest community, one of many small Chicago suburbs, though it did not border any other municipalities yet. It was surrounded by vast stretches of undeveloped land, particularly to the north and south, and its residents were conservatively Republican and tightly knit Catholic or Evangelical. Sunday services at Naperville's nine churches and twelve organized congregations were the only reason police needed to direct traffic. Many residents were employed by Kroehler Manufacturing Company and used First National, the only bank in town.

Aerial view of the collision of the *Exposition Flyer* engine and the *Advance Flyer* on April 25, 1946. Associated Press photograph. *Courtesy of Paul Hinterlong.*

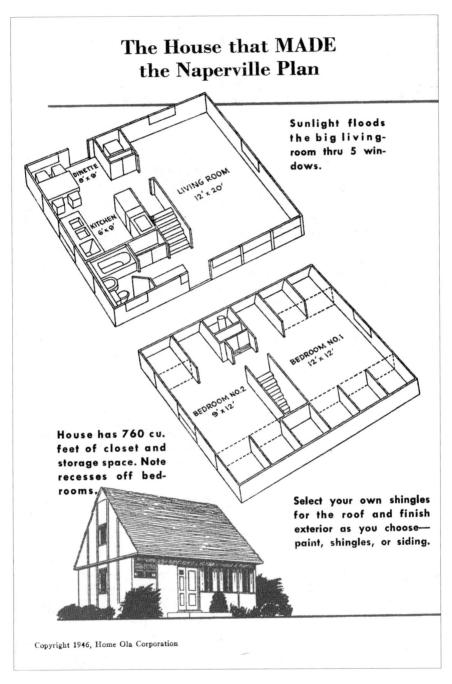

The House that MADE the Naperville Plan

Sunlight floods the big living-room thru 5 windows.

DINETTE 8' x 9'

LIVING ROOM 12' x 20'

KITCHEN 6' x 9'

BEDROOM NO.1 12' x 12'

BEDROOM NO.2 9' x 12'

House has 760 cu. feet of closet and storage space. Note recesses off bedrooms.

Select your own shingles for the roof and finish exterior as you choose— paint, shingles, or siding.

Copyright 1946, Home Ola Corporation

A page from a Home-Ola Homes booklet. A handful of these veteran-built, prefabricated homes are still standing in Naperville. *Courtesy of Paul Hinterlong.*

Most roads were still only two lanes, including Washington, which came to a T-intersection at Bauer Road.

Like so many American towns and cities, Naperville experienced an extreme housing shortage when the GIs returned home. The use of the GI Bill by a large number of veterans complicated matters for Naperville and all localities with colleges and universities where soldiers flocked for an opportunity at higher education. North Central College attracted many veterans. Naperville native Mary Anne Brock, PhD, wrote about the Naperville housing crisis in her 2017 paper, "Angeline Gale, Educator, Mentor, Naperville Service Organization Veterans Counselor and Housing for WWII Veterans in Naperville, Illinois 1945–1947":

> *Abortive attempts to build apartment houses led the Naperville City Council and Miss Angeline Gale, Veterans Counselor, to successfully establish the Naperville Service Organization (NSO) to provide temporary housing that became Trailerville* [in Kendall Park]*.…In 1945, the NSO began the task of finding homes for the veterans* [and directed veterans] *to confer with Miss Angeline Gale at the NSO office at Naperville High School. Miss Gale was uniquely qualified to serve this organization for she had been guidance counselor at Naperville High School since 1928.*[131]

The embarrassment of our soldiers living in housing that was a little better than what they had lived in while in service was appalling to most. A plan was proposed by "Frederick Jones whose advertising agency handled the account for Home-Ola pre-fabricated houses." Miss Gale and Jim Goetsch, a representative of Naperville Vets Incorporated, went to Chicago to investigate and negotiate for affordable housing for Naperville vets. The company would prefabricate all the material and ship it to Naperville via the CB&Q Railroad. Each home included plumbing, wiring and a furnace. Veterans would form teams to build these homes for one another. Normal construction time was 150 hours, but ambitious crews finished one home in 99 hours. Miss Gale and the "Naperville Plan" were given commendation by future president Dwight Eisenhower and made part of the Congressional Record. Mayor Nichols wrote a letter of support in a 1946 Home-Ola advertising pamphlet:

> *Naturally, I am proud of Naperville and our 106 years of history. But I am more proud than ever today. Our veterans are giving us a splendid example of their fine inborn qualities which they demonstrated "the hard*

way" in the war. Their courage, determination, team-work and individual responsibility are winning the battle of housing much faster than in most other cities. I am proud of these men and of their fellow townsfolk whose unselfish cooperation has helped greatly to get homes quickly for the fine young families of these veterans.[132]

Thirty-nine Home-Ola homes were built in Naperville. At the time of publication, only eight survive.

In 1951, Mayor James L. Nichols concluded sixteen years in office with the election of Charles V. Wellner. That same year, city council vowed to rid Naperville of outhouses on Water Street. During the decade, residents also witnessed the Korean War, the escalation of the Cold War between the United States and the Soviet Union and the heightening of the African American civil rights movement, each having its own unique local impact through the years. "With the outbreak of hostilities in Korea, Mayor James L. Nichols and other civic leaders began to organize a [war disaster] plan which when set up can be put into immediate effect in case of an air attack," reported the *Chicago Tribune* on July 27, 1950. Despite the national anxiety and local growing pains, Naperville remained a wholesome, big-hearted community, able to escape stressful news with the help of Centennial Beach, Naperville Municipal Band concerts, more than 120 active clubs and organizations, the Young Men's Christian Association and many local sports, including the Redskins (changed to Redhawks in 1992) of Naperville High School and the Cardinals of North Central College. Plus, North Central College often hosted top-tier speakers, such as poet Carl Sandburg and Senator Robert A. Taft, the eldest son of President William H. Taft. According to the *Sun's* Genevieve Towsley in 1953, Naperville is also "where the druggist takes you home when you ask to call a cab. Where a hardware man will sell you doorknobs and then offer to put them on for you. Where a doctor sits up all night by the bedside of a critically ill patient."[133]

In early December 1952, a massive citywide search began for two Naperville children, Jean Peterson, six, and Edward Rosenstiel, three, who disappeared without a trace while playing in Rosenstiel's backyard. More than one thousand people searched for weeks as part of a regional effort that united the community during the Christmas holiday season. The *Sun's* Jean Schmus reported that Naperville's "extraordinary manifestation of courage, kindness and love" displayed during the search demonstrated the "true meaning of Christmas." Volunteers worked tirelessly to wade through

Tony del Ciello was a familiar street vendor in Naperville. Ciello started sharpening services in the western suburbs around 1976. *Courtesy of Paul Hinterlong.*

the DuPage River and drain more than fifty million gallons of water from the quarry and look for the bodies through two feet of mud. The large-scale search was matched by a giant volunteer effort. The Salvation Army provided food and hot drinks, and numerous local restaurants and families contributed complete dinners or snacks, which were distributed to the

workers by more local volunteers. A variety of other donations poured in from community groups, corporations and individuals.

The bodies were eventually discovered in the DuPage River near Webster Street, and funerals were held in early February 1953, but the mystery of their deaths remained unsolved. According to the *Chicago Daily Tribune*, the community was baffled by the location of the bodies, and some, including Marshal M. Erb, doubted the bodies had been in the river since their disappearance. Multiple attempts to search the river before, during and after the quarry draining took place with no discovery during the initial efforts. "Officials and citizens who took part in searching the shallow river said they were unable to understand how experienced men, using grappling hooks from boats and wading in hip boots, could have overlooked both bodies." A month later, a DuPage County coroner's jury decided the children had accidentally drowned.[134]

In 1955, Edward Sanatorium, one of the Midwest's first tuberculosis treatment centers, was converted into a community hospital. The new board of directors of Edward Hospital had fifteen members, including board president Judge Mel Abrahamson and Judge Win G. Knoch. The board officially assumed operational responsibilities of the two-story, forty-five-bed general hospital on October 1, 1955. "Naperville people and those in the surrounding area now have their own hospital—a sound building, well-equipped, and capably staffed with doctors, nurses and other professional people," Abrahamson told the *Naperville Sun*. The first patient was two-year-old Freddie Maurer, who was kicked by a horse. To help raise money for the new hospital, several farmers did what they do best: they banded together and offered what they could to help their neighbor. An auction of equipment and livestock, including cattle, chickens, ponies and geese, netted the hospital nearly $6,000. In addition, the new Edward Hospital received a grant of $59,600 from the Ford Motor Company Foundation.[135] Within four years, Edward had become a public, tax-supported hospital, and Eugene Morris was hired as hospital administrator. Morris led the hospital through major expansion projects; the first, in 1962, more than doubled the number of hospital beds to 110. On July 1, 1966, Eugene Morris watched Lillian Avery, a patient at Edward Hospital, sign the papers making her America's first Medicaid recipient. A Napervillian, Duane Carlson of Blue Cross Association, and Robert Ball of the U.S. Social Security Administration choose Avery because she was a Blue Cross participant and a patient well on the way to a full recovery.[136] The following year, Edward Hospital built another large addition, bringing the bed count to 133.

Search team looking for Jean Petersen and Edward Rosenstiel, who went missing on December 7, 1952. Their mysterious deaths were never solved. *Courtesy of Paul Hinterlong.*

The new Eisenhower Expressway (I-290) was completed in 1955, followed by the East–West Tollway (I-88), which opened in 1958, with Naperville Road having the first full interchange west of Oak Brook at the time. Tolls initially cost drivers of passenger cars approximately two cents per mile. This new transportation artery between Chicago and Naperville triggered a surge in residential, retail, commercial and industrial development. In 1963, Northern Illinois Gas moved its research facility to Naperville. The following year, Bell Laboratories announced it would be building a massive new facility for its electronic switching division just north of the tollway's Naperville Road interchange. Bell Laboratories estimated the 590,000-square-foot building would cost between $7 and $9 million. In the years that followed, city council helped attract and shape the development and expansion of more research and technology businesses in the Naperville area, including Standard Oil/BP, which built multiple research and laboratory buildings on its technology campus. NALCO and others formed the Research and Technology Corridor. Naperville's technology industries were a natural link

Postcard view of the Administration Building of the Edward Sanitarium, built in 1921. The sanitarium would become Edward Hospital in 1955. *Courtesy of Paul Hinterlong.*

Lillian Avery of Naperville, first Medicare beneficiary; her husband, Robert; and hospital administrator Eugene Morris. Photograph from the Associated Press. *Courtesy of Paul Hinterlong.*

Edward Hospital 1967 addition. The $620,000 expansion increased the number of beds to 133, including state-of-the-art amenities. *Courtesy of Kramer Photography.*

between Fermilab and the National Argonne Lab. The educational levels and cultural diversity of the engineers, scientists and other professionals from these firms soon influenced Naperville's neighborhoods, school boards and local curriculum.[137]

The U.S. Army also expanded its presence in the Naperville area in the 1950s. To leverage its new supersonic guided missile program and protect U.S. cities from the risk of any Cold War attacks, more than three hundred Nike missile bases were constructed in the United States between 1953 and 1974. Operated by the Army Air Defense Command (ARADCOM), Nike bases protected an overlapping area, thus creating a defensive ring around key cities like Chicago. From 1956 to 1963, nearly 125 military personnel lived and worked at the local Nike missile base, better known as C-70 and located at the corner of Diehl Road and Mill Street. Its control site was later redeveloped into an office park, and the launch site is today Nike Sports Complex. At the time it was built, the visual of a barbed-wire fence, concrete buildings and guard dog cage served as a constant reminder of Cold War tensions. Having missile silos in one's "backyard" caused many Napervillians to build bomb shelters. John Case moved his family into the basement of his hybrid seed corn business, Agrinetics, during the Cuban Missile Crisis in 1962.[138]

The events of 1957 surrounding the desegregation of Central High School in Little Rock, Arkansas, and the later bombing of the Little

Postcard view of Bell Labs' Indian Hill Campus along Interstate 88, known as the Research and Technology Corridor. *Courtesy of Paul Hinterlong.*

Nike Sports Complex was originally a Nike Ajax missile defense site during the Cold War. The missile silos were replaced with sports fields. *Photographed by the author.*

Rock school board offices in 1959 did not appear to have direct effect on Naperville. Genevieve Towsley wrote about and pressured local ministers and the city council about minority youth groups who came to the North Central College for conferences but were not allowed to swim at Centennial Beach. In 1959, more than two hundred predominantly South American athletes stayed in Naperville at the college during the Pan American Games. Just below a large headline about the Little Rock bombing was the headline "Push Probe in Mystery at College," referring to the death of a Brazilian athlete, Ronaldo Duncan Arantes, on Chicago Avenue in Naperville. In the early morning hours of September 7, 1959, Arantes, who was known to brag about buying guns in America for resale in Brazil, was found without the $2,000 his brother claimed he brought to America, his pockets ripped and an apparent self-inflicted gunshot wound to the chest. Arantes was right-handed, and the powder marks from the gun were on his left hand. The gun was recovered a few feet from the body, but the mystery of who shot Arantes was never solved, as most of the prime suspects returned to their countries after the competitions.[139]

As commercial office development increased, so did the need for schools, services and healthcare. In March 1964, the *Sun* published a picture of twelve members (representing three generations) of the Shoger/Breitwieser family taking the Sabin oral vaccine to prevent polio. In the picture, Bob Anderson of Oswald's Pharmacy is administering the dosages. The crippling and sometimes fatal poliomyelitis virus, or polio, was a real scare to Napervillians and the country. The Nichols Library and local U.S. Post Office facility both began expansion projects around this time. North Central College had several buildings newly built or modernized, such as the remodeled Pfeiffer Hall in 1967 and the newly built residences Rall Hall and Student Village in 1966. Naperville retail business was also strong in the '60s. Two grocery chains, the National and the A&P, opened new stores. In December 1953, Naperville voters authorized significant school modernizations, including the construction of a new elementary school north of Ogden Avenue. Beebe Elementary, named after the long-standing district superintendent, opened in 1955 with 318 students. Other schools sprouted like mushrooms: Highlands Elementary (1958), Elmwood Elementary (1960), Lincoln Junior High (1963), Mill Street Elementary (1966) and Prairie Elementary (1969).[140]

On Christmas Eve 1953, residents learned that the Planning Commission had given tentative approval for a new half-million-dollar subdivision proposed by Harold Moser. Earlier in the year, Moser Lumber was

Three generations of the Breitwieser family receiving the polio vaccine on March 19, 1964. Pharmacist Robert Anderson of Oswald's Pharmacy is administering the Sabin vaccine. *Courtesy of Russ Breitwieser.*

advertising in Naperville newspapers, promoting construction materials and home renovation services. Moser, now capitalizing on a housing shortage, was moving into full-scale residential development projects. He soon needed to comply with a subdivision control ordinance adopted in June 1954 by Naperville government. The ordinance requested that builders contribute to the construction of streets, sewers, curbs and gutters.[141]

The name Harold Moser was already iconic in Naperville by the mid-1950s. His family moved to Naperville in 1916 when he was a toddler. Though crippled with a rare bone disease in his youth, Moser never slowed down. By age twenty-one, Moser had established himself as a local business entrepreneur by launching the *Naperville Sun* newspaper. After selling the newspaper, Moser began operating a coal yard. However, he recognized the shift in real estate and construction trends caused by the housing shortage and converted his coal yard into a lumber yard. Initially, Moser built homes on in-fill or vacant lots in existing neighborhoods. Moser's first

residential building project was a 62-lot community called Forest Preserve located on the city's west side. Moser purchased land from the DuPage Forest Preserve (the former Burlington Park), had it surveyed into lots, sold the lots and built homes. It wouldn't take long before Moser was leading the residential building boom in Naperville. The success of Forest Preserve Phases I, II and III led Moser to think bigger. He purchased Sam Wehrli's farm to build Moser Highlands, originally planned to have 575 homes. His early success motivated him to continue at an aggressive pace. He bought the Fred Hoffman farm south of Edward Hospital, which was developed into West Highlands. Next, he moved on to Saybrook, Maplebrook and Cress Creek.[142]

In 1953, the Naper Aero Club was formed by a group of local pilots who wanted to establish a restricted landing area nearby. They initially leased land on the John Fender farm on South Washington until 1955, when Alvin H. Beidelman Jr. purchased nearly one hundred acres of farmland, located along Route 59 between Seventy-Ninth and Eighty-Third Streets, from Milton Eichelberger. Beidelman then sold twelve acres of the newly acquired land to the Aero Club, which eventually became Naperville's private residential airpark community, allowing its residents to use the runways (the community was expanded in the 1980s and '90s after Moser's Macom Corporation purchased the majority of Naper Aero Club shares and agreed to develop the land east of the runway).[143]

In January 1960, Naperville's city council approved the annexation of nearly 1,600 acres of land, essentially doubling the city's size overnight and making space for considerable population growth. Giant headlines sprawled across the *Clarion* read, "Council Keeps Annexing; Doubles Naperville's Size" and "Moser Outlines Plans for Next Ten Years." More than 1,000 acres of the acquired land came from six farms north of the city: the Nadelhoffer, Ehrhart, Wiesbrook, Fry, Case and Meisch family farms. Moser, who was firmly establishing his reputation as the area's hottest residential developer, would develop the farmland. His plans for the newly annexed portion of Naperville called primarily for single-family homes but also included "a garden apartment section, school, park, church and neighborhood shopping sites." Infrastructure was an equally important matter, so the plans also called for two sanitary disposal plants, as well as street and storm sewer projects. To properly develop the rapidly growing city, Moser and Naperville needed the services of an urban planner. "We don't want an ordinary planner to design Naperville because then we will look like an ordinary community," the *Clarion* quoted Moser as saying

Naper Aero Club/Aero Estates, built in the 1950s as a fly-in residential neighborhood, one of the first in the United States. *Courtesy of Paul Hinterlong.*

in early 1960 when Naperville's population reached 12,933. "We need someone who will think along the lines of present Naperville and I am seeking that type of person to design these new developments." The urban planning firm that was eventually chosen to consult for Naperville was St. Louis–based Harland Bartholomew and Associates.[144]

The desire to keep Naperville extraordinary was, in part, a response to community anxiety over Naperville's expansion plans. Existing residents cited uncontrolled growth, poor planning and lack of infrastructure as their biggest concerns. An editorial in the *Clarion* urged the city to retain control over the growth:

> *The city faces two alternatives: to expand following a basic program laid out in a master plan, or to expand without a preconceived program....The subdividers of the future won't be all hometown boys with a deep-seated sense of responsibility toward the community. Already large corporations with a rightful concern for large profits, and little concern for maintaining the charm and heritage of our community, are seeing to (or have already) purchased property in the area that will be the corporate Naperville of tomorrow. The city must control these developments.*[145]

Recently elected Naperville mayor William G. Zaininger was quick to acknowledge citizens' fears. In late January 1960, the *Clarion* introduced "a series of bi-monthly articles" authored by the mayor and city council members to keep people informed about Naperville's growth and future plans. In Zaininger's first published article, he clarified five key problem areas the city would be addressing in the decade ahead: sanitary services, the electric department, traffic patterns, a plan commission and requesting studies.[146]

With the land annexed and infrastructure improvements underway, Moser next began preparing the builders. At a spring meeting of about one hundred construction professionals, Moser advised the contractors that they would need to "work hard to construct houses that will attract buyers" and highlighted four innovations in home selling: more blacktopped roads, a new playground, more parking area and an advertising and promotion campaign bigger and better than ever before.[147]

The first major subdivision project following the annexation was to be called Saybrook. In mid-February 1961, not long after the city council approved the subdivision, Naperville citizens learned new details about the greater "Saybrook area," a phrase used to describe an area that stretched far

Unidentified men with map of Naperville. By the 1960s, Naperville was expanding rapidly to the south toward Will County. *Courtesy of Kramer Photography.*

beyond today's Saybrook subdivision. While more than 70 percent of the larger plan featured single-family homes, two business-commercial areas were also highlighted: one located on Naperville-Wheaton Road between the toll road and Ogden Avenue, and the other on North Aurora Road between Mill and Ogden. The plan, presented to the city council by Harland Bartholomew and Associates, also proposed a "northside high school…on the Hurley property" and an elementary school/park site at each of the five major residential areas. The consultants estimated that thirty thousand people would populate the Greater Saybrook area, spanning 3,500 acres, within fifteen to twenty years.[148]

Saybrook builder Ralph Smykal hired twenty-six-year-old Chuck George, owner of Charles Vincent George Architects and

future designer of Naperville's Sesquicentennial Riverwalk and Millennium Carillon Tower, to design Saybrook's traditional two-story, three- and four-bedroom homes that resembled Colonial homes in New England. "I designed Saybrook model homes from my basement for the first two or three months and then moved into the lower level of Smykal's office space," George said. "Saybrook was my first job in Naperville and the lion's share of my business when I first started. Every couple years we had a new model row. And then we jumped over to Cress Creek. We had four to six draftsmen working at that time." Saybrook earned additional attention for reportedly being among the first residential developments in the country to have a swimming pool and a tennis club.[149]

The building boom in Naperville produced a very large number of homes similar in style to most any postwar neighborhood. Split-levels, raised ranches and revival styles of Colonial or French homes were popular. But Naperville has a goodly number of unique homes with sharp angles, protruding "bows" or balconies, asymmetrical rooflines and orange doors. These homes were designed and built by Chicago native Don Tosi. When Tosi was five or six, he spent over a year with his grandparents in Italy surrounded by old-world architecture. In 1941, he graduated from Morton High School in Cicero and enrolled in the Illinois Institute of Technology, where he started a program in architecture. Tosi also enrolled in classes at the Chicago Academy of Fine Arts, but his education was cut short by World War II. Throughout the war, Tosi corresponded with nationally famous architect Bruce Goff, a mentor he'd met at the academy. Goff encouraged Tosi's studies and asked him to join a "new" design firm dedicated to a new school of organic architecture called Kebyar. *Kebyar* is the Balinese word for "the process of flowering."

When Goff was commissioned to build a house for artist and academy instructor Ruth VanSickle Ford, he asked his young twenty-five-year-old prodigy Tosi to be his general contractor. It was this benchmark that set Tosi's design and philosophy in building. The postwar building boom supplied Tosi with plenty of work. Because he had a family to support, the demands of architectural schooling were replaced by self-study and hard work. Building and designing close to the Ford Home in Aurora, Tosi created unusual designs that fit into the landscape. In Naperville, he built many cookie-cutter homes of the split-level and Georgian Revival type. Tosi's unusual Naperville designs were the direct inspiration of Frank Lloyd Wright and Bruce Goff and were in demand by artistically inspired clients from Chicago who wanted to live in something different than the run-of-the-mill tract housing of the suburbs. In the article "The Homes of Builder Don A. Tosi" published in

The Alpine II model was one of a number of unique homes designed and built by Napervillian Don Tosi. This house was demolished in 2016. *Photographed by the author.*

Historic Illinois, sixth-generation Napervillian, preservationist and Tosi expert Charlie Wilkins writes:

> *The modern Aurora and Naperville houses of Don A. Tosi (1923–2009) represent a significant contribution to Illinois history....Tosi homes displayed a definite modernist bent that seemed out of place alongside their more conventional-looking counterparts....*[The homes of] *Tosi also provide valuable perspective into the rise of Naperville....Sixty years have passed since* [Tosi] *first began designing and building his singular, modernist-inspired homes. Two generations have now grown up in these homes shaped by Tosi's remarkable dreams and designs. With each passing year, more and more of his houses achieve the "fifty-year rule," by which a majority of historic structures are evaluated for possible inclusion in the National Register of Historic Places. With this point in mind, preservationists would do well to consider the valuable contributions Tosi and other distinctive postwar builders made to Illinois history and the state's built environment.*[150]

Naperville's building boom drew regional attention, and in the spring of 1961, the *Chicago Tribune* published a feature story about the growing suburb. City engineer George Wight told the *Tribune* that Naperville's population

was now thirteen thousand residents and that the city would see more than $8.5 million in construction during the next two or three years, as well as about one thousand new residents annually. The *Tribune* article reported "13 large-scale projects" under construction or in advanced planning stages, including two supermarkets, a $1.8 million addition to Naperville Community High School, $175,000 for additional classrooms at Beebe Elementary School and a $2.2 million addition to Edward Hospital that would expand it from 45 to 109 beds.

Also at this time, Naperville approved a $175,000 referendum for a new wing on the Nichols Public Library. An addition to the much-used and overcrowded 1897 library was requested as early as 1926 and 1930, though no action by the council of library board was taken. Even after a fire nearly gutted the interior in 1934, no expansion plans ever materialized until the library board selected Northfield architect Albert R. Martin Jr. to design an addition that would double the size of Nichols Library. Martin was married to Napervillian Eleanor Beckman, whose family were staunch supporters of the arts, the library and the community of Naperville. The Mid-Century Modern wing was typical of the designs Martin produced for communities in the Chicago suburbs, particularly schools. In 1962, Naperville City Council approved the Cress Creek plan, which included six hundred homes and an eighteen-hole golf course and clubhouse. Cress Creek is often reported to be the first community in Illinois built around a golf course.

In response to the desires of local youth to have a place of their own, "The Barn" youth center opened on Martin Avenue in 1965. The Barn was a meeting place and concert venue managed by a student board and an adult board that worked in harmony to produce programs and activities for Naperville-area youth. In response to the era of the automobile, the Naperville National Bank opened a drive-in window. It wasn't long before local banks started issuing credit cards to their customers. The first annual Last Fling parade, inspired and promoted by local barber Rick Motta, was held on Labor Day weekend 1966. The Naperville Park District was officially created a year later. In 1967, as part of a special section on the thirteenth annual Spring Festival of Homes, the *Chicago Tribune* praised Naperville for its "rural quiet, city convenience" and reported that "if you want to head for the quiet of the country but stay within easy reach of city convenience… Naperville offers the pleasant atmosphere of a small, long-established college community. It's the home of North Central College and the Evangelical Theological Seminary….The growing town has its modern shops, too, and commuter trains and expressways make it convenient to downtown Chicago."

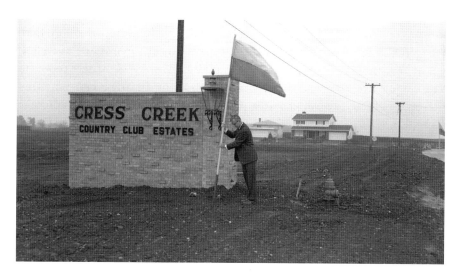

Cress Creek Country Club Estates was founded in 1963 as Chicagoland's first subdivision country club. *Courtesy of Kramer Photography.*

By the end of the decade, Naperville's police department employed twenty-seven full-time officers; the fire department consisted of nine professional firefighters and thirty-one trained volunteers.[151]

During the 1960s, the nation grieved over the assassinations of President John F. Kennedy and Martin Luther King Jr. and witnessed the escalation of the Vietnam War. Many young men and women from Naperville were affected by the war, some from participation in the war and others from the loss of loved ones. The following service record by an anonymous author illustrates the bravery and service of just one Napervillian during the Vietnam War. Kenneth Shimp (1947–1975) is buried in the Naperville Cemetery.

> *Vietnam Service Awards of Special 5 Kenneth J. Shimp/April 1967– June 1968 162nd Aslt Hel Co. ST5 Vultures: Awarded first air medal with "V" device with one oak leaf cluster for distinguished, meritorious achievement in sustained aerial flight support of combat ground forces of the Republic of Vietnam during the period of April 14 to September 21, 1967. Awarded the Bronze Star with "V" device for heroism and an extended tour of duty July 7, 1968 in connection with military operations against hostile forces May 2, 1968. Awarded second air medal with 27 oak leaf clusters July 7, 1968 signifying that he completed 750 combat missions in Vietnam.[152]*

Naperville Fire Department celebrates one hundred years in 1974. The 1957 firehouse and police station is now Lou Malnati's Pizzeria. *Courtesy of Kramer Photography.*

National politics heavily revolved around war and civil rights. During these years, Naperville transitioned from a quiet community to a thriving suburb along a rapidly developing technology and research corridor of the Chicago area. One particular Amoco scientist created a fashion statement that defined the 1960s and 1970s. Delbert Meyer was working for Amoco in Whiting, Indiana, when he discovered a chemical reaction for the efficient and commercial use of purified terephthalic acid, or polyester. Perhaps no other brightly colored, creaseless fabric could define an era of disco dancing and business suits as polyester does. Meyer relocated to Naperville, where he became the director of new product research and development. In 1989, he was awarded $150,000 by Amoco for his contributions to the industry. By 1966, Naperville residents enjoyed the services of eighteen parks, ten schools and two banks, including Naperville Savings and Loan. More than 2,000 single-family homes were built in Naperville between 1960 and 1968, as well as about 700 apartment units, of which 518 were delivered in the year 1968. Despite Naperville's commercial and residential growth of the mid-twentieth century, farming was still a critical ingredient to the local economy and also a key source of community pride. Each week, the *Naperville Sun* held a photo contest for readers to identify the "Mystery Farm of the Week." Farmers were among the many residents concerned about responsible growth. While local newspapers reported the population "explosion," residents were

Ink-blotter advertisement for the Naperville Building & Loan Association. Building and loan associations encouraged saving and investing and helped people buy homes. *Author's collection.*

busy discussing and debating numerous issues related to education, law enforcement, housing, government and business.[153]

The Bell Laboratories relocation announcement in 1964 meant hundreds of families would soon be looking for homes in the area. A parade of vendors, including Naperville home builder Ralph Smykal, traveled to Bell Laboratories' Holmdel, New Jersey office to present their respective products and services to relocating employees. G. Kenneth Small, Bell Laboratories' public relations director, informed builders that Bell families would need bigger homes for larger families. Small eventually bought a home in Saybrook and became an active member of the community. A few years later, Small campaigned for mayor and was elected for one term (1971–75).[154] As long as there were large parcels of land to annex (scores of annexations took place in the following decades), Naperville leaders wanted to seize development growth opportunities and retain control. Naperville and Aurora signed a mutual boundary agreement in 1974 that established future limits of each city's expansion toward the other. "The legally binding agreement, the first of its kind in the State of Illinois, also set up the Aurora-Naperville Intergovernmental Coordinating Committee (ANICC)," wrote Kay Stephens in 2008. "Its primary purpose was the joint coordination of planning and development in a specified area between the two communities....Passage of that boundary agreement insured that neither municipality would annex an area beyond those limits without written authorization from the other government. Prior to that agreement, a developer could have requested annexation to either city." In 1977, the *Chicago*

Tribune declared Illinois the "annexation capital of the United States," but due to the foresight of Mayor Small and the council in 1974, Naperville did not have serious annexation concerns. The annexation agreement actually helped curtail rogue developers who wanted to build without regulation. The *Tribune* reported, "Naperville, for instance has mutual boundary agreements with both Lisle and Aurora. 'It's a different ballgame now,' said Walt Newman, Naperville's planning director. 'Now we tell the developer what to do.'" Walter S. Newman earned a master's degree in architecture from MIT and a master's degree in planning from Miami (Ohio) University. His background was well suited to direct a revision of the city's zoning ordinance and the development of Naperville's first comprehensive master plan. Newman accepted the position of director of community development in March 1976 and moved his family to Naperville.[155]

Housing was one of the most contentious national issues of the civil rights movement, which aimed to eliminate discriminatory realty and lending practices. In Naperville, there was also the challenge of developers primarily building single-family homes aimed at middle and upper classes. Chicago City Council passed a fair housing ordinance in 1963 that prohibited discrimination "against any person because of his race, color, religion, national origin or ancestry." According to the *Encyclopedia of Chicago*, "The dual housing market, in which whites can live anywhere they can afford but blacks and other minorities face restricted access, extended beyond the borders of Chicago proper. During the 1950s and early 1960s, white suburbanites often turned against pioneer black neighbors." Following Chicago's lead, suburban groups began to consider similar legislation. North Central College hosted lectures, including one by Martin Luther King Jr., to educate students and residents about civil rights initiatives. In early 1964, the Naperville Community Council, a coordinating body of Naperville organizations, formed a Human Relations Study Group to determine the feasibility and necessity of creating a human relations organization in Naperville. A few months later, the group reported its findings: "[W]e would be remiss in our responsibility if we did not recommend some form of human relations group which could study the local situation, assist the local authorities, and help meet the challenge of contemporary and future needs for the city." Despite public support and endorsement from multiple organizations and churches, the establishment of a Human Relations Commission didn't even make the council's agenda. The committee, however, continued campaigning for fair housing in Naperville. On April 4, 1968, Martin Luther King Jr. was

assassinated in Memphis, Tennessee. One week later, the U.S. Civil Rights Act, or Fair Housing Act, was signed into law. On July 1, 1968, Naperville City Council approved its first anti-discrimination housing ordinance and the creation of a Housing Board to enforce the ordinance. In 1973, Naperville City Council approved a new fair housing ordinance intended to improve upon the 1968 ordinance.[156]

In 1970, Naperville covered twelve square miles and its population reached 22,617, a 75 percent increase over the previous decade. Naperville North High School and Jefferson Junior High opened for the fall semester, and North Central College replaced its semester calendar with trimesters. With support from Mayor Milton Staufer, Naperville transitioned in 1969–70 from a commission form of government to mayor-council-manager. Instead of five elected city commissioners and a mayor, Naperville would now hire a manager, who was responsible to the city council. The new city charter detailed the powers and duties of the mayor, council and manager. Following an interim appointee, C. William Norman was the city's first professional manager. Also in 1970, Gerwin Rohrbach, president of St. Louis–based General Planning and Resource Consultants, delivered a nearly one-hundred-page report titled "Directions for Growth" to George Olson, chairman of the Naperville Planning Commission. The report highlighted Naperville's "accelerated growth due to its role as the focal point of development along the East–West Tollway" and agreed with municipal leaders that "annexation will be of great importance to both commercial and residential development because in these proposed areas Naperville will be able to determine its future through the type of land uses allowed, quality of structures built and the density of infilling in these areas." As the city grew, so did its need for a municipal center. In 1971, city hall moved off Jefferson Avenue to the former electric building on the northeast corner of Jackson and Webster, now the home of Egg Harbor Restaurant and other retail venues.[157]

In June 1970, Naperville leaders first learned of the proposed regional shopping center just west of Route 59 that would become Fox Valley Shopping Center. Toward the end of 1971, Naperville's city manager and mayor were invited to view a model and proposal of the shopping mall. A few weeks later, Mayor Kenneth Small explained that Fox Valley Shopping Center would go to the neighboring town of Aurora because of Naperville's lack of sewer services and its stricter development controls. The loss of the shopping mall tax revenue resulted in many long-term benefits for Naperville, such as favorable commercial and industrial development.[158]

City council and staff, 1970. Council meetings were held on the second floor of city hall, now La Sorella di Francesca restaurant. *Courtesy of Kramer Photography.*

Naperville's growing pains continued through the 1970s with boundary disputes and ongoing infrastructure issues related to water supplies and sewage filtration. To improve the city's wastewater treatment, the 122-acre Springbrook Regional Water Reclamation Center was built. Strategically located at the southern edge of the city, the plant benefits from topography that slopes from north to south, eliminating expensive pumping costs. The Office of Civil Defense was created, along with a new Emergency Operating Center, for disaster preparedness. The Evangelical Theological Seminary merged with Garrett Theological Seminary and moved to Evanston. After Naperville North High School and Jefferson Junior High both opened in 1970, five more schools opened in the 1970s, including Maplebrook (1974), Washington (1977), Steeple Run (1977), Scott (1978) and Madison (1978). In 1972, Naperville reorganized into two districts. Following the dissolution of Elementary District 78 and High School District 107, the thirty-two-square-mile Community Unit School District 203 was established. Community Unit School District 204 was formed, with Naperville Central High School receiving students from the District 204 boundary area until Waubonsie Valley High School opened in 1975. Naperville Community High School was renamed Naperville Central after the opening of Naperville North in 1970. After about a century of publishing, the *Naperville Clarion* officially closed its doors in the early 1970s.

Following the presentation of preliminary downtown plans in 1971, the Central Area Naperville Development Organization (CAN-DO) was formed in 1972 to promote the revitalization of downtown. More than 120 volunteers contributed to the planning, including representatives from city council, League of Women Voters, Naperville Confederation of Homeowners, Naperville Chamber of Commerce, Naperville Park District, Naperville Plan Commission and downtown businesses. Naperville and CAN-DO partnered with San Francisco–based Brown/Heldt Associates for environmental planning, architecture, landscape and urban design. Brown/Heldt's Thomas E. Brown, a Naperville native, was actively involved in the firm's master plan for the central business district, as well as the municipal center and the concept for a controversial walking path along the DuPage River. By July 1974, a series of reports featured proposals and sketch plans for street and sidewalk improvements, new parking, a new plan for Jefferson Street, storefront renovations, a riverwalk, Central Park upgrades and adaptive reuse of residential blocks surrounding the central business district. With improvements underway, thirty-nine trees were planted and downtown streets were widened to accommodate larger automobiles. Soon, parking meters were removed, and downtown parking has been free ever since. Fred Kleinhen, the last Naperville police officer to collect change and tokens from the downtown meters, was gifted a parking meter upon his retirement. It was later made into a lamp.[159]

Another example of Naperville's "can-do, make-it-happen" attitude originated in 1969 when a dozen determined residents, led by former actress Jane Sindt, worked to save the 105-year-old St. John's Episcopal Church from the wrecking ball. Together, the residents formed the Naperville Heritage Society on February 5, 1969, for the sole purpose of preserving the Civil War–era building, a specimen of Gothic Revival architecture with large stained-glass windows, carved pews and elaborate stenciled interior finishes. The society identified the nearby city-owned site of the Martin Mitchell house, which had been the city museum for the last three decades, as the church's new location. The greatest challenge the fledgling Naperville Heritage Society now faced was raising nearly $30,000 to cover moving and restoration costs. Cash and in-kind donations from residents, businesses and the city, as well as proceeds from the society's inaugural antiques show, helped raise enough funds in time. In June 1970, the church building was divided into three sections and transported through town to its new site without breaking a single pane of stained glass. The successful rescue of St. John's Church, renamed Century Memorial Chapel, turned out to be the first of

Postcard view of the Elmer Koerner Band Shell (1966–2000) in Central Park. Photographed by Jo Lundeen Photography. *Courtesy of Paul Hinterlong.*

many historic building relocations to the former Caroline Martin Mitchell estate. Additional old structures already lost to history, such as Fort Payne and the Pre-Emption House, were reconstructed. A museum campus vision was developed by Jane Sindt and Brown/Heldt's Thomas Brown, who was still busy on the new downtown. "Tom is a fifth generation Napervillian and his affection for his hometown is reflected in the resulting design," explained Duane E. Wilson, a founding member of the Heritage Society. In 1976, Naper Settlement was officially established via a city ordinance, and three years later, the city council awarded the Heritage Society a management contract for the administration and development of the museum campus. "It was acknowledged that it could never be as elaborate as Sturbridge Village in Massachusetts or Williamsburg in Virginia but it was also known that there was no such village preserving the architecture and way of life in the early days of northern Illinois," wrote Wilson. Margaret "Peggy" Frank, a Chicago native but living and working in Delaware, was the settlement's first paid director (1979–2012). Peggy's passion and development of the small history village led to significant preservation efforts, successful capital

campaigns, award-winning exhibits and national accreditation by the American Alliance of Museums. Her dedicated and skillful work with the city and her genuine love of the community of Naperville made Naper Settlement one of the best cultural attractions in the Chicagoland area.[160]

"Today's Naperville is a tribute to [Tom's] expertise and vision," explained Naperville historian Kay Stephens. "He insists that Chuck George and Rick Hitchcock 'really did all the design work for a number of years to create and develop the Riverwalk after I just kicked it off by recommending it in my study.' He also praises the high caliber of others with whom he worked during those remarkable days, especially Director of Public Works Ned Becker, City Manager Bill Norman, and CAN/DO President Jim Wehrli. He remembers fondly the early 1970s and his admiration for the community leaders who dared to dream big dreams."[161]

At the close of the 1970s, Naperville residents, like many American drivers, waited in long lines for gas during the oil shortages (1973) and energy crisis (1979). The lines were even more inconvenient for Naperville, which still had car dealerships, gas and services stations in the downtown. The energy crisis particularly created an economic recession that many companies could not weather. After almost eight decades in business locally, Kroehler closed its Naperville plant in 1978, one of many U.S. companies to shutter their doors during this time of economic uncertainty. However, signs of the new era ceremoniously began in late 1979 as Naperville now spanned twenty-two square miles and reached a population of 42,601. Plans were already underway for the biggest party in Naperville history, the city's 150th birthday, including Brown's exciting riverwalk idea.[162]

Chapter 7

MORE FLOWERS ON THE PATHWAY OF LIFE

"The World's Greatest Need"
A little more kindness and a little less greed;
A little more giving and a little less need;
A little more smile and a little less frown;
A little less kicking a man when he's down;
A little more "we" and a little less "I";
A little more laughs and a little less cry;
A little more flowers on the pathway of life;
And fewer on graves at the end of the strife.
—Anonymous

If one were to walk far enough on the south side of the Naperville Riverwalk, past the Carillon and behind the RiverPlace apartment buildings, one would find a gray granite stone carved with a version of an anonymous poem that began circulating around 1914 and was much longer originally. It was even made into a hymn by C. Austin Miles in 1939. The stone was originally located on Washington Street and Chicago Avenue at the Netzley automobile sales and service dealership. A memorial plaque was added to the stone in 1979 to remember Naperville car dealer Clyde "Budd" Netzley, his nephew Rufus Dirck Schumacher and Netzley's stepfather, Harry E. Ridley. The spirit of the poem is quintessential Naperville. The memorial is fittingly located on the Riverwalk that is a community-based, predominantly volunteer-constructed and ever-growing physical reminder of the Naperville "can do!" attitude. *Chicago Tribune* reporter Casey Bukro

The White Plaza on the Riverwalk. *Standing, left to right*: Al and Naomi Rubin and Mary Lou Wehrli; *sitting, left to right*; Eva and Harold White and Judge Knoch. *Courtesy of Kramer Photography.*

said, "How many people say 'I love you' to their community and leave the message written in stone, flowers, and water? That's what the people of Naperville did with their $1.5 million Riverwalk project, a two-year effort that transformed a shabby downtown riverfront into a bright symbol of civic pride and unity."[163]

The Naperville Riverwalk was just one component of a huge birthday party called the Naperville Sesquicentennial to mark the 150th year since the founding of Naper's settlement. The party planning started in 1979 with the mayor-appointed Sesquicentennial Commission. More than eighty commission members and hundreds of volunteers were led by Amoco

executive Duane Wilson and later Frank Allston. Men sprouted old-time beards, and "A Nifty One Fifty" logo appeared on hats, T-shirts and buttons all over town. Parades, concerts, galas and souvenirs were planned, including a revival of Stenger beer. Wil-O-Way Manor (now Meson Sabika) prepared a special menu with braised young quail, roast pheasant and a special buffalo steak with a "unique" sauce. Many of the events mirrored those of Naperville's epic centennial celebration in 1931, including the children's parade and aqua-thon. A re-creation of the 1831 Naper settlers' wagon train from Fort Dearborn to Naperville was the highlight of the celebration. Carefully planned and led by Eldon and Madeline Hatch, the trek lasted three days from June 3 to 5. Horses, wagons and supplies were procured for the twenty-three men, women and children dressed in period clothing who rode on either one of the thirteen horses or three wagons winding their way from the lakefront in Chicago through the suburbs to Naperville. It surely would have been a sight to see horse-drawn wagons meander through the skyscrapers of Chicago. The trek ended with a large community ox roast. Allston, who took charge of the celebrations when Wilson was transferred out of state, said:

> *Naperville has one foot firmly planted in the 19th Century and the other in the 21st Century. No other city honors its heritage so richly while, at the same time, carefully planning its orderly growth as a major metropolitan center.... Typical of this respect for the past and concern for the future was Naperville's Sesquicentennial celebration. Conceived in 1978 as a year-long commemoration without governmental financial support, the Sesquicentennial brought together Napervillians of all walks of life, irrespective of whether they had been born here or only recently arrived.*[164]

The energy, excitement and memories of the sesquicentennial would help Naperville through the difficult economic transitions that would affect the United States and Naperville in the early 1980s. The global economy was changing, and many industries faced with mounting expenditures and low sales had to make difficult decisions. In 1981, the Kroehler family sold its controlling stock to an investor group "headed by Peter R. Harvey and John J. Harvey, president and chairman, respectively, of the Artra Group, Inc., of Northfield, and Kenneth L. Kwaitt, an attorney for the Harveys. Peter Harvey said the group was acting independently of Artra." Shortly thereafter, Kroehler Manufacturing officially dissolved. All of the plants were closed. A variety of reasons have been proffered for how what was once the World's

Largest Furniture Maker could close. The Kroehler family released some of the top management positions to non-family members who were not familiar with the stringent guidelines and business acumen of founder Peter Kroehler. When the family returned to management, the damage had been done. The largest profit in company history was $3.8 million in 1972. The profit losses of $8.8 to $18.4 million in the four years following 1976 were too overwhelming to recover from. Some attribute the hiring of internationally famous award-winning interior designer Angelo Donghia, through no fault of his own, as the reason Kroehler was unable to recover from losses. Top company executives felt that Donghia's modern, sleek designs were fresh and marketable with the Kroehler brand. The furniture, however, was priced higher than the average Kroehler costumer was used to paying, and the furniture was hard to produce. Donghia preferred all-white fabrics (e.g., "Cream on white diamonds"), which were hard to keep clean during production and shipping. A former Kroehler employee referred to the decision to hire Donghia as "Kroehler's million dollar mistake." The Kroehler name was purchased by other furniture manufacturers but not produced in any of the former Kroehler factories. It is a powerful lesson that at the same time Kroehler Manufacturing Company, a major employer in Naperville, was closing plants and laying off top executives and workers, Napervillians banded together to celebrate just as they did in 1931 during the Depression.[165]

The City of Naperville bought the Kroehler factory complex in 1980 for $1.5 million with the intent to relocate the municipal offices and consolidate city services. The plan never materialized. Councilwoman Margaret "Peg" Price cast the deciding vote with councilmen Joseph Phelan and James Newkirk to sell the Kroehler property and move forward with a 1975 plan to build a municipal center downtown. Once again, the factory was for sale. The property sat idle for a few years before a LaCrosse, Wisconsin developer, Warren Loveland, bought the property for $1.2 million in 1985 with the intent of putting $17 million into renovating the old factory. Loveland's plan included 118 apartments, fifty thousand square feet for office space and sixty thousand square feet for retail space with specialty shops, several restaurants, a health club and a fresh-food marketplace. Loveland utilized a U.S. Housing and Urban Development (HUD) Insured 220 Mortgage that insures loans for multi-family housing projects in urban renewal areas, code enforcement areas and other areas where local governments have undertaken designated revitalization activities. He was also issued DuPage County's first tax-exempt bond for office property. Loveland said, "When I was down here

[Naperville] visiting my wife's family, I used to jog by the plant every morning, that's when I got interested. I knew you could do something special with a building like this....We're going to have the best location by the only rapid-transit stop in the fastest-growing suburb in Chicago." Loveland called his development the Fifth Avenue Station but repainted "Kroehler Mfg. Co.—World's Largest Furniture Manufacturer" on the south façade. In 2009, Bev Frier organized the OMNIA Performing Arts Center consortium to build a three-theater complex on the north side of Naperville, including Fifth Avenue Station. The large complex would include housing, retail and commuter stations for bus and train passengers. At the time of publication, the City of Naperville is contemplating new developments surrounding the historic and iconic building.[166]

In November 1981, by a vote of three to two, the Naperville City Council decided that city hall belonged downtown and not across from the train station. The council voted in July 1982 to purchase property south of the DuPage River bounded by Eagle on the west, Aurora on the south and Webster on the east. Six Chicago-area architectural firms were asked to compete for the design of the new municipal center. Fujikawa, Johnson and Associates won the competition. The ninety-three-thousand-square-foot, three-story building with a two-level parking deck was built by Wil-Freds Construction Company at a final cost of $16 million. The project was over a year behind and ran nearly $4 million over initial costs. The Naperville Municipal Center was much needed. From the time of initial discussion regarding a new city hall in 1980 to move-in day on January 24, 1992, the population of Naperville had doubled. The Municipal Center is the seat of Naperville government, a polling location and a community gathering place right in the heart of Naperville. In 1981, Naperville entered the National Municipal League's All-America City competition and was awarded an honorable mention. Considering the hundreds of applicants, the fact that Naperville made the top twenty-two was quite an accomplishment. An anonymous editor from the *Chicago Tribune* gave a few reasons why Naperville should be an All-America City:

> But probably its most important achievement is that Naperville, unlike many neighboring suburbs that also grew rapidly in the last four decades, has not forgotten its past....Rehabilitation of several buildings and streets in downtown Naperville to create a 19th-Century appearance has given the area an unusual charm and enabled businesses there to survive the construction of Fox Valley, which has seriously weaken[ed] downtown Aurora.[167]

Naperville thrived in the 1980s. The Research and Development Corridor along Interstate 88 was attracting more technology-based employers, though not without concerns. C.E. Raymond Combustion Engineering, Inc. was awarded a bid from the Environmental Protection Agency to burn 14.5 million pounds of cyanide-laced chips that had been illegally stored in various locations around northern Illinois. The chips were the byproduct of film production. City council approved the burn in a 3–2, vote believing the process to be safe. Naperville resident Basil Constantelos was the Midwest director of waste management for the Environmental Protection Agency (EPA). He signed the emergency permit in December 1982 allowing the test burn of 1,000 pounds of the chips. He said he "has no fears about safety because it is a 'carefully constructed test.' Under the federal permit, the firm will conduct six days of tests." Nearly six hundred Naperville citizens who did not want to be "chemical guinea pigs" rallied with Kyle Kopitke and the Citizens Against the Cyanide Burn (CACB) on January 7, 1983. After many protests and court proceedings, the Illinois General Assembly approved a $4

Citizens Against the Cyanide Burn (CACB) protest. Photograph by Jack Lenahan of the *Chicago Sun-Times. Courtesy of Paul Hinterlong.*

The Riverwalk Art Fair has been a tradition since 1985. The Naperville Art League organizes and hosts this annual event. *Courtesy of Jo Lundeen Photography.*

million bill to securely ship the waste out of Illinois to a proper hazardous waste facility.[168]

In the early 1980s, Naperville enjoyed the Naperville Woman's Club's first juried art show. The art fair was established in 1959, but by 1982, the club had to preselect the large number of artists requesting booths. The Naperville Woman's Club Art Fair highlights some of the best art in America. Although the Equal Rights Amendment to the U.S. Constitution did not pass, woman power was alive and well in Naperville in the 1980s. Councilwoman Peg Price was elected to council in 1979, and by 1983, she was the only female mayor ever elected in Naperville. Also in 1983, Mary Lou Cowlishaw was elected to the Illinois House of Representatives to represent Naperville. While working on the editorial board of the *Sun*, she was elected to the District 203 School Board from 1972 to 1983. Cowlishaw served in the Illinois General Assembly from 1983 to 2002. The Naperville Art League installed *Landform*, by artist Jack Arnold, along the Riverwalk at Eagle and Jackson, and the Naperville Jaycees converted the Salfisberg quarry into the Paddleboat Pond in 1984. In 1984, the council was expanded to six members when the population of Naperville had risen to 55,197. The Naperville Art League started the Riverwalk Art Fair in 1985.

The Nichols Library, despite its 1962 addition, had outgrown its facilities by the mid-1980s. The city council and the library board approved a new $6 million facility just west of the old Nichols Library on Jefferson between Webster and Eagle. The sixty-three-thousand-square-foot library is the anchor for the entire Naperville Library system, which has added two more libraries since 1986. The Naper Boulevard branch opened in 1992, and the Ninety-Fifth Street library branch opened in 2003, 105 years after the founding of Naperville's first public library. The Old Nichols Library was used for other city offices and services and rented to community groups. The building was sold to Truth Lutheran Church, a Chinese American congregation, in 1996. At one time, Truth Lutheran leased space to the Philip R. Cousin African Methodist Episcopal Church. In 2017, the church sold the property to an out-of-town developer that planned to remove the historic structure and replace the face of the 1898 building on the new construction. The library was given protective covenants in 1996 that protected the façade and entryway only. A grassroots preservation group led by Charlie Wilkins and Barb Hower—who wrote the landmark designation for the property— led to the creation of the Save Old Nichols Library (SONL) community group. After months of outreach, lobbying and educational meetings, SONL was able to persuade the Historic Sites Commission and the Naperville City Council to landmark the original Nichols Library. At the time of publication, the majority of the old library is being preserved and stabilized for inclusion with the new development.[169]

During the 1980s, the last of the service stations and car dealerships made their exodus from downtown Naperville to west Ogden to what would become known as Automobile Row. Through the efforts of Marjorie Osborn and city planner Walt Newman, Naperville City Council passed a historic preservation ordinance and created Naperville's only historic district on the east side of town. At the time, Osborn was on the mayor-appointed Naperville Planning Commission and one of the first District 203 board members. The district Newman and Osborn created was carved from the much-larger Naperville Historic District placed in the National Register of Historic Places in 1977. While historic Naperville was being preserved, another shining new building was being built on the tech corridor. The "N" building was designed by world-famous Helmut Jahn for MetroWest office group. Jahn also designed the State of Illinois Building in downtown Chicago. The design is a result of developer Howard Ecker's wish that the lower floors be larger than the top floors while maintaining the cube shape. According to Sam Scaccia, of Murphy/Jahn Architecture, "In reality,

Postcard view of Village Pontiac, the first of the "downtown" Naperville dealerships to move west along Ogden Avenue, forming Dealers Row. *Courtesy of Paul Hinterlong.*

the sloping angles that create the 'N' are a nifty coincidence, the result of Jahn's flair for artistic, post-modern design and a need to support a series of terraces on the building's front side." The iconic building was at the time of construction the tallest building in DuPage County. Mayor Peg Price said, "I think it's very impressive, and I'm proud it's in our community."[170]

The Exchange Club of Naperville was chartered in 1987. The club raises funds for the elimination of child abuse and domestic violence. The Exchange Club of Naperville's largest fundraiser and the ultimate Naperville Fourth of July celebration is Ribfest. Ribs, rides, vendors and music provide a fun family weekend for a good cause. Since the first Ribfest in 1988, the Exchange Club has raised over $16 million for fifty local charities. Ribfest, like so many community events, is brought to your home by the locally produced community television station Channel 17. The Naperville Community Television Channel 17 (NCTV17) began in 1987 and today excels and exemplifies its mission to "connect residents by celebrating and capturing the spirit, character, and experience of our community through engaging video storytelling." NCTV17 is an important information source with lively reporting and is a producer of award-winning documentaries. In 1990, the fire department moved out of the 1957 fire station on Jefferson (now Lou

Fourth of July in Naperville is Naperville Exchange Club's Ribfest! *Courtesy of Jo Lundeen Photography.*

Malnati's Pizza). Station 1 was built on Aurora Avenue as part of a Public Safety campus nestled around Lake Osborn, named in honor of Marjorie Osborn, civic leader and advocate for water resource management. In 1990, the population of Naperville had risen to 85,351, and Osie Davenport became the first African American woman elected to District 203 school board. Davenport, also a member of the African-American Leadership Roundtable, and Underground Railroad expert Glennette Tilley Turner helped found the African-American Festival in 2010. The festival was held at Wentz Hall on the campus of NCC. Davenport said, "When you watch it, yes, it's entertaining....But when you get involved, it takes you deeper into it, right in the heart of the experience....Broadening the community's cultural experiences is the purpose of the two-day celebration that includes dance performances, history lessons and a gospel festival."[171] The Naperville Education Foundation was founded in 1992 to help students by funding programs that fall outside of the tax-generated budget. The foundation has helped thousands of students get the opportunities to learn and grow. Naperville, like many suburban communities, switched to Lake Michigan water in 1992. The draw on the aquifer was considered to be too great. The last dairy cows left Naperville for a Wisconsin farm in 1993. Farm life that had dominated Naperville for over a century was now fading quickly. By 1994,

the population of Naperville surpassed the 100,000 mark, and Naperville City Council was enlarged to eight members. Calamos Investments moved out of Chicago for a brand-new location in Naperville along Route 59 and Interstate 88. The Midwest Save Our Ancestor's Remains & Resources Indigenous Network Group (or SOARRING) Pow Wow was founded in 1994 to preserve and protect Native American culture. In 2005, North Central College students opened a coffee house and music venue called the Union in the old Church of the Brethren building on Van Buren.

Naperville history will be forever indebted to the fifty years of public service unselfishly given by A. George Pradel. Pradel, known as "Officer Friendly," served on the Naperville police force from 1965 to 1995. He was elected mayor in 1995 and would serve twenty years. Pradel said, "On Friday I reported to Chief [David] Dial, on Monday he reported to me." A *Tribune* headline proclaimed, "Big-City Naperville Votes for Town's Past." Pradel said of his first election, "To [the voters], I represent the values in life that they want—family, security, a sense of community." The voters of Naperville agreed and reelected Mayor Pradel in 1999, 2003 (unopposed), 2007 and 2011. He will always be the longest-serving mayor in Naperville history since term limits were introduced. Mayor Pradel guided the city through times of plenty and times of lean. He worked with many councils to help guide Naperville to a better place. He welcomed dignitaries and showcased the very best of Naperville. On September 4, 2018, just one day short of his eighty-first birthday, Mayor George Pradel passed away. His visitation was held in the Naperville City Council chamber, banked with flowers and public safety officers from both the police and fire departments. Thousands of mourners said "goodbye" to Officer Friendly for two days. Mayor Pradel's enthusiasm for his hometown and the people who make this community great will never be forgotten. The summer after his first election, July 1995, seventeen inches of rain fell in twenty-four hours. Severe flooding along the DuPage and in low-lying subdivisions caused millions of dollars of damage. As recovery efforts were underway, Brand Bobosky organized the Century Walk Corporation of public art that same summer. The first piece of art was a relief sculpture, *Naperville's Own*, honoring the Naperville Municipal Band. Since 1996, more than forty-six statues, murals, mosaics and sculptures have been added memorializing Naperville people, places and events. In 1999, the concrete band shell was condemned by the city, and a new facility was built. The new concert stage is equipped with a music library and a practice room. The outer doors contain a mural created by Barton Gunderson for Century Walk titled *The Great Concerto*.

Right: Mayor Emeritus A. George Pradel, "Officer Friendly." Mayor Pradel was Naperville's longest-termed mayor (1995–2015). *Courtesy of Kramer Photography.*

Below: The Naperville Junior Woman's Safety Town on the corner of Aurora and River Road opened in 1996. *Courtesy of Jo Lundeen Photography.*

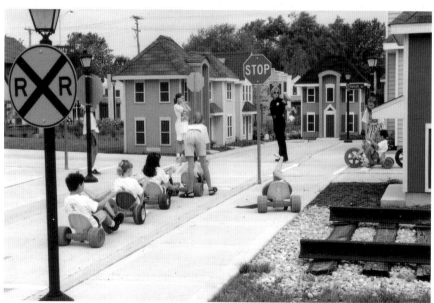

In 1978, the Naperville Junior Woman's Club brought a national bicycle and neighborhood safety program to Naperville in cooperation with the Naperville Police Department. Officer Pradel was one of the key instructors. In 1996, a permanent Safety Town was built on the eastern edge of the Public Safety campus on Aurora Avenue at River Road. In 2015, Safety Town was renamed the A. George and Patricia Pradel Safety Town of Naperville. The miniature town helps teach students about the rules of the road and how to be safe.

In 1999, Naperville, like so many communities across the globe, prepared for the turn of the new millennium with parties and celebrations. Worries about how computers would react to the date change were a real concern but proved to be a non-event. Naperville built the Moser Tower and Millennium Carillon to mark the beginning of a new one-thousand-year span of time. The bell tower contains seventy-two bells cast in bronze; the largest, "Big Joe Naper," weighs nearly six tons. A grand parade through Naperville at night helped usher in a new year and a new millennium. The first carillon concert was given in June 2000 and is now held once a week during the summer months by carillonneurs from around the world.

Early in the new millennium, Naperville saw an increase in population (128,358) and in teardowns. It would not be long before Naperville led the suburbs and the nation in the number of old homes being replaced by larger homes. There were twenty-five teardowns in Naperville in 2001. In 2003, there were sixty-five teardowns. In the beginning of the teardown era, the styles of the newer homes borrowed elements of older styles of architecture, mostly Victorian fretwork, dormers and wraparound porches. Stylistic interpretations of Italian villas, French country houses and Arts and Crafts homes were also built in Naperville neighborhoods. The replacement of homes began in the oldest part of Naperville on the west side of Main Street. The homes in this neighborhood, part of Naper's original town survey, range in date of origin from 1834 to 1970. Most of the homes were wood-framed examples of common architecture in the Hall and Parlor, front-end gable and classic L styles. The most expensive home in Naperville at the time of publication is $8.75 million on Perkins Court.

The DuPage Children's Museum was founded in 1987 in a van that traveled to various libraries and park districts. The museum specializes in early learning, particularly math and science. Temporary locations in Elmhurst and Wheaton were used between 1989 and 2001. The museum moved to Naperville in its current location in the former Moser Lumber Company building in 2001, offering hands-on activities and demonstrations.

The Downtown Naperville Alliance (DNA) was created out of the chamber of commerce to address issues concerning the core of Naperville. Signage, curb appeal and parking were and are major concerns of the DNA. Anderson's Bookshop won the Illinois Family Business Award in 2001. The Dan Shanower/911 Memorial was dedicated along the Riverwalk at the Municipal Center in 2003 and is the location of a very somber Memorial Day service. Naperville native U.S. Navy commander Shanower died on September 11, 2001, while working in the Pentagon on that terrible day when terrorists crashed planes into the World Trade Center, the Pentagon building and a field in Pennsylvania. Shanower was the son of NCC professor Don "Doc" Shanower, who founded Summer Place Theatre. Perhaps at no greater time than September 2001, Stephanie Penick launched *Positively Naperville,* "an independent, reader supported, monthly newspaper published in Naperville [and] committed to spreading a positive message about community service, special events, important fund-raisers and Naperville's rich history." From its humble beginnings of just four pages, *Positively Naperville* has grown in substance and is read all over the world.[172]

By 2004, the economy had begun to look grim. Several old businesses from downtown Naperville left the downtown for larger retail space and parking options. When local, home-grown businesses like City Meat Market, Oswald's drugstore and Wilma's café left downtown, their buildings were filled with national chain stores and restaurants. Construction and growth ground to a halt in 2008. The real estate bubble burst, and many homes and mortgages were foreclosed. Developers like Neumann Homes and MACOM filed for bankruptcy. Land once surveyed for new subdivisions and business parks was now vacant. In 2013, the lowest home sale price was $271,400. Yet Naperville retained its titles as "Best Place to Live," "Safest Place to Live" and "Best City to Raise Kids."[173]

The population of Naperville rose to 141,853 in 2010. The Naper Homestead Park was dedicated with the help of the Illinois Public Museum Capital Grants program. The park features interpretive signage about the settlement of Naperville, the Naper family, prairies and archaeology. A one-ton bronze statue of Joseph Naper created by Naperville artist Dick Locher and Mount Morris artist Jeff Adams was installed in 2013. Adams's foundry, Inbronze, also created the Century Walk sculptures *Horse Market Days, Symbiotic Sojourn* and *Two in a Million.* Locher is a Pulitzer Prize–winning editorial cartoonist who drew and later wrote stories for the Dick Tracy comic strip from 1983 to 2010. The Dick Tracy statue by Locher and Don Reed on the Riverwalk stands guard over Naperville.

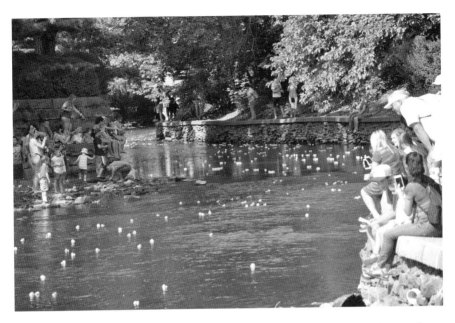

Riverwalk Foundation Duck Race. The fastest duck receives $1,981 to honor the year the Riverwalk was created. *Courtesy of Jo Lundeen Photography.*

Amy Scheller became Naperville's first Naperville Fire Department bureau chief in 2014. Scheller had joined the fire department in 1998. In 2015, Mayor Steve Chirico was elected mayor, and for the first time, Naperville City Council was equally represented by four women and four men. The first woman elected to council was Barbara Bean in 1971. The "N" building sold for $33 million, and the ThinkGlobal Arts Foundation dedicated a Peace Pole in Veterans Park in 2015. The city council election of 2017 was another historic moment for Naperville. For the first time in 186 years, Naperville elected a person of color to the city council. Dr. Benjamin "Benny" White retired as a lieutenant colonel field artillery officer in the U.S. Army in 2008. Dr. White taught at West Point and served as a professor of military science/battalion commander of the Reserve Officer Training Corps at Wheaton College. He served on the School District 204 board from 2012 to 2015.

There have been many "firsts," awards and accolades for Naperville. According to the City of Naperville website on February 21, 2018, Naperville has received 123 awards and "bests." Here are a few:

- America's 50 Best Cities to Live List
- Top 10 Small Cities Quality of Life
- Best Places to Live (various organizations awarded this honor)
- Best Place for Early Retirement
- Civic Federation's Urban Innovation Award
- Top 10 Best Cities for Families
- Top 100 Safest Cities in America

In 2031, thirteen years from the time this book is published, Naperville will celebrate its bicentennial. Two hundred years of settlement, challenges, growth, natural disasters, revival, mistakes, parades, setbacks, festivals, competitions, recognitions, sorrows and glory days will be retold and remembered with much pomp and ceremony. What activities will be planned? Will someone take on the personas of Joseph and Almeda Naper and volunteer to sail from Ashtabula, Ohio, to Chicago with thirteen families? Will the square scoop make a comeback at local ice cream shops? Whatever will be done, Naperville, the surrounding communities and visitors alike will be in wonder of the community so close to Chicago and yet so uniquely its own. Like the DuPage River that winds its way through downtown, the timeline of Naperville stretches long, moving fast and sometimes slow but

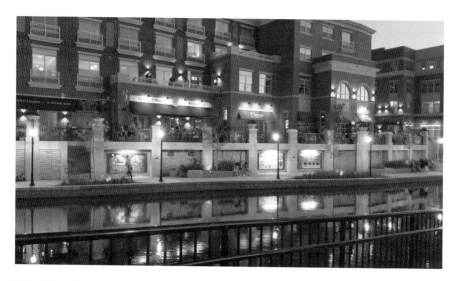

Water Street development at night, a vibrant part of Naperville's downtown and Riverwalk. *Photographed by the author.*

always flowing on and on. We are all transplants along these riverbanks. Some of us have been here longer than others. Some of us are merely passing through. Ralph Naper, the grandson of Joseph Naper, did not stay in Naperville. He sailed west over the wide expanse of prairies in 1899 and founded Naper, Nebraska.[174]

From the people before us and to the people after us, we hear and say:

Welcome to Naperville. This is my home.

Willkommen in Naperville. Das ist mein Zuhause.

‫ברוכים הבאים‬ Naperville. ‫זה תיבה שלי‬.

Bienvenido a Naperville. Esta es mi casa.

Vitajte v Naperville. Toto je môj domov.

欢迎来到内珀维尔。这是我的家。

Vítejte v Naperville. To je můj domov.

Bienvenue à Naperville. C'est ma maison.

Καλώς ήλθατε στο Naperville. Αυτό είναι το σπίτι μου.

Naperville में आपका स्वागत है यह मेरा घर है।

Maligayang pagdating sa Naperville. Ito ang aking tahanan.

Welkom bij Naperville. Dit is mijn huis.

‫مرحبا بك في نابرفيل. هذه بيتي‬.

Velkommen til Naperville. Dette er mitt hjem.

Witamy w Naperville. To jest mój dom.

Sveiki atvykę į Naperville. Tai mano namai.

Chào mừng đến với Naperville. Đây là nhà tôi.

Добро пожаловать в Naperville. Это мой дом.

네이처 빌에 오신 것을 환영합니다. 이게 내 고향이야.

ネーパーヴィルへようこそ。これは私の家です。

‫به نابرویل خوش آمدید این خانه من است‬.

NOTES

Chapter 1

1. Watts, *Reading the Landscape of America*, 96ff.
2. Thompson, *DuPage Roots*, 3ff.
3. Maas, *Bicentennial View*, 12.
4. *United States of America v. Sanitary District of Chicago*, 4 District Court of the United States 1818 (1914).
5. Angle, *Prairie State*, 15.
6. Belue, *Long Hunt*, 20.
7. Butterfield, *History of George Rogers Clark's Conquest of Illinois and Wabash Towns*, 302.
8. Davis, *Frontier Illinois*, 118.
9. Buley, *Old Northwest*, vol. 1, 44.
10. Keating, *Rising Up from Indian Country*, 243.

Chapter 2

11. J. Seymour Currey, "First Settler Landed Here by Captain's Order," *Evanston (IL) News*, May 6, 1918; Reeling, *Evanston*, 130. Scott family scholar Roy Grundy refutes the counterfeit claim in his article "Evanston, Illinois, First Settled by the Apparent Use of Counterfeit Coins," *The Centinel: Quarterly Journal of the Central States Numismatic Society* 33, no. 2 (Summer

1985): 34–35. Holderman's Grove, now Lisbon, was named for Abraham Holderman, who bought out Pierce Hawley's claims. Hawley, a Vermont native, settled in Indiana in 1818 and came to Illinois in 1825. *United States Biographical Dictionary*, 12, 13; Fort Payne DAR, *Naperville Centennial*, 70.

12. This grove was named Hollenbeck's Grove after pioneer George Hollenbeck and was located somewhere between Oswego and Yorkville. Blanchard, *History of DuPage County*, 26, 29.

13. Blanchard, *History of DuPage County*, 29.

14. Maritime History of the Great Lakes, maritimehistoryofthegreatlakes. ca, accessed March 18, 2017. Known ships in which Naper was either the owner or captain between 1823 and 1831 include *General Huntington*, *DeWit Clinton, Commerce, Fair Play, Telegraph, Pioneer* (steamboat), *John Richards* and *Traveler*.

15. Maritime History of the Great Lakes, maritimehistoryofthegreatlakes. ca, accessed March 18, 2017.

16. Blanchard, *History of DuPage County*, 21, 30.

17. Dexter Graves memorial, *Eternal Silence* by Lorado Taft, Graceland Cemetery, Chicago.

18. Fort Payne DAR, *Pioneers*, 6; Gingold, *Ruth by Lake and Prairie*, 189–92; Harmon, *Story of an Old Town*, 26.

19. Blanchard, *History of DuPage County*, 32; Fort Payne DAR, *Naperville Centennial*, 68; Richmond and Vallette, *History of the County of DuPage*, 7.

20. Fort Payne DAR, *Naperville Centennial*, 10, 59; Fort Payne DAR, *Pioneers*, 104; Blanchard, *History of DuPage County*, 52.

21. Booth, *Archeological Investigations at the Joseph Naper Homestead Site*, 68.

22. Buley, *Old Northwest*, vol. 2, 66.

23. Whitney, *Black Hawk War*, vol. 2, 475; vol. 1, 448, 472.

24. Ibid., vol. 2, 539. Brown's body was buried first outside Fort Payne and then transferred to the first Naperville Cemetery at the corner of Washington Street and Benton Avenue. In 1842, it was moved again to the current Naperville Cemetery on South Washington Street.

25. *Cleveland Advertiser*, June 20, 1832.

26. *Star and Banner* (Gettysburg, PA), July 10, 1832.

27. George Martin to R. and G. Martin, November 2, 1833, Martin Collection, Archives of the Naperville Heritage Society/Naper Settlement (ANHS/NS).

28. Ibid.; receipt, Joseph Naper to George Martin, November 18, 1833, Martin Collection, ANHS/NS. Although both histories of DuPage County, written in 1857 and updated in 1877, state that Alexander

Howard's home was the first frame house built in DuPage County, credit (since 1931) has been given to George Martin's home. Alexander Howard's house is now preserved at Naper Settlement as the Paw Paw Post Office. Richmond and Vallette, *History of the County of DuPage*, 7, 89; Richmond, *History of DuPage County*, 151.

29. The Proceedings of the Naperville Lyceum, 1836–1842, Naper Collection, ANHS/NS.

30. The First Congregational Church of Naperville Collection, 1833–current, ANHS/NS.

31. *U.S. Biographical Dictionary* (1876), 12–13.

32. Richmond, *History of DuPage County*, 41.

33. *Illinois State Register and People's Advocate* (Vandalia, Illinois), May 13, 1837, in Buley, *Old Northwest*, vol. 2, 271–72.

34. Plat of Naperville, 1842, Map Collection, ANHS/NS. The Pre-Emption Act of 1841 would be the standard for all land sales until its revision in 1891.

Chapter 3

35. Pease, *Story of Illinois*, 270.

36. Quaife, *Chicago's Highways*, 72–79. The Pre-Emption House was located on the southeast corner of Jackson Avenue and Main Street. The New York House was located directly opposite on the northeast corner. Scott's Naperville hotel was located on the north side of Jefferson between Washington and Main Streets. John Stevens built a large hotel on the southeast corner of Eagle Street and Jefferson Avenue; however, it was used primarily to board students and later his own extended and numerous family members. If a "prairie schooner" is considered to carry household goods and 5 or 6 women and children, with 1 to 3 menfolk on foot or horseback, then the average number of travelers passing through Naperville would be 300 to 450 per day. Considering hotel accommodations in the mid-nineteenth century, a common room could hold 20 guests and private rooms could hold between 4 and 6. A hotel the size of the Pre-Emption House or the New York House could potentially board 38 to 40 people per night.

37. Quaife, *Chicago's Highways*, 84, 161.

38. Fort Payne DAR, *Naperville Centennial*, 17, 18; charter, Southwestern Plank Road Corporation, September 1848, ANHS/NS.

39. McAlester, *Field Guide to American Houses*, 38.

40. Ibid., 39. The sales tallies of the Chicago-based supply firm of Harmon, Loomis and Company, which are kept in the collection of the Chicago History Museum, record the many building supplies Naper and Butler purchased for use in Naperville. Barrels of various-sized nails were bought in abundance in the early part of the summer, and by the fall, boxes of window glass and replacement tools (chisels, gougers and files) had been ordered. Harmon, Loomis and Company Collection, Chicago History Museum/Archives.

41. Pease, *Frontier State*, 390-93.

42. Blanchard, *History of DuPage County*, 698.

43. Richmond and Vallette, *History of the County of DuPage*, 106.

44. An Act to Incorporate the Naperville Academy was passed on February 27, 1841. The act set up Naper and others as trustees charged with raising subscriptions. This academy must not have come to pass, for another Act to Incorporate the Naperville Academy was passed on February 17, 1851, naming the first principal, Reverend Hope Brown, and Henry L. Peaslee, Salinius M. Skinner, John Collins and Alymer Keith as trustees.

45. Ditzler, *Academy Scrapbook*, vol. 1, ANHS/NS.

46. Schmidt, *When the Democrats Ruled DuPage*, 57, 65, 66.

47. Givler, *Euclid Lodge No. 65*, 15.

48. Pease, *Frontier State*, 400.

49. Humphrey, *Illinois*, 147.

50. Scobey, "Echoes of the Mexican War," 41.

51. Schmidt, *When the Democrats Ruled DuPage*, 54.

52. Pease, *Frontier State*, 369-75, 380. Pease believes that this cartoon was the first editorial cartoon printed in an Illinois newspaper. Turner, *Underground Railroad in Illinois*, 187. The Alexander Howard House or Paw Paw House, formerly on the northeast corner of Jefferson Avenue and Eagle Street and now at Naper Settlement, was long considered a stop on the Underground Railroad. The Israel Blodgetts, formerly of the Scott Settlement, were known abolitionists and had close ties to Naperville.

53. Vermont was the first state to ban slavery, in its 1777 constitution. In 2015, interim director Mike Krol and the Naperville Heritage Society restored the grave site of Sybil Dunbar through a generous donation from John and Taylor Koranda and the Naperville Special Events and Cultural Amenities fund (SECA).

54. Richmond and Vallette, *History of DuPage*, 66.

55. Fort Payne DAR, *Naperville Centennial*, 17, 19.

56. Richmond and Vallette, *History of DuPage*, 69; Fort Payne DAR, *Naperville Centennial*, 24; Ditzler, "Newspaper Scrapbook," vol. 1, 40, ANHS/NS.

57. Knobloch, *DuPage County*, 25; Richmond and Vallette, *History of DuPage*, 91.

58. Fort Payne DAR, *Naperville Centennial*, 20; Johnson, "I Was Hanged."

59. Schmidt, *When the Democrats Ruled DuPage*, 82.

60. Ibid., 80.

61. Letter, President James Buchanan to "Gentlemen [of Naperville]," Murray Collection, ANHS/NS. Delana R. Eckles was appointed chief justice of the Supreme Court for the Territory of Utah on May 6, 1858.

62. "Utah War," en.wikipedia.org/wiki/Utah_War, captured on December 5, 2008; Mason, *Brigham Young*, 114.

63. Schmidt, *When the Democrats Ruled DuPage*, 68, 74; Givler, *Euclid Lodge*, 7.

64. Letter, John Haight to Elvira Haight, November 29, 1860, "Burch Divorce" file, ANHS/NS.

65. *Naperville Sentinel*, April 19, 1861.

Chapter 4

66. The Illinois Secretary of State database of Civil War soldiers from Naperville lists 117 recruits in 1861, 75 in 1862, 21 in 1863, 51 in 1864 and 27 in 1865; www.cyberdriveillinois.com/departments/archives/databases/datcivil.html.

67. Ditzler, *Reflections of a Bygone Era*, 18; *Naperville Sentinel*, April 25, 1861.

68. *Naperville Sentinel*, April 25, 1861.

69. Ibid., May 9, 1861.

70. Schmidt, *Bugles in a Dream*, 4.

71. *Sentinel*, April 25, 1861.

72. David B. Givler, unpublished letters and diaries, Manuscript Collection, ANHS/NS, 6. Givler entered the Seventh Illinois U.S. Infantry as a musician at the age of twenty. Two years later, he was made a private. Ditzler, *Reflections of a Bygone Era*, 18.

73. Eddy, *Patriotism of Illinois*, vol. 2, 539; Goodrich, *Tribute Book*, 160, 161.

74. Adam L. Dirr, unpublished diary, June 25, 1861–June 18, 1864, Civil War Collection, ANHS/NS; Strong, *Yankee Private's Civil War*, 77.

75. Hicken, *Illinois in the Civil War*, 8; *Sentinel*, May 30 and June 6, 1861.

76. *Sentinel*, miscellaneous issues, April 25–June 20, 1861.

77. Strong, *Yankee Private's Civil War*, 1, 217.

78. Ditzler diaries, 1860s; Strong, *Yankee Private's Civil War*, 1. The *Sentinel* newspaper folded in 1862 and was replaced by the *DuPage County Press* in 1863. The *Press* was owned by Robert Naper and Robert K. Potter from 1863 to 1868. Few issues were printed or survive in the historical record.

79. Ditzler, *Reflections of a Bygone Era*, 22.

80. Ibid., 21.

81. Pease, *Story of Illinois*, 186.

82. Knobloch, *DuPage County*, 129; *Holland's Business Directory of Naperville*, 64.

83. Nicholas Stenger probate files, DuPage County Courthouse, Box 232. Incidentally, two of John Stenger's daughters married into Naperville brewing families; Barbara Stenger married Joseph Egermann, son of Xavier Egermann (once a rival brewery), and Mary Stenger married Joseph Schamberger. For nearly a year, Schamberger operated a small brewery in the Stenger buildings before he took his bride and some of the Stenger brewery equipment to Astoria, Oregon, where he conducted a very successful brewery.

84. *History of the Naperville Fire Department 1874–1999* (HNFD), 11.

85. *Naperville Clarion*, January 5, 1870.

86. Ibid., February 2, 1870; Roberts, *History of North Central College*, 18. An Act to Incorporate North-Western College went into force on February 15, 1865. North-Western trustees responded to the *Aurora Herald* by noting the "half-dozen church spires and other moral and cultural advantages of [Naperville]." Roberts, *History of North Central College*, 51.

87. *Naperville Clarion*, January 5, 1870.

88. The Naperville Historic District, created in 1986, was carved from a much larger national landmark district established in 1977. The national district covers all of downtown Naperville, some of the west side or original town of Naperville and the Kroehler factory. The movement to create a historic district in Naperville was led by civic leader Marjorie Osborne and then city planner Walt Newman.

89. Many legends have developed regarding that fateful night. The five missing books, for example, were presumed to have burned in the Great Chicago Fire of 1871. Tax collectors' books in the vault at the DuPage County Courthouse have evidence labels from the Illinois State Supreme court case attached and were therefore not burned in the fire. In addition, the missing books were indexed in the late 1890s, so they must have gone missing after that time.

90. Before the war, Captain Blanchard was as a law partner with Merritt Hobson, who was also of Company K, Thirteenth Illinois U.S. Infantry.

Blanchard died in December 1863 of wounds received during the Battle of Ringgold Gap, Georgia, fought earlier in November of that same year. Merritt Hobson left the United States Army for health reasons in 1862. He returned to Naperville briefly before moving to Iowa, where he also practiced law. He died at the age of thirty-two in Ottumwa, Iowa, and is buried in the Naperville Cemetery. The GAR was mostly a social organization whose members presented flags and honor guards at funerals, marched in parades and held yearly encampments, recounting the heroes and battles of the Civil War. The Naperville GAR closed in 1943 when the post's last member, Lewis M. Rich, died at the age of ninety-eight. The GAR organization was officially closed in 1956 at the death of its last member, drummer boy, Company C, First Minnesota Heavy Artillery, Albert Woolson (1850–1956) of Duluth, Minnesota.

91. *Holland's Business Directory*, 36, 37; Steck, *Lovisa M. Steck.*
92. *Holland's Business Directory*, 15.
93. The D.A. Sanborn Company was founded in 1867 by Daniel Sanborn and operated until 1977. The maps of more than twelve thousand United States cities are an invaluable resource showing the change over time in the built environment. Naperville was mapped by the Sanborn Company in 1886, 1892, 1909, 1920, 1926 and 1943. The Baptist church/curfew and alarm bell is on display at Naper Settlement. *History of the Naperville Fire Department*, 15.
94. James L. Nichols, "Autobiography as Told to His Wife Elizabeth Barnard Nichols," August 15, 1895, 13. On a curious note, Nichols signed his name "James Levi Nichols" on all official documents pertaining to his membership in the Naperville Euclid Lodge. Thank you to Tim Ory for bringing this to my attention.

Chapter 5

95. D.B. Givler, "Forward," *Naperville Clarion*, March 12, 1890.
96 *Popular Mechanics*, October 1914, p 163.
97. Roberts, *North Central College*, 126.
98. Bickhaus, *History of Naperville District 203*, 12.
99. City council minutes, December 12, 1922; December 31, 1923; 1927; 1935.
100. Kroehler and Kroehler, *Our Dad*, 15.
101. City Council minutes, January 21 and 28, 1910.
102. Ibid., January 28, 1910.

103. Tingley, *Structure of a State*, 196.

104. Lebeau and Keating, *North Central College and Naperville*, 18.

105. Judd Kendall VFW Post 3873, www.napervfw3873.org, accessed January 29, 2018.

106. *Naperville Clarion*, June 1, 1917.

107. "SS. Peter & Paul Church Destroyed by Fire," *Naperville Clarion*, June 8, 1922; "17th Anniversary of SS. Peter and Paul Church Fire Sunday," *Naperville Clarion*, June 1, 1939. The KKK cards found in the vertical files at Naper Settlement were marked "Reference Only" but have since been added to the permanent collection. Donor information is not available.

108. "Why a Centennial Celebration in Naperville?," *Naperville Clarion*, February 26, 1931.

109. "Centennial Preparations Are Gaining Headway," *Naperville Clarion*, March 5, 1931; "Permanent Memorial Now Possible for Centennial," *Naperville Clarion*, March 26, 1931; "Official Program Centennial Celebration," *Naperville Clarion*, May 28, 1931; "Naperville Centennial Pageant," *Naperville Clarion*, June 4, 1931; "100 Yrs. of Progress Vividly Portrayed in 2 Day Celebration," *Naperville Clarion*, June 11, 1931; "Centennial Park!—Is It to Be Realized?," *Naperville Clarion*, June 25, 1931; "Swimming in Quarry Enjoyed Since Saturday," *Naperville Clarion*, July 2, 1931; Lebeau and Keating, *North Central College and Naperville*, 26.

110. Naperville City Council minutes, May 31, 1932, July 15, 1935; *Naperville Clarion*, January 22, 1942.

111. Wood, "Small Town Weathers the Depression," 144.

112. Ibid., 25.

113. Lebeau and Keating, *North Central College and Naperville*, 26; "Screen Savor," *Naperville Sun*, August 18, 2002; Genevieve Towsley, "City Hard Hit by 1930's Depression" (1959), *View of Historic Naperville from the Sky-Lines*, 208; Forest Preserve District of DuPage County, "McDowell Grove," www.dupageforest.org/Conservation/Forest_Preserves/McDowell_Grove.aspx, accessed May 19, 2017.

114. Kroc with Anderson, *Grinding It Out*, 46ff.

115. "Mrs. Caroline Martin Mitchell Passes Away at Pine Craig," *Naperville Clarion*, October 15, 1936; "Caroline Martin Mitchell Will Filed for Probate," *Naperville Clarion*, November 12, 1936; "Mitchell Gift Settled; City Gets 205 Acres, 2 Homes," *Naperville Clarion*, February 2, 1939; "Inspect Caroline Martin Mitchell Museum Tuesday," *Naperville Clarion*, September 7, 1939. Also see *Naperville Clarion*, September 14, 1939.

116. "Nichols Mayor; Keller, Nelson, Myers and Clementz Elected; Retain Taverns by 662 Votes," *Naperville Clarion*, April 20, 1939; "City Distributes 50% More Electricity Than in 1936," *Naperville Clarion*, April 27, 1939; "Seminary Nears Close of Its Most Successful Year," *Naperville Clarion*, May 4, 1939; "Begin Work on Two New Homes During Past Week," *Naperville Clarion*, May 4, 1939; "18 States, 5 Nations Are Represented at N.C.C.," *Naperville Clarion*, October 12, 1939; "Annual Naperville Auto Show Opens Tomorrow," *Naperville Clarion*, October 19, 1939.

117. Hageman, *Naperville Area Farm Families History*, 45.

118. Lebeau and Keating, *North Central College and Naperville*, 26, 28.

Chapter 6

119. "Naperville Celebrates V-J Day All Night!," *Naperville Sun*, August 16, 1945.

120. "Larry Nadelhoffer, G.M. 1/c, Missing in Action" and "George Massier S 1/c Missing in Action Since June 30," *Naperville Sun*, August 16, 1945.

121. "Kroehler Mfg. Co. Plans $1,200,000 Plant Expansion; Add 2000 Employees," *Naperville Clarion*, September 13, 1945.

122. Grossman, Keating and Reiff, *Encyclopedia of Chicago*, 932–33; *Naperville Clarion*, September 13, 1945; Genevieve Towsley, "What's Naperville Like?," *Naperville Clarion*, October 29, 1953.

123. *Naperville Clarion*, October 11, 1945.

124. "Naperville Public Schools Enrollment Now Totals 1042," *Naperville Clarion*, September 13, 1945; Bickhaus, *History of Naperville District 203*, 24–28. School enrollment data found in 1947 Planning Commission minutes document. In the document, the chairman reports total school registration for public schools in 1947 as 1,074. As part of the same document, a December 9, 1948 meeting reports public school enrollment as 1,134, including kindergarten. In 1947, the city council passed the ordinance for creating the Planning Commission, which included the mayor, city attorney, chairman of the zoning board of appeals and twelve other citizens.

125. Bickhaus, *History of Naperville District 203*, 27. The airport was designed and drawn by V.F. MacDonald on July 15, 1944. Map Collection, ANHS/NS.

126. The Catholic and Lutheran school and North Central College enrollment data was reported by Naperville Planning Commission

members Eller and Mihulka during a December 9, 1948 meeting. Genevieve Towsley, "What's Naperville Like?," *Naperville Clarion*, October 29, 1953; "Kroehler Gifts in Naperville Are Announced," *Chicago Sunday Tribune*, January 14, 1945; Lebeau and Keating, *North Central College and Naperville*, 25; Peter E. Kroehler obituary, *Chicago Daily Tribune*, August 16, 1950. Also see Naperville Government List, napervillevoter.com.

127. U.S. Census Bureau; *Naperville Clarion*, January 3, 1946; Hageman, Meisinger, McDonald and Weisbrock, *Naperville Area Farm Families History*.

128. *Treasures of the Naperville Heritage Society and Naper Settlement*, January–April 2009. See Naperville Planning Commission chairman's report of 1947 statistics; Towsley, "What's Naperville Like?" *Naperville Clarion*, October 29, 1953.

129. *Evening Gazette* (Pittston, PA), February 28, 1888.

130. Spinner, *Tragedy at the Loomis Street Crossing*, 32–45; *Chicago Daily Tribune*, April 26, 1946; *Naperville Sun*, April 26, 2006.

131. Brock, "Angeline Gale," 1.

132. *The Naperville Plan: Veterans Own Homes Without Cash*, advertising pamphlet of the Home-Ola Corporation, Chicago, 2.

133. U.S. Census Bureau; Towsley, "What's Naperville Like?," *Naperville Clarion*, October 29, 1953; James Moore, "Naperville and the Population Boom," *Naperville Sun*, February 10, 1966; Lebeau, *Timelines*, 15. For median income, see "Directions for Growth" (General Planning and Resource Consultants, May 1970), 23. The 120 organizations figure is from Robert M. Stephen, "The 1950's: Gracious Rural Living Preserved in a Modern, Expanding Suburb," in Wehrli and Wehrli, *Sesquicentennial Photo Album*, 117. Washington Street was widened in 1969 and 1975, according to Lebeau, *Timelines*, 45, 47.

134. Jean Schmus, "True Meaning of Christmas Found in Search Here," *Naperville Sun*, December 18, 1952; "1,000 to Comb 10 Sq. Miles Today in Naperville Child Hunt," *Chicago Daily Tribune*, December 20, 1952; "Hold Funerals of Naperville Children Today," *Chicago Daily Tribune*, February 5, 1953; "Two Naperville Tots Drowned, Jury's Verdict," *Chicago Daily Tribune*, March 12, 1953.

135. Andrlik, *Building Saybrook*, 7; "Hospital Board Takes Over the Edward Hospital Institution Here Saturday, October 1," *Naperville Sun*, October 6, 1955; *Chicago Tribune*, October 23 and December 15, 1955.

136. Bill Bird, *Chicago Tribune*, July 6, 2016.

137. Brian J. Miller, "A Small Suburb Becomes a Boomburb: Explaining Suburban Growth in Naperville, Illinois," *Journal of Urban History* 2 (2016):

1141; Hal Foust, "Toll Trip Average: 2.3c a Mile!," *Chicago Daily Tribune*, April 16, 1960; Andrlik, *Building Saybrook*, 7; "Standard Oil Technical Center Taking Shape," *Chicago Daily Tribune*, December 21, 1969.

138. "Nike Missile Base C-84, Barrington, Illinois," Historic American Engineering Record, Library of Congress.

139. *Chicago Tribune*, September 8, 1959.

140. Lebeau and Keating, *North Central College and Naperville*, 34. The Student Village was demolished in 2015 and replaced with a state-of-the-art Science Center, which opened in 2017. Bickhaus, *History of Naperville District 203*, 34–35, 132–33. Also see *Naperville Clarion*, December 10 and 17, 1953.

141. *Naperville Clarion*, December 24, 1953; Miller, "A Small Suburb Becomes a Boomburb," 1139.

142. Penick, "Profiles in Excellence: Macom Corporation," *Naperville: 175 Years of Success*; Harold White obituary, *Chicago Tribune*, April 20, 1993; Andrlik, *Building Saybrook*, 8.

143. Naperaero.com, accessed May 16, 2017; "The Naper Aero Club Story" by Harold E. White, ANHS/NS.

144. *Naperville Clarion*, January 14, 1960; Penick, *Naperville: 175 Years of Success*; John Lucadamo, "Moser, Naperville Grow Up Together," *Chicago Tribune*, April 15, 1989; Michael E. Ebner, "Harold Moser's Naperville," *Illinois Periodicals Online*; Robert Kuhn, "Council Keeps Annexing, Doubles Naperville's Size," *Naperville Clarion*, January 14, 1960; Joanne D. Maxwell, "Moser Outlines Plans for Next Ten Years," *Naperville Clarion*, January 14, 1960; Andrlik, *Building Saybrook*, 8.

145. "Rescind the Annexations," *Naperville Clarion*, January 14, 1960.

146. "Mayor Outlines Problems Facing the City," *Naperville Clarion*, January 28, 1960. Mayor Zaininger took office on May 4, 1959, and remained in office for two terms, until April 24, 1967. Andrlik, *Building Saybrook*, 10.

147. "Moser Tells Builders 'Easy Sell' Is Over," *Naperville Clarion*, May 5, 1960.

148. Dale B. Westin, "City Council Approves First Unit of Saybrook," *Naperville Clarion*, February 9, 1961. At the time, Loomis Street stopped just north of Ogden Avenue. Jane White, "Predict 30,000 for Saybrook Area: Officials View Subdivision Plan," *Naperville Clarion*, February 16, 1961.

149. Chuck George interview with author Todd Andrlik, June 18, 2015; "Naperville Builder Incorporates Suggestions of Home Seekers," *Chicago Tribune*, February 22, 1964. Also see "Naperville Architectural Firm

Celebrates 50 Years, Is Recognized for Local Landmarks," *Positively Naperville*, September 19, 2013.

150. Wilkins, "Homes of Builder Don A. Tosi," 3, 8.

151. "Naperville Booms with New Building," *Chicago Tribune*, May 25, 1961; Andrlik, *Building Saybrook*, 13–14; "Naperville OKs Cress Creek Plan: 600 Homes and 18 Holes," *Chicago Tribune*, March 3, 1962. For sample first golf course community claim, see "Townhomes and Condos for Sale in Naperville, Illinois—January 2017," *Naperville Patch* (patch.com), January 4, 2017; Lebeau and Keating, *North Central College and Naperville*, 35, 38.

152. Fox Valley Genealogical Society, *Naperville Cemetery*, 442f.

153. Moore, "Naperville and the Population Boom," *Naperville Sun*, February 10, 1966. For median income, see "Directions for Growth" (General Planning and Resource Consultants, May 1970).

154. The land where Bell Labs was built was annexed to Naperville in 1976. Andrlik, *Building Saybrook*, 52–54.

155. Stephens, *Naperville in the 1970s*, 15; *Chicago Tribune*, June 23, 1977.

156. Grossman, Keating and Reiff, *Encyclopedia of Chicago*, 589; "Report of Human Relations Study Group of the Naperville Community Council, May 12, 1964"; Lebeau and Keating, *North Central College and Naperville*, 35, 38. According to the "Directions for Growth" report, more than five hundred apartment units were constructed in Naperville in 1968, more than all previous years combined.

157. Stephens, *Naperville in the 1970s*, 8; Lebeau and Keating, *North Central College and Naperville*, 35, 38; Lebeau, *Timelines*, 46; "Directions for Growth" (General Planning and Resource Consultants, May 1970), xiii.

158. Stephens, *Naperville in the 1970s*, 14–15.

159. "What Lies in Naperville's Future? Downtown Plan Presented," *Beacon-News*, March 18, 1971; Stephens, *Naperville in the 1970s*, 17–18, 32–33, 46; Blackman, *Downtown Naperville*, 8; Bickhaus, *History of Naperville District 203*, 56, 132–33; Miller, "A Small Suburb Becomes a Boomburb," 1142.

160. *Treasures of the Naperville Heritage Society and Naper Settlement*, January–April 2009; Duane E. Wilson, "Naper Settlement," in Stephens, *Naperville in the 1970s*, 34–35. Thomas E. Brown is the great-great-grandson of William Briggs Greene, whose pioneer homestead, land and Oak Cottage form the large DuPage County Forest Preserve at Hobson Road and Green Road.

161. Stephens, *Naperville in the 1970s*, 33.

162. Lebeau and Keating, *North Central College and Naperville*, 25; Grossman, Keating and Reiff, *Encyclopedia of Chicago*, 932–33; Lebeau, *Timelines*, 49.

The Kroehler brand was sold, and its furniture is still available for sale today. "For 150ᵗʰ Year: Commission Organizes for 1981," *Naper News* (City of Naperville, November–December 1979), 1.

Chapter 7

163. Casey Bukro, "A River of Love Flows through Naperville," *Chicago Tribune*, September 6, 1981.

164. Wehrli and Wehrli, *Sesquicentennial Photo Album*, 165.

165. In a February 20, 1983 edition of the *Chicago Tribune*, a *New York Times* reporter, John Duka, asked Angelo Donghia about his 1977 Kroehler contract. Donghia responded, "It was a disaster. I, who had always checked everything out, discovered too late that I had signed a contract in which I had no control of production. The samples I saw in every city were like nothing I had developed. I had assumed quality would be there and it wasn't."; William Gruber, "Kroehler Execs Quit after Group Buys In," *Chicago Tribune*, July 29, 1981.

166. OMNIA, "FAQ," www.omniaarts.org/faq, accessed September 24, 2018; Stevenson Swanson, *Chicago Tribune*, December 30, 1986.

167. *Chicago Tribune*, December 16, 1983.

168. Flynn Roberts, "Naperville Oks Design Contract," *Chicago Tribune*, August 4, 1988; Eleanor Nelson and Andrew Fegelman, "DuPage Wary of Naperville Plan to Burn Cyanide Chips," *Chicago Tribune*, December 21, 1983; *Chicago Tribune*, January 9, 1984, February 17, 1984.

169. *Positively Naperville*, September 19, 2017; *Chicago Tribune*, September 21, 2017, April 25, 2018; *Naperville Sun*, May 3, 2018; *Daily Herald*, September 22, 2016, May 17, 2017.

170. *Chicago Tribune*, March 2, 1986, July 21, 2005.

171. *Daily Herald*, April 15, 2010.

172. "About," *Positively Naperville*, www.positivelynaperville.com/about-pn, accessed November 7, 2017.

173. "City of Naperville Awards and Recognitions," www.naperville.il.us/contentassets/497a97cdf9e74c3eb6ec03a5eb513159/naperville-awards.pdf, accessed March 18, 2018.

174. Naper Nebraska, www.napernebraska.org/history, accessed January 17, 2018.

BIBLIOGRAPHY

Adams, James N. *Illinois Place Names*. Springfield: Illinois State Historical Society, 1968.

Andrlik, Todd. *Building Saybrook*. Naperville, IL: JAR Books, 2015.

Angle, Paul M., ed. *Prairie State: Impressions of Illinois, 1673–1967, by Travelers and Other Observers*. Chicago: University of Chicago Press, 1968.

Balesi, Charles J. *The Time of the French in the Heart of North America, 1673–1818*. Chicago: Alliance Française, 1992.

Banash, Stan. *Roadside History of Illinois*. Missoula, MT: Mountain Press Publishing Company, 2013.

Bateman, Newton, and Paul Selby, eds. *Historical Encyclopedia of Illinois and History of DuPage County*. Chicago: Munsell Publishing Company, 1913.

Belue, Ted Franklin. *The Long Hunt: Death of the Buffalo East of the Mississippi*. Mechanicsburg, PA: Stackpole Books, 1996.

Bickhaus, Phoebe. *History of Naperville Community Unit School District 203*. Naperville, IL: Naperville Community School District 203, 1997.

Blackman, Joni Hirsch. Images of America: *Downtown Naperville*. Charleston, SC: Arcadia Publishing, 2009.

Blanchard, Rufus. *History of DuPage County*. Chicago: O.L. Basking & Company, 1882.

Booth, Don. *The Archeological Investigations at the Joseph Naper Homestead Site*. O'Fallon, IL: SCI Engineering, Inc., 2007.

———. "The Naperville Heritage Society and the Naper Settlement Investigations of Captain Joseph Naper's Homestead Site." *Illinois Antiquity* 46, no. 4 (December 2011).

Brock, Mary Anne. "Angeline Gale, Educator, Mentor, Naperville Service Organization Veterans Counselor and Housing for WWII Veterans in Naperville, Illinois, 1945–1947." Naperville, IL: unpublished manuscript, 2017.

Brown, Thomas, and Held Associates. *Naperville Central District Urban Design Plan, Progress Report 1–3*. San Francisco, 1972–74.

Buck, Stephen J. "To Hold the Prize." *Illinois Historical Journal* 85, no. 4 (Winter) 1992.

———. "A Vanishing Frontier: The Development of a Market Economy in DuPage County." *Illinois Historical Journal* 93, no. 4 (Winter 2000–1).

Buley, R. Carlyle. *The Old Northwest Pioneer Period, 1815–1840*. Indianapolis: Indiana Historical Society, 1950.

Butterfield, Consul Wilshire. *History of George Rogers Clark's Conquest of Illinois and Wabash Towns 1778 and 1779*. Columbus, OH: Press of J.H. Heer, 1904.

Clare, Jini Leeds. *Century Walk: Art Imitating History*. Naperville, IL: Century Walk Corporation, 2010.

Colton, J.H. *The Western Tourist or Emigrants Guide*. New York, 1846.

Combination Atlas Map of DuPage County Illinois. Elgin, IL: Thompson Bro's and Burr, 1874.

Cowlishaw, Mary Lou. *This Band's Been Here Quite a Spell...1859–1981*. Naperville, IL: Naperville Municipal Band, Inc., 1981.

Davis, James E. *Frontier Illinois*. Bloomington: Indiana University Press, 1998.

Davis, R. Edward. *Early Illinois Paper Money*. Chicago: Hewitt Brothers, n.d.

Ditzler, Hannah. "History of the Naper Academy." Vol. 1, 1850–1864. Unpublished, Ditzler Collection, Naperville Heritage Society/Naper Settlement (ANHS/NS).

———. "Newspaper Scrapbook." Vol. 1, 1855–1872. Unpublished, Ditzler Collection, ANHS/NS.

———. *Reflections of a Bygone Era*. Edited by Genevieve Towsley. Naperville, IL: Bank of Naperville, n.d.

Eddy, T.M. *The Patriotism of Illinois: A Record of the Civil and Military History of the State in the War for the Union*. Vol. 2. Chicago: Clarke & Company, 1865.

Fort Payne Chapter, Daughters of the American Revolution. *Naperville Centennial 1831–1931*. Naperville, IL, 1931.

———. *Pioneers of Naperville: A Memorial Volume*. Naperville, IL, 1953.

Fox Valley Genealogical Society. *Naperville Cemetery: A History in Stone*. Naperville, IL: www.lulu.com, 2008.

Fry, John E. *My Dad Says...* Naperville, IL: Wheatland View Publishing, Inc., 2000.

Gingold, Katherine Kendzy. *Ruth by Lake and Prairie: True Stories of Early Naperville, Illinois.* Naperville, IL: Gnu Ventures Company Publication, 2006.

Givler, Oscar H. *Euclid Lodge No. 65, A.F. & A.M. 1849–1904.* Naperville, IL: Naperville Clarion, 1904.

Goodrich, Frank B., ed. *The Tribute Book: A Record of the Munificence, Self-Sacrifice and Patriotism of the American People During the War for the Union.* San Francisco: H.H. Bancroft and Company, 1867.

Grossman, James R., Ann Durkin Keating and Janice L. Reiff, eds. *Encyclopedia of Chicago.* Chicago: University of Chicago Press, 2004.

Hackett, James E. "Geologic Factors in Community Development at Naperville, Illinois." *Environmental Geology Notes,* no. 22 (June 1968).

Hageman, Ruth, Earl Meisinger, Lenore McDonald and Florence (Sis) Weisbrock. *Naperville Area Farm Families History.* Plainfield, IL: Bloom Printing Corporation, 1983.

Harmon, Ada Douglas. *The Story of an Old Town: Glen Ellyn.* Glen Ellyn, IL: Glen News Printing Co., 1928.

Hicken, Victor. *Illinois in the Civil War.* Urbana: University of Illinois Press, 1966.

Higgins, Jo Fredell. Images of America: *Naperville, Illinois.* Charleston, SC: Arcadia Publishing, 2001.

———. Images of Modern America: *Naperville.* Charleston, SC: Arcadia Publishing, 2016.

History of the Naperville Fire Department 1874–1999. Marceline, MO: Walsworth Publishing, 1999.

Hitchens, Harold L., ed. *Illinois: A Descriptive and Historical Guide.* Chicago, 1947.

Holland, John. *Holland's Business Directory of Naperville, Illinois for 1886.* Chicago: Holland's Publishing Company, 1886.

Hoxie, Frederick E. *Encyclopedia of North American Indians.* New York: Houghton Mifflin Company, 1996.

Humphrey, Grace. *Illinois: The Story of the Prairie State Centennial Edition.* Indianapolis, IN: Bobbs-Merrill Company, 1917.

Johnson, Don. "I Was Hanged." Lisle, IL: unpublished manuscript, 2017.

Keating, Ann Durkin. *Chicagoland: City and Suburbs in the Railroad Age.* Chicago: University of Chicago Press, 2005.

———. *Rising Up from Indian Country.* Chicago: University of Chicago Press, 2012.

Keller, Ronald, and Julie Phend. *The First 150 Years: A History of the Naperville Band.* Naperville, IL: Naperville Municipal Band, Inc., 2008.

Knobloch, Marion. *DuPage County: A Descriptive and Historical Guide*. Elmhurst, IL: Irvin A. Ruby, Distributor, 1948.

Kolb, Adrienne, and Lillian Hoddeson. "A New Frontier in the Chicago Suburbs: Settling Fermilab, 1963–1972." *Illinois Historical Journal* 88, no. 1 (Spring 1995).

Kroc, Ray, with Robert Anderson. *Grinding It Out: The Making of McDonald's*. New York: St. Martin's Press, 1977.

Kroehler, Delmar, and Kenneth Kroehler. *Our Dad*. Chicago, 1941.

Ladley, Diane A. *Naperville's Haunted Memories*. Charleston, SC: Arcadia Publishing, 2009.

Lebeau, Pierre. *Timelines: North Central College and Naperville History, 1831–1995*. Naperville, IL: North Central College, 1995.

Lebeau, Pierre, and Ann Durkin Keating. *North Central College and Naperville: A Shared History, 1870–1995*. Naperville, IL: North Central College, 1995.

Maas, David E., and Charles W. Weber, eds. *A Bicentennial View: DuPage Discovery 1776–1976*. Wheaton, IL: Columbian Lithography Company, 1976.

Mason, David Vaughn. *Brigham Young: Sovereign in America*. New York: Routledge, 2014.

Matter, Herb. *Is It Eden? Is It Camelot? Is It Paradise? Better Yet…It's Naperville!* Naperville, IL: self-published, n.d.

McAlester, Virginia S. *A Field Guide to American Houses*. New York: Alfred A. Knopf, 2013.

McCluggage, Robert W. "The Pioneer Squatter." *Illinois Historical Journal* 82, no. 1 (Spring 1989).

Moore, Jean, and Hiawatha Bray. *DuPage at 150 and Those Who Shaped Our World*. West Chicago: West Chicago Printing Company, 1989.

Moy, Caryl Towsley. *Naperville's Genevieve: A Daughter's Memoir*. Naperville, IL: AuthorHouse, 2008.

Naperville Today…Tomorrow: A Prospectus for an Official Plan for Naperville, Illinois February 1951. Naperville, IL: City of Naperville, 1951.

Naperville Woman's Club Commemorative History. Naperville, IL: Naperville Woman's Club, 2007.

Newman, Walter S. *Report on the Historic District City of Naperville*. Naperville, IL: City of Naperville, 1981.

Pease, Theodore C. *The Centennial History of Illinois*. Vol. 2, *1818–1848*. Springfield, IL: Centennial Commission, 1918.

———. *The Story of Illinois*. Chicago: University of Chicago Press, 1959.

Penick, Stephanie. *Naperville: 175 Years of Success*. Pinckneyville, IL: Community Link Publishing, 2006.

Portrait and Biographical Record of DuPage and Cook Counties. Chicago: Lake City Publishing Company, 1894.

Pratt, Harry E. *The Great Debates*. Springfield, IL, 1956.

Quaife, Milo M. *Chicago's Highways Old and New*. Chicago: D.F. Keller & Company, 1923.

Reed, Christopher R. "African American Life in Antebellum Chicago, 1833–1860" *Illinois Historical Journal* 84, no. 4 (Winter 2001–2).

Reeling, Viola Crouch. *Evanston: Its Land and Its People*. Evanston, IL: Fort Dearborn Chapter Daughters of the American Revolution, 1928.

Richmond, C.W. *History of DuPage County, Illinois*. Aurora, IL: Knickerbocker & Hodder, 1877.

Richmond, C.W., and H.F. Vallette, *A History of the County of DuPage, Illinois*. Chicago: Scripps, Bross & Spears, 1857.

Roberts, Clarence N. *A Clear and Steady Light: A Brief History of North Central College*. Naperville, IL: North Central College, 1981.

———. *North Central College: A Century of Liberal Education 1861–1961*. Naperville, IL: North Central College, 1961.

Saints Peter and Paul Parish: 150 Years of Sharing Word. Naperville, IL, 1996.

Schmidt, Leone. *When the Democrats Ruled DuPage*. Warrenville, IL: Compositors Corporation, 1989.

Schmidt, Royal J. *Bugles in a Dream: DuPage County in the Civil War*. Elmhurst, IL: DuPage County Historical Society, 1962.

Schwartz, Thomas F. "The Springfield Lyceums and Lincoln's 1838 Speech." *Illinois Historical Journal* 83, no. 1 (Spring 1990).

Scobey, Frank F. "Echoes of the Mexican War." *DuPage Historical Review* 1, no. 5 (1950), 41.

Souvenir of the Naperville Home Coming May 29th to June 1st, 1917. Milwaukee: Hammersmith and Kortmeyer Company, 1917.

Spinner, Chuck. *The Tragedy at the Loomis Street Crossing*. Naperville, IL: AuthorHouse, 2012.

Sproul, Margaret, ed. *Our Town in Illinois*. Naperville, IL: Naperville Sun, 1968.

Steck, Calvin, ed. *Lovisa M. Steck: Her Life's Work and Character as Reflected by Her Writings*. Chicago: Hammond Press, 1924.

Stephens, Kay. *Naperville in the 1970s: The Defining Years*. Naperville, IL: self-published, 2008.

Strong, Robert H. *A Yankee Private's Civil War*. Edited by Ashley Halsey. Chicago: Henry Regnery Company, 1961.

Tezek, James. *Snapshots of Our Past: A Pictorial History of Naperville*. Marceline, MO: Heritage House Publishing, n.d.

Thompson, Richard A., ed. *DuPage Roots*. Ann Arbor, MI: Braun Brumfield, Inc., 1985.

Tingley, Donald F. *The Structure of a State: The History of Illinois 1899–1928*. Chicago: University of Illinois Press, 1980.

Towsley, Genevieve. *A View of Historic Naperville from the Sky-lines*. Naperville, IL: Naperville Sun, 1975.

Turner, Glennette Tilley. *The Underground Railroad in Illinois*. Glen Ellyn, IL: Newman Educational Publishing, 2001.

Twentieth Century Atlas of DuPage County, Illinois. Chicago, 1904.

The United States Biographical Dictionary and Portrait Gallery of Eminent and Self-Made Men. N.p.: American Biographical Publishing Co., 1876.

Warner and Beers. *Atlas of the State of Illinois*. Chicago: Warner & Beers Publishers, 1876.

Watters, Mary. *Illinois in the Second World War: Operation Home Front*. Vol. 1. Springfield: Illinois State Historical Society, 1951.

———. *Illinois in the Second World War: The Production Front*. Vol. 2. Springfield: Illinois State Historical Society, 1952.

Watts, May Theilgarrd. *Reading the Landscape of America*. Reprint, Rochester, NY: Nature Study Guild Publishers, 1999.

Wehrli, Jean, and Mary Lou Wehrli. *The Sesquicentennial Photo Album: 1831–1981*. Naperville, IL: Naperville Sun, 1981.

Whitney, Ellen M., ed. *The Black Hawk War, 1831–1832*. Springfield: Illinois State Historical Library, 1970.

Wilkins, Charlie. "The Homes of Builder Don A. Tosi." *Historic Illinois* 34, no. 4 (December 2011).

Wood, Doris. "A Small Town Weathers the Depression: Naperville, Illinois, 1929–39." Naperville, IL: unpublished manuscript, 1972.

INDEX

ABOUT THE AUTHOR

History is in Bryan Ogg's blood. For over a decade, he served as curator of research at Naper Settlement, a living history museum in Naperville, Illinois. While maintaining the library and archives at the Settlement, he aided patrons researching Naperville and the region. Additionally, he collaborated on the creation of exhibits and programs for the museum.

Prior to beginning his career in Naperville, Bryan taught history courses at Illinois Central College in East Peoria, Illinois. In addition to his many students, Bryan has trained countless volunteers and interns throughout his nearly thirty years in the museum field. Bryan was a member of the staff at the Peoria Historical Society as the curator of collections and exhibits; the site manager of the 1868 Pettengill-Morron Home; and worked at the Missouri Historical Society and the traveling *Titanic* exhibit in St. Louis and Chicago.

Other published works of Bryan's include *Peoria Spirits: The Story of Peoria's Brewing and Distilling History*; *Wish You Were Here: Peoria Edition*; and several editions of a monthly column for the *Positively Naperville* newspaper. He is a frequent guest lecturer at local schools and colleges, service groups, clubs and organizations.

Bryan's hobbies also revolve around history—he has extensive knowledge of antiques and loves to haunt antique shops and estate sales to add postcards to his collection. An avid genealogist, Bryan has researched his own history extensively, as well as uncovering fascinating tidbits about Naperville residents past and present. He loves to visit historic sites and is an advocate for preserving old buildings, most recently the 1897 Nichols Library in Naperville.

In 2017, the 4:44 Naperville Rotary named Bryan a Paul Harris Fellow and the Fort Payne Chapter of the Daughters of the American Revolution awarded him the Excellence in Community Service Award. A native of Morton, Illinois, Bryan earned his bachelor's degree in history from the University of Sioux Falls and his master's degree in history from Western Illinois University.

Visit us at
www.historypress.com
···